HEPHAISTUS ON THE ATHENIAN ACROPOLIS

T0154446

SELECTED PAPERS ON ANCIENT ART AND ARCHITECTURE

SERIES EDITOR
MEGAN CIFARELLI

NUMBER 7
Hephaistus on the Athenian Acropolis:
Current Approaches to the Study of Artifacts
Made of Bronze and Other Metals

HEPHAISTUS ON THE ATHENIAN ACROPOLIS

CURRENT APPROACHES TO THE STUDY OF ARTIFACTS MADE OF BRONZE AND OTHER METALS

edited by

Nassos Papalexandrou and Amy Sowder Koch

Archaeological Institute of America
Boston, MA
2023

HEPHAISTUS ON THE ATHENIAN ACROPOLIS

Copyright 2023 by the Archaeological Institute of America

All rights reserved. No part of this work may be reproduced or transmitted in any form or by any means, electronic or mechanical, including photocopying and recording, or by means of any information storage or retrieval system, except as may be expressly permitted by the 1976 Copyright Act or in writing from the publisher. Requests for permission should be addressed in writing to The Archaeological Institute of America, 656 Beacon Street, 6th Floor, Boston, MA 02215-2006 USA.

ISBN 978-1-931909-44-0

Cover design by Susanne Wilhelm. Front cover: © Archive YSMA-ESMA: Interior of phiale after conservation. © Hellenic Ministry of Culture and Sports/Ephorate of the City of Athens, Acropolis Restoration Service (Photo T. Souvlakis 2013)

Library of Congress Control Number: 2023014582

Printed in the United States on acid-free paper.

Contents

PREFACE

This volume publishes the revised and edited papers presented in an unforgettable AIA-organized colloquium session under the same title as this book in the 121st Annual Meeting of the Archaeological Institute of America (Washington, DC, January 4, 2020). We express thanks to all contributors for their eager collaboration and to all members of the SPAAA editorial committee for accepting our proposal for publication. We especially acknowledge series editors Kate Topper and Megan Cifarelli for their indefatigable commitment to it throughout the process. We thank Kevin Mullen for keeping the project alive through the difficult years of the pandemic, also the two anonymous reviewers for their constructive criticism and feedback. In accordance with the scholarly nature of SPAAA, we have tried to keep as closely as possible to the papers as presented on January 4, 2020. We are of course responsible for any errors. We submit this volume hoping that it will stimulate discussion of an aspect of the archaeology of the Athenian Acropolis which is no less fascinating than its well-known monuments of architecture and sculpture.

Contributors

Diane Harris Cline is associate professor emerita at George Washington University in history and Classics. Her early work in epigraphy explored the inventory lists of the Parthenon treasures. Beginning in 2012, she introduced Social Network Analysis to the study of ancient biographies and social communities. Her experiments with Actor-Network Theory have focused on the relationships between people, places, and materiality in sanctuaries.

Eleni Karakitsou is an archaeologist responsible for the documentation and archives of the Parthenon restoration works in support of the Acropolis Restoration Service (YSMA). Her experience is documented in numerous publications ("Embolia and Poles from the Monuments of the Athenian Acropolis,""Ceramics and Ceramic Tiles of the Classical Period from the Theban Kadmeia") and conference papers. She is an active participant in the ongoing university excavations by the National and Kapodistrian University of Athens at Kotroni (Epidaurus), Kadmeia (Thebes), and Tanagra.

Amy Sowder Koch is currently associate professor of art history at Towson University in Baltimore, MD. She is an art historian and archaeologist specializing in the study of ancient bronzes (particularly hydriai).

Andronike Makres is a founding member of the Hellenic Education & Research Center in Athens. She graduated from the University of Athens and holds a doctorate in ancient history from Oxford University. A board member of the Greek Epigraphic Society, Andronike is the author (with Alev Scott) of *Power and the People: The Enduring Legacy of Athenian Democracy* (Pegasus, 2020) and of numerous articles on Greek history and epigraphy.

Nassos Papalexandrou teaches at the University of Texas at Austin. His latest book is *Bronze Monsters and the Cultures of Wonder: Griffin Cauldrons in the Preclassical Mediterranean* (University of Texas Press, 2021).

Germano Sarcone is a PhD candidate in Classics at the Scuola Normale Superiore of Pisa and former fellow at the Italian Archaeological School at Athens. His specializes in Greek art and iconography, with a special focus on archaic Athens

and the Northern Aegean. He has authored several articles and is member of the editorial board of the "Annuario della Scuola di Atene e delle Missioni Italiane in Oriente." He is the author *Una comunità di età arcaica ai confini della Daunia*, 2020 (a Daunian/Samnite necropolis at Monte Calvello). He is currently excavating at Hephaistia (Lemnos, Greece) and Agrigento, (Valley of the Temples).

Adele Scafuro teaches at Brown University. She is broadly interested in Greek literature and history, with a particular focus on the intersections of law, civic institutions, social life, and performance. She has widely published on ancient law, Greek epigraphy, and literature (especially orators, drama, history). She is author of *The Forensic Stage: Settling Disputes in Graeco-Roman New Comedy* (Cambridge University Press, 1997), *Demosthenes Speeches 39–49* (University of Texas Press, 2011), and co-editor of the *Oxford Handbook of Greek and Roman Comedy* (Oxford University Press, 2018, with M. Fontaine).

Introduction:
A Historiographic Essay

Nassos Papalexandrou and Amy Sowder Koch

The study of artifacts made of bronze and other metals from the Athenian Acropolis has been a poor relative in the archaeology of Athens's sacred rock since the beginning of systematic work on the Acropolis in 1834. Compared to the near-encyclopedic record of Athenian architecture, sculpture, and painted ceramic vases from the Acropolis, metal studies have lagged far behind.

The complex histories of excavation, publication, and display of bronze objects from the Athenian Acropolis have had far-reaching consequences for our understanding of objects, styles and techniques particular to Athenian craftsmen, and the role of Athens as a metalworking center relative to other sites.

This volume aims to change this status by publishing the reworked and expanded presentations offered at an organized colloquium devoted to the study of bronzes from the Athenian Acropolis presented in January 2020 at the 121st Annual Meeting of the Archaeological Institute of America held in Washington, DC. Our inspiration derives from Chiara Tarditi's ground-breaking publication of numerous remnants of bronze vessels (mainly handles) found on the Acropolis as well as from our and the contributors' research interests.[1] Our aim is to resuscitate interest in the important finds made of bronze and other metals found on the Acropolis since the 1830s and to highlight areas of current and future research in this area. This introduction aims to provide a brief historiographical overview on the subject, delineate broadly the biography of metallic finds from the Acropolis, and introduce the six papers of the volume.

From 1834–1836, Ludwig Ross, Ephor of Antiquities, conducted extensive excavations on the Acropolis. His published short reports in German scientific journals make frequent mention of discoveries of several artifacts made of metal,

bronze in particular, especially in the area around the Parthe-
non.[2] His studies were not comprehensive; the exact number
of these artifacts is as unknown as what happened to them.
In 1891–1892, A. G. Bather published a few bronze objects,
taking special interest in fragments with inscriptions, but nei-
ther inventoried or described the objects he mentions, mak-
ing it difficult to be sure which objects he is referring to when
comparing against remains in the storeroom today.[3] In 1894,
André de Ridder published the catalogue of bronzes pur-
chased by the Archaeological Society of Athens and displayed
at the Polytechneion. In it, only four artifacts are reported
with certainty as deriving from the Acropolis and could have
been found in this early period of the Acropolis' excavations.[4]
A number of these early finds may have been included in de
Ridder's comprehensive catalog of 1896 (see infra). A few of
Ross's finds in 1836 did not fare well after their discovery.
From 1834 to 1875, an old Ottoman-era house north of the
Parthenon near the Erechtheion functioned as the repository
of small finds other than stone sculpture.[5] These bronze finds
resided there until the thefts reported in Greek newspapers in
1862 and 1863.[6] The appearance of these bronze artifacts de-
cades later first in the Collection Oppermann and since 1874
in the Cabinet de Médailles of the Bibliothèque Nationale
de France, where they still reside, generates questions about
the circumstances of their theft and their illegal export from
Greece.[7] Among them, a fine bronze statuette of a centaur
and a severe bronze Athena of the Promachos type, which
Ross describes with unusual detail and enthusiasm, should
rank among the earliest bronze artifacts found in controlled
excavations and reported in a scholarly manner not long after
their discovery.[8] Their theft and illegal export from Greece
is symptomatic of the precarious state of antiquities on the
Acropolis in the years before the foundation of the Archaeo-
logical Society of Athens in 1837 and the completion of the
Acropolis Museum in 1875.[9]

From 1885–1890, the great Acropolis excavations by Pan-
agiotis Kavvadias produced a plethora of metallic finds, the
most choice of which appeared in the comprehensive but sum-
mary catalogue by de Ridder in 1896.[10] This compendium
is still standard because of its relative comprehensive nature
but is now largely outdated. It contains 835 entries, many of
which are the remnants of larger objects that largely perished
in the Persian destruction of the Acropolis or subsequent

upheavals of its stratigraphic horizons after 480 and during Pericles's building projects on the Acropolis. In the years leading up to and during the duration of the great excavation very few select finds were published soon after their discovery by Greek or other archaeologists in the most prominent scholarly venues of the time.[11] These were figurative works of the best quality and preservation but were upstaged by the great sculptural masterpieces in marble brought to life by Kavvadias and his team. Ever since then, the Acropolis has been typecast foremost as a repository of stone sculpture, with the metallic finds, figurative or other, relegated to the margins of scholarly attention. The museological dimension of this attitude is evident in the post-WW2 installation of the old Acropolis Museum and also permeates the conception and focus of the new Acropolis Museum, in operation since 2009. More than a century later than the conclusion of the main phase of Kavvadias' excavations, the bronze finds from the Acropolis remain divided between the National Archaeological Museum and the Acropolis Museum at Makrygianni St. south of the Acropolis. Their presentation in the Acropolis Museum does not do merit to the existing record of artifacts or their potential to show the wealth of the Acropolis in metals over the ages.

One imagines that in the 1880s the archaeological world was bedazzled, perhaps even overwhelmed, by the sheer number of architectural and sculptural masterpieces that were much easier to treat than the demanding metallic finds. A characteristic example of this attitude is manifest if one compares attitudes to bronze finds before and after the great excavation. For example, take a look at the mode of publication of what must be one of the earliest metallic finds from the Acropolis to be treated in some detail as a reportable archaeological find in a scholarly journal: The ship-shaped lamp NM 7038 was discovered in 1862 in the "approximate center of the Erechtheion" ("ἐν τῶι κέντρωι περίπου τοῦ Ἐρεχθείου") and published by archaeologist Athanasios Rhoussopoulos in the second issue of the *Archaeologiki Ephemeris* of the same year.[12] As a preliminary report, Rhoussopoulos' entry is only 20 lines long but conveys essential technical information about this find, reports opinions by K. S. Pittakis and Adolf Bötticher, and even attempts an interpretation of it as a suspended dedicatory object. Most importantly, Rhoussopoulos correctly identifies the artifact as a lamp! If we fast forward

3

now to the same artifact's entry in de Ridder 1896, we discover that the ship lamp merits only five lines of description and, curiously enough, the bibliographic apparatus of the entry does not even contain a reference to Rhoussopoulos' entry in the *Archaeologiki Ephemeris*.[13] Contrary to the exemplary analytical method adopted for bronzes by Ross or by Adolf Furtwängler (1890), de Ridder's compendium was supposed to be brief, even in cases of admired masterpieces, like the well-known kouros de Ridder no. 740 (NM 6445). Unlike the ship-lamp, however, the exquisite kouros is accompanied in de Ridder's entry by an already extensive set of bibliographic references, publications that had appeared between the discovery of the kouros in March 24, 1888 and November 30, 1895, when de Ridder completed his manuscript on the Acropolis bronzes.[14] The conclusion is unavoidable that bronzes were small finds and though of some value they were not deemed worthy of any scholarly attention commensurate to that lavished on the great sculptural masterpieces of the Archaic period. Only a few representational pieces of a "fine style" were treated more extensively.

This attitude persisted throughout the 19th century, when in Greece epigraphic, architectural, and sculptural monuments were esteemed more than others, as evident, for example, in the publications of the *Archaeologiki Ephemeris*, the scholarly journal of the Archaeological Society of Athens, the organization that undertook many excavations on behalf of the Greek state, most extensively on the Acropolis, in the 19th century and long afterward. In the volume for 1883, Kyriakos Mylonas, an archaeologist involved in the Acropolis excavations conducted under the supervision of ephor of antiquities P. Eustratiades, reports on "Finds of the excavation on the Acropolis."[15] The sequence of presentation of these finds ("ἐπιγραφαί, ἀρχιτεκτονικά, γλυπτά, χαλκᾶ καὶ πήλινα," "inscriptions, architectural pieces, sculpture, bronzes, and terra-cottas") also follows an implicit hierarchical standard despite his statement that all these finds were valuable (τίμια) and worthy of deep study and analysis (33). He gives a list of 21 various bronze finds (45–47) in a brief manner, which sharply contrasts with the longer description and analysis he accords to the pieces of sculpture in poros or marble (38–45).

The opening of the old Acropolis Museum in 1874 meant that the growing number of small finds kept in the old house

near the Erechtheion found a more suitable home. A small number of bronzes deemed most showy or aesthetically pleasing were put on display in its galleries. The great excavations of the 1880s, however, produced an unmanageable plethora of finds great and small, so that in 1888 a smaller annex was built on its east side to accommodate finds deemed of secondary importance. Bather undertook a preliminary cleaning of several finds and published extensive analytical reports on them. He characteristically writes that,

> at the time of the excavation [Kavvadias's] the Greek authorities selected those objects in bronze which had any obvious archaeological interest and placed these in the larger museum on the Acropolis. All the other bronze remains were indiscriminately and somewhat carelessly packed in several large boxes and stored in the small Museum [mentioned above as "annex"] … owing to careless storing and the piling of heavy objects on the top of light, a large number of fragments have been further broken up; and secondly, there is absolutely no record of the place or depth at which any of these were found.[16]

There is no doubt that the Acropolis Museum, restricted in space and personnel as it was, was inadequate for handling the Acropolis bronzes, the majority of which ended up in the National Archaeological Museum, where they were properly curated and inventoried by archaeologist Valerios Stais.[17] The inventory had already finished when de Ridder published his catalog of the Acropolis bronzes in 1896. Meanwhile, in Greece the experimental study of conservation of metals, especially made of bronze, steadily progressed in the last decades of the 19th century.[18] A protagonistic role in the systematic conservation of the Acropolis bronzes was played by Othon Rhousopoulos (1856–1922), a professor of chemistry who collaborated closely with Kavvadias and conserved many bronzes of the National Museum in his laboratory at the Academy of Industry and Commerce, just blocks away from the National Museum.[19] The newly founded National Museum was not equipped with a proper conservation laboratory until much later.

Well over a century after this partage of finds between the Acropolis Museum and the National Archaeological Museum, many of the Acropolis' small finds remain unpublished

and unknown. In March 2009, a new gallery dedicated to jewelry and silver vessels from all over Greece was inaugurated in the National Museum, painstakingly researched and installed by two curators, the late Elissavet (Betty) Stasinopoulou and Eleni Zosi.[20] Pride of place in this gallery has a miniscule head of a golden griffin rendered in filigree, a veritable masterpiece of goldwork whose size is inversely analogous to its significance in this discussion (NM 7257).[21] According to the museum's official inventory book, this artifact derives from the Acropolis. Along with it are listed a few entries for a few more artifacts wrought in gold, all from the Acropolis (NM 7255, NM 7256, NM 7258, NM 7259, NM 7260).[22] Compared to the wealth of the sanctuary in gold and silver in antiquity, these artifacts are quantitatively insignificant. However, they remind us that, as Diane Harris has shown in her seminal study of the Athenian treasure lists, at its heyday the Acropolis doubled as a mindboggling treasury of objects wrought in precious metals like gold and silver.[23] In addition to these finds and the overwhelming majority of bronze artifacts, the record of the Acropolis in metallic finds should also include, for example, discoveries made by Ross such as iron tools (interpreted by Ross as stonemasons' tools, found in layers associated with the construction of the Parthenon) and artifacts made of lead. The richness of the Acropolis in metals also can be documented as early as the Late Bronze Age: in Kavvadias's excavations a significant hoard of weapons and tools was discovered embedded in the Mycenaean wall on the south side of the Parthenon.[24] What is more, in 2004 the National Museum added to its collections a Mycenaean gold signet ring from debris produced during work for the extension of the old Acropolis Museum in the 1950s.[25] If indeed the gold ring came from the Acropolis, it would join the gold griffin mentioned above in its capacity to point to the lost wealth of the Athenian Acropolis centuries earlier than its heyday of the Archaic and Classical periods.

By the early 1890s a great number of Acropolis bronzes had found a permanent home and proper curatorial care in the National Archaeological Museum. However, a significant number of bronzes remained on the Acropolis, the majority of which remained until 1914 in the annex or in the basement of the main building of the Acropolis Museum. Of these, those considered not suitable for the main display were stored, in a rather disorderly fashion, in the annex. In 1915, director An-

tonios Keramopoulos reported that many of these bronzes (along with a few iron artifacts) were conserved and exhibited more properly in the eastern gallery of the annex, which was retrofitted with iron shelves.[26] His report included a presentation of a good number of already conserved parts of bronze vessels and attempts a typological classification according to functional groupings.[27] He was careful to stress that these are not works of art but as products of industrial activity they contribute to understanding many aspects of everyday life in antiquity.[28] This is a valuable first illustrated presentation of numerous artifacts, many of which were finally fully published by Tarditi in 2016.[29] In addition to vessel parts, Keramopoulos's report also includes categories other than parts of vessels: cymbals, weighing scales, wheels, weapons, decorated sheet fragments, buckles, nails, also a few inscribed bronzes, which will be published by Androniki Makres and Adele Scafuro, contributors to this volume.[30]

The Acropolis bronzes remained divided between the Acropolis Museum and the National Archaeological Museum from the 1890s to the 1970s. Between late-October 1940 and May 1941, in both museums most Acropolis bronzes, along with most other antiquities under their care, were carefully packaged and securely hidden away in anticipation of damage, destruction, or pillaging during the approaching war.[31] As it turned out later, this move proved instrumental for their preservation during the difficult years of WW2 and the civil wars of 1944–1949. After the war ended, their unpacking, identification, conservation, and display took several decades. This process was still going on in the early 1970s, when a large number of bronzes were transferred from the storerooms of the Acropolis Museum to the National Museum in order to be registered, conserved, and studied. In summer 1973, Petros Kalligas reported that the "majority of bronzes that were not on display [in either museum], were assembled in a special space of the Chalkotheke (gallery of metalwork) where they were classified and sent for conservation in the conservation laboratory."[32] Only a small representative sample remained on display at the Acropolis Museum, which continued its function until 2007. The installation of the new Acropolis Museum at Makrygiannis St. resulted in one more reshuffling of the corpus of bronzes, but to this day most of the Acropolis bronzes remain in the National Museum with a small selection on display at the metalwork gallery.

At the new Acropolis Museum, a representative sample of 87 bronzes (Geometric to Late Archaic periods) are exhibited in display cases lining the east wall of the archaic sculpture gallery. Elsewhere in the museum a small sample of the LBA bronzes (tools and weapons) are on display as well.

The early publications mentioned so far have made known to a wider public of scholars a large corpus of bronzes, many among which were subsequently discussed in more specialized publications that addressed in depth their stylistic, typological, and chronological aspects.[33] Starting with Lolling's fundamental publication, epigraphists have given particular attention to the great plethora of inscriptions on bronze artifacts or their remnants (bases, handles), very often, however, with no or little attention to the physicality of the inscription (its immediate functional context on the bronzes).[34] In the 20th and early 21st centuries, there were very few new discoveries of bronzes found on the Acropolis, but at least these later discoveries preserve a record of their findspots on the Acropolis.[35] Most remarkable are the following: a bronze boar (AM 6447), probably an attachment to a lost vessel, found "on June 1st, 1954, in the fill of the triangular gallery of the old museum";[36] and an inscribed bronze plaque "found in 1958 near the north side of the museum when the courtyard was enlarged."[37] Last but not least, in this volume Eleni Karakitsou presents an unexpected and most interesting find from the interior of the Parthenon's southwest entablature, a piece which may well be the most recent (and enigmatic) metallic find from the Acropolis.[38]

The challenges described up to this point, including the lack of excavation records for the metal finds, the initial decision not to inventory the objects, the separation between multiple collections, and lack of access to the stored objects not on display in the National Museum or old Acropolis Museum have frustrated scholarly efforts to create a complete catalogue of surviving bronze objects excavated from the Acropolis and to understand the development of Athenian metalwork. Obstacles to researching bronzes from the Acropolis, however, are not limited to issues related to modern archaeology.

Tarditi further identifies three key complicating factors beginning in antiquity that are likewise detrimental to our understanding of ancient Athenian metal objects and bronze-working practices: poor physical condition of the surviving bronze objects, misalignment between written evidence and

physical remains, and the limits of the surviving evidence to a date presupposed to provide a *terminus ante quem* of 480 B.C.E.[39] With its inclusion of 1135 fragments of bronze vessels recorded to have been excavated from the Acropolis, Tarditi's important volume represents a major step toward a fuller understanding of the site and its metalworking traditions. Although the constraints remain formidable, the essays in this volume likewise seek to build on both ancient and modern limitations, using newly published evidence in concert with previously known finds to expand our assessments of the objects as well as Athens's role as a center of metalworking more generally.

Only three basins of the 1,135 vessels that Tarditi catalogues from the storerooms of the National Museum survive completely intact; otherwise, only fragments of hammered walls and cast handles remain.[40] The highly fragmentary state of the excavated bronze objects raises questions about the initial deposit of materials and whether the vessels were intact when they were buried, whether their current fragile state is indicative of natural processes like erosive soil, more modern damage through aggressive excavation, or even whether these remnants represent broken cast-offs that escaped the melting pot for recasting.[41] Metal objects, but especially bronze, were prone to recycling into other, more useful objects in times of need or when they became damaged, which presents its own challenge to the survival of the material. The extremely fragmentary state of the preserved bronze remains makes it easy to understand the historical prioritization of the relatively intact large-scale marble sculpture and architecture excavated from the same contexts. Luckily, the cast handles of many bronze vessels are the most recognizable, defining parts; as the site of the primary ornamentation, the sculpted terminals provide good evidence for comparing styles of Athenian objects to those made or found elsewhere.

In her essay on bronze hydriai from the Acropolis in this volume, for example, Amy Sowder Koch uses the newly published hydria and kalpis handles from the Acropolis, published by Tarditi as a starting point to define aspects of a recognizable Athenian style, to reevaluate the place of Athens in the production of metalwork in the Archaic and Early Classical periods, and to assess the roles of both locally made and imported objects as dedications to Athena in Athens. In his essay on monumental tripod-cauldrons from the Athenian

Acropolis between the eighth and seventh centuries B.C.E., Germano Sarcone investigates over 70 fragments of bronze tripod-cauldrons to offer new reconstructions and proposes that the oversized monuments represent a new opportunity for self-presentation within the context of the polis in the Geometric and Orientalizing periods. Similarly, Nassos Papalexandrou leverages the evidence for Orientalizing griffin cauldrons from the Acropolis to highlight the wealth of dedications on the Acropolis even at this early date, to identify relationships between Athens and other Greek poleis, and to offer new ideas about the construction, development, and use of cauldrons from the seventh century B.C.E.

Another complicating factor relates to ancient documentation and the relative lack of supporting textual evidence. While bronze was an expensive material compared to terracotta, for instance, it was not as valuable as silver or gold, and so its presence was not as meticulously recorded in the written record. Even in Athens, where inventoried lists of votive objects offered to Athena on the Acropolis appear in the Hekatompedon inscription from the early fifth century B.C.E. and in lists reported annually by the *tamiai* from 434 B.C.E. to the end of the following century, bronze objects do not regularly appear.[42] These inscriptions focus on silver and gold objects as repositories of accumulated, available wealth. Unfortunately, in the end we are left with epigraphic evidence for precious metal objects that do not survive and archaeological evidence for bronze ones that are seldom recorded.

In this volume, Diane Harris Cline uses epigraphic evidence from the Hekatompedon inscription to track the social life of a group of 21 bronze objects, using Actor-Network theory to assess various relationships and human actions that resulted in the production, transportation, and eventual dedication of these metal objects to the goddess. Andronike Makres and Adele Scafuro jointly present evidence for a group of 11 dedications with inscriptions from the Acropolis, highlighting the epigraphic testimony not only to identify the objects they once supported but also to provide evidence for the act of dedication and important information about the dedicant. Makres's and Scafuro's contributions also offer a way to circumvent the lack of contextual data we have for bronze objects from this site (because of the decision not to inventory the objects or record their findspots at the time of excavation) by using letterforms as evidence for the date

of the offering, if not necessarily the fabrication of the object itself.

The archaeology of the Acropolis itself is problematic for understanding Athenian contributions to the development of Greek metalwork. Given the context in the buried debris of the Persian invasion of Athens, evidence from the Acropolis is presumed to provide a *terminus ante quem* of 480 B.C.E., although Tarditi argues for a wider berth in considering the objects to date from the first half of the fifth century by the time they were all deposited.[43] Objects made or offered after that date (or ca. 450 B.C.E. at the very latest) simply do not survive. For Athenian production after the mid-fifth century, we rely on epigraphic sources, iconography, and textual evidence, but not physical artifacts, which is of course problematic. We have been left to question whether Athens continued as an important center of metalwork after that time, although gaining a better footing on defining Athenian styles from the earlier Classical period helps us to identify Athenian objects when they are discovered elsewhere, thereby building our base of evidence for a continued production. The evidence of bronze objects supports Tarditi's proposal to expand the date of the burial of the Persian debris slightly past 480 B.C.E. For example, the undecorated bronze hydria handles with simple, round terminals are a hallmark of bronze hydria production from the second quarter of the fifth century B.C.E., based on stylistic and contextual data from other sites. So many of these handles were excavated from the Acropolis that we can now not only propose that the Acropolis material included objects made after 480 B.C.E. but also that Athens may have been a leading site in the production of these kalpides.

Given the constraints, a full catalogue raisonné of metal objects from the Athenian Acropolis may never be possible. Stylistic studies in conjunction with scientific approaches, such as archaeometry, could be a fruitful avenue for future study to help in determining the chronology of the excavated objects. Studies like Tarditi's and the essays presented in this volume represent new directions in studies of bronze artifacts, seeking to restore Athens's prominence in metallurgy and to recalibrate our understanding of Greek bronzeworking traditions with new perspectives in mind. We hope that this volume will be just the beginning of a fruitful period of discovery and reinterpretation of the bronze vessels from Athens and beyond.

Notes

[1] Tarditi 2016.

[2] Ross 1855, 105: centaur, bronze helm of Corinthian type; 106: "Hephaistos" statuette, Athena Promachos; 107: owl; 107: fragments of two more Corinthian helmets, iron tools of stonemasons, a lead color container ("Farbentopf"); 111: numerous cast handles and legs of vessels, arrow heads and spearheads, a human-shaped handle of mirror or vessel; 141: unspecified bronzes mixed with pottery shards, fragments of architectural terra-cottas, etc. For most of them Ross notes the stratigraphic context.

[3] Bather 1892–1893a, 1892–1893b; Tarditi 2016, 17.

[4] De Ridder 1894, 39 (no. 152), 138 (no. 801), 168 (no. 909), 174 (no. 933).

[5] Kokkou 2009, 166,

[6] Παλιγγενεσία, 25, November 24, 1862; 260, November 2, 1863; theft and illegal digging and trade of antiquities (*archaiokapeleia*) was endemic in Greece throughout the 19th century and has remained so to this day. In March 1884, P. Eustratiades lost his job in as ephor of Antiquities because of a theft again in the Acropolis Museum (Petrakos 2013, 198–99).

[7] Centaur: Babelon and Blanchet 1895, 219, no. 514 (Ross 1855, 105, fig. 6); Athena Promachos: Babelon and Blanchet 1895, 68, no. 149 (Ross 1855, 106, fig. 7); running gorgon: Babelon and Blanchet 1895, 312–13, no. 706; male figure wearing *pilos* with arms stretched out in front of him: Babelon and Blanchet 1895, 350, no. 811 (Ross 1855, 106); griffin: Babelon and Blanchet 1895, 337–38, no. 774 (mentioned as found on the Acropolis in 1864).

[8] Centaur: Ross 1855, 105, fig. 6; Padgett 2003, 155–58, no. 23; Athena: Ross 1855, 106, fig. 7; Babelon and Blanchet 1895, 68, no. 149.

[9] Foundation of Athens Archaeological Society: Petrakos 2004; old Acropolis Museum: Papalexandrou 2016.

[10] De Ridder 1896.

[11] E.g.: Kavvadias 1886 (bronze statuette of kore, 0.18 m high); Stais 1887 (bronze hammered image of Athena, originally gilded); Studniczka 1887 (four statuettes with inscribed bases in the type of spear-brandishing Promachos); Sophoulis 1887 (head of a bronze statue).

[12] Rhousopoulos 1862, 39 (§9).

[13] De Ridder 1896, 139–41, 140, fig. 95. Note that the object was inscribed but neither Rhousopoulos nor de Ridder mention the inscription. It is not listed in Lolling 1899 either.

[14] De Ridder 1896, 268, 3.

[15] Mylonas 1883.

[16] Bather 1892–1893a, 124.

[17] Kokkou (2009, 248) writes that a systematic department with collections of pottery, figurines, bronzes, and minor arts was insti-

tuted in 1888 with Stais as the person in charge. In 1907 Stais also authored a detailed guidebook with a special section on the bronzes from the Acropolis, a valuable source for the history of display of these bronzes (Stais 1907, 237).

[18] Krinos and Rhousopoulos 1888, 231, where three Acropolis bronzes are listed as subject to successful experiments involving a water solution of hydrochloric acid (HCl) for the removal of layers of rusted metal.

[19] Moraitou 2020; 2016, 239–40.

[20] Papalexandrou 2010, 551–52.

[21] Papalexandrou 2010, 551.

[22] We are grateful to National Museum curator Dr. Christina Avronidaki for this information about the inventory of Acropolis finds in the National Archaeological Museum. This is not the place to address in detail how much remains to be done to complete the work of publication of the Acropolis finds.

[23] Harris 1995.

[24] Kavvadias 1888, 30.

[25] Papazoglou-Manioudaki 2009.

[26] Keramopoulos 1915, 20.

[27] Keramopoulos 1915, 20–34. His classification includes handles, rims, shoulders, bases of vases, and a few entire small vases (19–26).

[28] Keramopoulos 1915, 20.

[29] A selection of these handles was accommodated in the post-WW2 exhibition of the Acropolis Museum, at the "alcove" located on the eastern end of the south side of the museum (Brouskari 1974, 120).

[30] Keramopoulos 1915, 27–34.

[31] At the National Museum, packaged bronzes were secured in the basements of the east wing of the building (Petrakos 2012, 90). Antiquities at the Acropolis Museum were secured either underneath the museum or in various concealed places around the Acropolis (Petrakos 2012, 92–93).

[32] Kalligas 1974, 99–100.

[33] Tarditi 2016; Scholl 2006; Touloupa 1991; Weber 1974; Touloupa 1972, 1969; Niemeyer 1964; Karouzou 1952; Gjødesen 1944; Wolters 1895.

[34] Lolling 1899.

[35] E.g., Sinos and Tschira (1972, 169) report on their discovery of a decorated hammered sheet in a trench on the south side of the Parthenon excavated in 1938.

[36] Brouskari 1974, 112.

[37] Brouskari 1974, 117.

[38] See also Vlassopoulou 2017, on a Late Archaic inscribed kylix that survived the Persian destruction and was used for applying color to the Parthenon during its construction. From the Parthenon's southwest epistyles. Vlassopoulou (2017, 35) also mentions

the discovery of handles from Merrythought cups ("or wishbone")
between the eastern metopes of the Parthenon and the blocks right
behind them.

[39] Tarditi 2017, 15–18.

[40] Tarditi 2017.

[41] Tarditi 2017, 15, 17.

[42] Tarditi 2017, 15.

[43] Tarditi 2017, 18 (with further bibliography).

Works Cited

Babelon, E., and J. A. Blanchet. 1895. *Catalogue des bronzes antiques de la Bibliothèque Nationale*, Paris: E. Leroux.

Bather, A. G. 1892–1893a. "The Bronze Fragments of the Acropolis." *JHS* 13:124–30.

———. 1892–1893b. "The Bronze Fragments of the Acropolis: II—Ornamented Bands and Small Objects." *JHS* 13:232–71.

Brouskari, M. 1974. *The Acropolis Museum: A Descriptive Catalogue*, translated by J. Binder. Athens: Commercial Bank of Greece.

Furtwängler, A. 1890. *Die Bronzen und die übrigen kleineren Funde von Olympia*. Berlin: Asher.

Gjødesen, M. 1944. "Bronze Paterae with Anthropomorphous Handles." *ActaArch* 15:101–87.

Harris, D. 1995. *The Treasures of the Parthenon and the Erechtheion*. Oxford Monographs on Classical Archaeology. Oxford: Oxford University Press.

Kalligas, P. 1974. "Χαλκὰ ἐξ Ἀκροπόλεως Ἀθηνῶν." *AAA* 7:99–102.

———. 1988. "Ἀπό την Ἀθηναϊκή Ἀκρόπολη: Το Ἀθηναϊκό ἐργαστήριο μεταλλοτεχνίας." In *Proceedings of the XII International Conference of Classical Archaeology, Athens, September 4–10, 1983*, 92–97. Athens: Greek Ministry of Culture.

Karouzou, S. 1952. "Ἀρχαϊκὰ μνημεῖα του Ἐθνικοῦ Μουσείου." *ArchEph* 1952:137–49.

Kavvadias, P. 1886. "Ἀνασκαφαὶ ἐν τῆι Ἀκροπόλει." *ArchEph* 1886:73–82.

———. 1888. "Ἀνασκαφαὶ ἐν τῆι Ἀκροπόλει." *ArchDelt* 1888:30–32.

Keramopoulos, A. 1915. "Μουσεία: Περισυλλογή καὶ συντήρησις ἀρχαίων ἐν τούτοις" [Museums: Collection and Conservation of Antiquities in Them]. *ArchDelt* 1 Suppl.:19–34.

Kokkou, A. 2009. Η μέριμνα για τις αρχαιότητες στην Ελλάδα και τα πρώτα μουσεία [The Care for Antiquities in Greece and the First Museums]. 2nd ed. Athens: Kapon.

Krinos, G., and O. Rhousopoulos. 1888. "Περὶ συντηρήσεως τῶν

χαλκῶν καὶ τῶν ἐγχρωμάτων ἀγαλμάτων." *Arch-Delt* 5:227–31.

Lolling, H. G. 1899. Κατάλογος τοῦ ἐν Ἀθήναις Ἐπιγραφικοῦ Μουσείου. 1: Ἐπιγραφαὶ ἐκ τῆς Ἀκροπόλεως; 1, Ἀρχαϊκαὶ Ἀναθηματικαὶ Ἐπιγραφαί. Athens: Archaeological Society of Athens.

Moraitou, G. 2016. "Η 'Οδύσσεια' της συντήρησης και της φυσικοχημικής έρευνας των αρχαιοτήτων στο Εθνικό Αρχαιολογικό Μουσείο." In Οδύσσειες [Odysseys], edited by M. Lagogianni-Georgakarakou, 237–60. Athens: Archaeological Resources Fund.

———. 2020. Ὄθων Α. Ρουσόπουλος (1856–1922) και οι απαρχές της επιστημονικής συντήρησης των αρχαιοτήτων στην Ελλάδα [Othon A. Rhousopoulos (1856–1922) and the Early History of Scientific Archaeological Conservation in Greece]. Athens: Archaeological Resources Fund.

Mylonas, K. 1883. "Εὐρήματα τῆς ἐν τῆι Ἀκροπόλει ἀνασκαφῆς." *ArchEph* 1883:33–48.

Niemeyer, H. G. 1964. "Attische Bronzestatuetten der spätarchaischen und frühklassischen Zeit." *AntP* 3:7–31.

Padgett, J. M., ed. 2003. *The Centaur's Smile: The Human Animal in Early Greek Art.* Princeton: Princeton University Art Museum.

Papazoglou-Manioudaki, L. 2009. "The Gold Ring Said to Be from the Acropolis of Athens." In Δώρον: Τιμητικός τόμος για τον καθηγητή Σπύρο Ιακωβίδη, edited by D. Daniilidou, 581–98. Athens, Greek Academy, Antiquity Research Center.

Papalexandrou, N. 2010. "Beyond the Acropolis: New Installations of Greek Antiquities in Athenian Museums." *AJA* 114.3:549–56.

———. 2016. "The Old Acropolis Museum, Athens, Greece: An Overdue Necrology." *Journal of Modern Greek Studies* 34.1:1–22.

Petrakos, V. 2004. Η απαρχή της Ελληνικής Αρχαιολογίας και η ίδρυση της Αρχαιολογικής Εταιρείας [The Beginning of Greek Archaeology and the Foundation of the Archaeological Society]. Athens, Archaeological Society.

———. 2012. Τα αρχαία της Ελλάδος κατά τον πόλεμο, *1940–1944* [The Antiquities of Greece during the War, 1940–1944]. Athens, Archaeological Society of Athens.

———. 2013. Πρόχειρον Αρχαιολογικόν *1828–2012*. Part 1: Χρονογραφικό [Archaeological Manual 1828–2012. Part I: Chronography]. Athens: Archaeological Society of Athens.

Rhousopoulos, A. 1862. "Δ'Ποικίλα." *ArchEph* 1862:35–40.

de Ridder, A. 1894. *Catalogue des bronzes de la Societé Archéologique d' Athènes.* Paris: E. Thorin.

———. 1896. *Catalogue des bronzes trouvés sur l' Acropole d' Athènes.* Paris: E. Thorin.

Ross, L. 1855. *Archäologische Aufsätze: 1. Sammlung.* Leipzig: Druck & Verlag von B. G. Teubner.

Scholl, A. 2006. "ΑΝΑΘΗΜΑΤΑ ΤѠΝ ΑΡΧΑΙѠΝ: Die Akropolisvotive aus dem 8. bis frühen 6. Jahrhundert v. Chr. und die Staatswerdung Athens." *JdI* 121:1–173.

Sophoulis, T. 1887. "Χαλκὴ κεφαλὴ Ἀρχαϊκῆς Τέχνης." *ArchEph* 1887:43–48.

Stais, V. 1887. "Ἀγαλμάτιον Ἀθηνᾶς ἐξ Ἀκροπόλεως." *ArchEph* 1887:31–34.

———. 1907. *Marbres et bronzes du Musée National, 1er vol.* Athens: P. D. Sakellarios.

Studniczka, F. 1887. "Ἀγαλμάτια ᾽Αθηνᾶς ἐκ τῆς τῶν Ἀθηνῶν Ἀκροπόλεως." *ArchEph* 1887:133–54.

Tarditi, C. 2016. *Bronze Vessels from the Acropolis: Style and Decoration in Athenian Production between the Sixth and Fifth Centuries BC.* Thiasos Monografie 7. Rome: Edizioni Quasar.

———. 2017. "Bronze Vessels from the Acropolis and the Definition of the Athenian Production in Archaic and Early Classical Periods," in *Artistry in Bronze: The Greeks and Their Legacy; XIXth International Congress on Ancient Bronzes,* edited by J. M. Daehner, K. Lapatin, and A. Spinelli. Los Angeles: J. Paul Getty Museum. http://www.getty.edu/publications/artistryinbronze/vessels/24-tarditi/.

Touloupa, E. 1969. "Une gorgone en bronze de l'Acropole." *BCH* 93:862–84.

———. 1972. "Bronzebleche von der Akropolis in Athen: Gehämmerte Geometrische Dreifüsse." *AM* 87:57–76.

———. 1991. "Early Bronze Sheets with Figured Scenes from the Acropolis." *Studies in the History of Art* 32:240–71.

Sinos, S., and A. Tschira. 1972. "Untersuchungen in Süden des Parthenon." *JdI* 87:158–231.

Vlassopoulou, C. 2017. "Χάλκινη ενεπίγραφη κύλιξ από την Ἀκροπολη." *Grammateion: Electronic journal on Ancient Greek Epigraphy, Topography and History* 6:33–41. https://grammateion.gr/sites/grammateion.gr/files/articles/grammateion_6_2017_33-41.pdf (accessed June 21, 2021).

Weber, M. 1974. "Zu frühen attischen Gerätfiguren." *AM* 86:27–46.

Wolters, P. 1895. "Bronzereliefs von der Akropolis zu Athen" *AM* 20:473–82.

The Social Life of Bronzes: Actor-Network Theory on the Entangled Acropolis

Diane Harris Cline

Abstract

Using social network diagrams, this chapter shows how the bronze arti-facts dedicated on the Acropolis in the Archaic period were linked with the humans and human activities, spaces, and temporal aspects involved in leaving an object on the Acropolis. Actor-network theory is applied to two inscriptions, IG I³ 510 and IG I³ 4, showing how the treasurers, Acropolis staff, and worshipers negotiated activities and behaviors on the Acropolis. Through relational materiality, we can follow the technolo-gies, material objects, traditions, and visitor experiences associated with bronze objects on the Acropolis of Athens and find them central to the creation and maintenance of the sanctuary as a sacred space.

EVERY BRONZE OBJECT EXCAVATED BY ARCHAEOLOGISTS on the Athenian Acropolis was left there by someone inten-tionally. No matter how much agency each one might have had, no bronze object reached the summit on its own. Seeing older objects, such as cauldrons with monstrous protomes, or late Geometric tripod-cauldrons, near one's own dedication might have reminded the dedicants of the continuity between the relatively deep past and their own day. Given the Athe-nian belief in their autochthony, these material collections could have seemed to tie them to their origins. Of course, many more things made of different materials reached the Acropolis, but this chapter will focus exclusively on bronzes, as that is the focus of this book.

How important were bronze objects on the Acropolis in the Archaic period, and how were they related to other objects, humans, and places? The social life of bronzes is a way of framing the archaeological study of bronze materials by situating the various types and shapes of bronze objects with the humans who made them, bought and sold them,

used them, made the decision to dedicate them, climbed the Acropolis carrying or transporting them, and ultimately left them behind, making their way back down without them.

This chapter is concerned with the codependencies, interactions, and entanglements between humans, human activities, bronze artifacts, places, and time. Actor-network theory (hereafter ANT) calls all of the above "actors" (or "actants," which I prefer not to use here).[1] An actor is an entity that has "the capacity to act and matter and make a difference in the world."[2] As an actor interacts with others in a relational web or network, changes occur. The web is a group of actors engaged in interaction. How were they entangled? What difference did the bronzes make on the Acropolis? In order to see these ties, we will use a type of social network visualization called field maps.

This way of interpreting Athenian religious activities is influenced by a set of theories derived from the field of science and technology studies, coming originally from sociology, and applied in widely divergent contexts. Because of its diverse applications, not all aspects of ANT can be applied to classical archaeology, nor is it easy to find a clear protocol for trying out the method. It comes down to this: ANT puts things and people in the same network, each having agency and codependency on each other. There is a kind of perpetual motion in manufacturing and using these objects for dedications on the Acropolis, an ecology of craftsmen, individual buyers, and religious personnel interacting with material things in an interesting way: The people need the objects to carry out their votive offerings and sacrifices, without which their rituals cannot be carried out. The links between members of a network, be they human or not, give energy and dynamism to the network.[3]

Of interest to us is the sociocultural religious practices on the Athenian Acropolis, made up of a web or network that includes the material objects, people, and their activities and behaviors, over time. These are the ways that I see ANT informing my view of what was happening on the archaic Acropolis. I like the idea that religious practice on the Acropolis was made up of relationships between human and nonhuman actors interacting in networks; that the ties between the actors are the behaviors and activities through which agency is made manifest; that inscriptions carrying distant ideas shaped activities and behaviors on the Acropolis; that

nonhuman actors have agency; that, through bronze dedications, bronzesmiths produced a kind of device or technology to help the Greeks communicate with the gods; that assemblages of actors and assemblages of networks were constantly changing and evolving through enrollment of new dedicants, new boards of treasurers, new craftsmen, new buildings, and new decisions reached by the *boule* and the *demos*; also that the bronzes were in constant change as they aged, or were cleaned and polished, patched, were bent or engraved. New dedications added to the assemblages were brought from a distance, touched by many hands en route, retaining in their materiality the memory of such relationships in their object biographies.[4]

Once deposited in a storeroom or temple or set up out of doors, each individual object was put under the care of the treasurers of Athena.[5] Entrapment ensued: once people started leaving bronze objects in the sanctuary, the treasurers and other officials were perpetually obligated to care for them. In a sense, the bronzes "made" the treasurers build and open their storerooms, design ways to organize and keep track of them, clean them, count them, and so on.[6]

Sanctuaries, Sacrifices, and Dedications

The Acropolis is just a rocky outcropping. It became sacred only when human activities and behaviors became entangled with material, nonhuman things.[7] The entanglement of humans and materials transformed the geographical features to make it a sanctuary.[8]

Jan Bremmer has refined to its essence the definition of a Greek sanctuary: that its purpose is to set apart a place to have sacrifices (altars) and make dedications (sheltering them in buildings).[9] Bronzes are involved in both activities. Humans, their activities, and nonhuman things (animals, dedications, ritual equipment) are entangled in a common place, the Acropolis. Actor-network theory tries to discover how these heterogeneous networks stabilize and become durable, while always evolving or changing as new actors are enrolled, which can be people or artifacts.[10]

As artifacts were brought to and left on the Acropolis, they combined, becoming assemblages that accumulated and grew over time, with certain bronze types (vessels, weapons and armor, statues and figurines) and specific shapes (basins, lebetes, cauldrons, hydriai, phialai) preferred over others.[11]

Bronze tripod-cauldrons, and cauldrons with protomes, were part of the earliest assemblages of votives on the Acropolis; these were typically only found in sanctuaries, including Olympia and Delphi, and did not have a secular civic, domestic, or funerary function.[12]

Object-Based Agency

How are we to understand why the Athenians brought so much bronze to the Acropolis, given the value of this precious metal, and how useful it was for making practical things needed in the city: tools, weapons, armor, cart components, horse bits, mirrors, pots and pans for manufacturing and daily use, and so on? How important were the bronzes to the ancient Athenians?

This is where we need to turn to ANT and the agency of bronze artifacts inside the system that kept the traditions of making and using bronze artifacts in place, that is, what they *make* humans do as well as the type of activities that they *enable* humans to do.[13] In ANT, the objects are said to have such agency; they compel activity in their human makers and users.[14] Mapping such entanglements gives us a rich, contextual picture of the centrality of bronzes on the Acropolis in the Archaic period. Anyone entering the Acropolis would see bronze dedications, ritual equipment, tools, and statues, and have had past experiences with them. To be clear, this includes women, who dedicated many bronze objects, including small and large vessels, statuettes, mirrors, and more between 530 and 480 B.C.E.[15]

The Athenians could not have conducted sacrifices without bronzes. The bronze dedications had work to do, for they were meant to catch the attention of the humans and gods, in an increasingly competitive environment.[16] As actors, these bronzes should be reframed as things that all had capacities to do something, like tools or devices. They were machines to bring delight to the gods.[17] They sometimes spoke directly to passersby, reawakening their message with each new performance—"what is written is present, the writer is absent."[18] As tools or devices, they required attention and *made* humans clean them, repair them, and wash them out. If the human is one node, and Athena is the other, the bronze offering is the towline in between, the edge tethering them together, enabling a sacrifice or a dedication to rise across the divide. The bronzes activated the god by calling their name in the

vocative case, speaking in the first-person singular. A bronze statue from 530–520 B.C.E. has this inscribed on its base:[19]

> For you, goddess, Melanthuros set me up, this *agalma*, having vowed a tithe (*dekaten*) of his works to the child of great Zeus.
> Σοί με θεά τόδ᾽ ἄγαλμα ἀνέθεκε Μελάνθυρος ἔργον | εὐχσάμενος δεκάτεν παιδὶ Διὸς μεγηάλο

The Greek word order places "for you" and "me" as the first two words, showing a relationship between the goddess and the statue who is speaking. The term *"agalma"* has no direct translation into English; its meaning is "something that delights a deity," so "dedication" is used as a poor translation, which in this case is a bronze statue, and after the Archaic period it became a word for statues.[20] The *agalma*, speaking through its inscribed base, tells us that it is directly connected with the person who offered it, knowing their reason for offering it, and is also in direct contact with two gods, Zeus and Athena. When we see a bronze vessel speaking for itself, we ought to listen: "I am for Athena," Ἀθεναίας εἰμί (IG I³, 580).

Entanglement on the Acropolis

Inscriptions entangle things and humans in peculiar ways. Stone or bronze stelae enable ideas to remain after the humans descend from the Acropolis or walk away. They can communicate decisions or ideas that originated from a distance. The worshipers expected that the dedicated object would stay on the Acropolis beyond the short time of their own visit. As Andronike Makres and Adele Scafuro show in this volume, the inscribed dedication on a bronze object is an extension of itself, but also of the inscriber and the dedicant. The voice of the epigram can become confused, or just fused, when the object speaks for itself, and sometimes in the first person: "I am sacred," ἱιερόν εἰμι (IG I³ 557).

When any bronze object came into the possession of the treasurers, there were regulations about the proper way to care for them, such as we find articulated in *IG I³* 4. While the treasurers of Athena were the general overseers for the Acropolis, the inscription puts them on notice that they are under the supervision of the *demos*, making them subject to audits and fines for violating the many prohibitions.[21] Although their terms were for one year, these were elected

positions, and treasurers could be reelected many times. In-stitutional knowledge was passed down about the right way to be a treasurer, how to care for the bronzes and other items in their treasuries.

On the Acropolis, the activities and responsibilities of the treasurers included organizing and handling these nonhuman material things and setting them in specific places. Two in-scriptions from the Archaic period that refer to or regulate this procedure specifically mention bronze dedications (*IG* I³ 510 and *IG* I³ 4). These may guide our understanding of the social activities and cultic responsibilities of religious ad-ministrators and their interactions with the material objects in their care. Regulations specified where bronze items (τὰ χαλκία) were supposed to be stored, and when they should be inspected. These kept the Acropolis organized and well managed, on behalf of the *demos*.

The two archaic inscriptions, one a dedication (*IG* I³ 510) and one a cult regulation decree (*IG* I³ 4), are separated by over sixty years and look very different from each other.[22] The dedication, consisting of four lines of text, is written on a small sheet of bronze, while the decree is much longer, with more than fifty lines of text inscribed on two large stone metopes. They both focus on the treasurers of Athena, who, as just mentioned, were elected by the *demos* of the Athenians, and were obligated to lawfully care for the sacred bronze objects on the Acropolis.

The aim here is to see how humans (treasurers), things (the bronzes), places (the Acropolis), and human activities and be-haviors are interrelated, and even entangled. Since the study of entanglement theory at its core is about studying relation-ships between humans and things, humans and humans, and things to things, here we have the opportunity to see how bronze objects combine with other dedicated material culture on the Acropolis (things with things, things with places), and how dependent treasurers were on having treasures to care for, and how the bronze treasures need humans as well (hu-mans with things).[23] For now, let us agree that relational data for studying entanglement requires thinking about relation-ships between heterogeneous entities.

IG I³ 510

Dating to the mid-sixth century B.C.E., *IG* I³ 510 is an in-scribed bronze sheet, which has nail holes at the corners, to

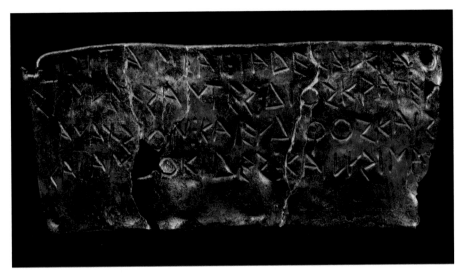

be affixed perhaps on a wood backing, so perhaps to a box or chest (fig. 1).[24]

Fig. 1. Bronze plaque (IG I³ 510); EAM X 6975, © Acropolis Museum, 2011, Photograph Vangelis Tsiamis.

> ℎοι ταμίαι ⋮ τὰ δὲ χαλκία ⋮ [—ca. 12–14—
> ἀνέθεσαν?]
> συνλέχσαντες ⋮ Διὸς κρατερ[όφρονι παιδί.
> ⋮ —ca. 8–10—]
> Ἀναχσίον ⋮ καὶ Εὔδιϙος καὶ Σ[—ca. 9–10—
> καὶ —ca. 9–10—]
> καὶ Ἀνδοκίδες ⋮ καὶ Λυσίμαχ[ος καὶ —ca. 8—
> καὶ —ca. 8—].
> The treasurers [dedicated] these bronzes [on be-
> half of the city? on the Acropolis?]
> having collected them;[25] to the mighty-[minded
> daughter] of Zeus.
> [The treasurers were] Anaxiōn, and Eudikos, and
> S[… and …]
> and Andokidēs and Lysimach[os and … and
> …].[26]

Before interpreting the text, we should savor the self-refer-
ential materiality, namely that the inscription about bronzes
is inscribed on bronze itself, so the inscription is part of the
assemblage. Moreover, the bronzes mentioned in the epigram
are dedications, as is this bronze plaque.[27]

At first glance, this text appears to have very little to say,
apart from the fact that there are bronze objects and there
are treasurers. It appears to be a dedication from the board
of treasurers to Athena. We note that the text is an epi-

gram in hexameter, which lifts it into the realm of a votive offering, with the inscription authoritatively connecting the treasurers to the goddess they serve. The unusual epithet, κρατερ[όφρονι, has parallels in the poetic language and meter of Homer and Hesiod,[28] and appears on two other known dedications from the Acropolis.[29]

In her discussion of the redating of the H-Architecture underneath the Parthenon, Elisavet Sioumpara asks who could have funded the temple at this time, around the first Panathenaic festival in 566/565 B.C.E.[30] Rather than assigning this to Peisistratus, she concludes that the board of treasurers might have been responsible for supervising the construction of the temple. Sioumpara suggests that these men, selected from among the wealthiest in Attica, may have funded the project collectively, both paying for it themselves and perhaps raising money from their friends, in addition to using sacred funds. *IG* I³, 510 is the very first time the treasurers are attested in epigraphy as *tamiai*, and the dates line up with the possibility that this bronze plaque is part of an offering they made upon completing the building project. If this suggestion is right, the treasurers may have collected some bronze offerings in order to move them inside the new temple, and this plaque commemorates that activity.

Here is where we might attempt to visualize the entanglements that are present. Rather than using Ian Hodder's term "tanglegram," for his wire diagram-like visualization of entanglement, which has not received much purchase, I have instead developed the concept of a field map, using Social Network Analysis software (NodeXL) to render entanglements and ANT networks in a visual form.[31]

In figure 2, we can see three versions of such a field map for this dedicatory inscription. In just four short lines, of which the third and fourth are people's names, we find humans, human activities, nonhuman things, and place, all entangled. The place is the Athenian Acropolis, of course, while the humans are the eight treasurers, each of whom are named in lines 3 and 4. The nonhuman things are the bronze objects, while the human activities are the collecting (συνλέχσαντες) of these objects (τὰ χαλκία) and the dedication of them (ἀνέθεσαν is a likely restoration) to the mighty-minded daughter of Zeus (Διὸς κρατερ[όφρονι παιδί), Athena.

Within the field map, the size of the nodes (seen as various-sized solid circles) is proportional to the number of other

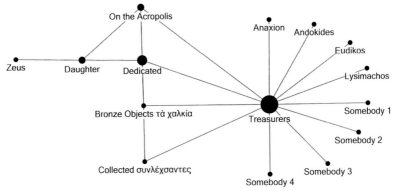

A. All actors in IG 1³ 510

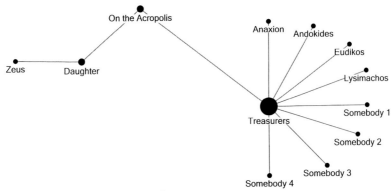

B. All actors minus the bronzes in IG 1³ 510

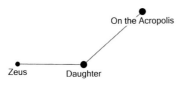

C. Consequences of losing the bronzes in IG 1³ 510

Fig. 2. Field map of treasurers and bronzes in three phases, based on IG I³ 510.

actors that link to it. Look, for example, at the largest node in the top diagram, within figure 2A. Here we find the treasurers, with the eight named men specifically identified. To the left, they are linked with the bronzes (nonhuman things), which they collected (human activity), and dedicated (another human activity), on the Acropolis (place), where we find Athena (daughter of Zeus) tied to the node "Dedicated."

This version is a straightforward field map of the entanglement of these heterogeneous elements. A temporal sequence for the human activities is implied, insofar as once having collected the bronzes, the treasurers were then ready to dedicate them; the inscription is restored to say that they were dedicated (ἀνέθεσαν), using the past tense, although at the moment of commissioning the inscription, that act was in the future. "The treasurers [dedicated] these bronzes … having collected them."

We should note that this is the case for most bronze dedicatory inscriptions, that is, that at the time the inscription is being written on a bronze dedication, it is inscribed as if the act of making the offering is already over, although that is still in the future. Undoubtedly someone at the bronzesmith's shop, or another specialist below the Acropolis, would have created the inscription well before the dedication. This differs from stone inscriptions, where the writing might have been done after the fact, in the sanctuary.

Now we can study the vital part that the bronzes play in this system, and try to understand this concept of their agency, that is, what the bronzes *make* humans do or enable them to do, and what humans cannot do without them. We can do this by asking what happens when we take the bronzes out of the picture? In the center of figure 2B, the bronzes have been removed, along with the human activities of collecting and dedicating them. We can plainly see that without the bronzes, there is no use in collecting or dedicating on the Acropolis. Human activities disappear. The connection between the treasurers and the goddess, the child of Zeus, is broken, because of the absence of the bronzes, which worked as the device or technology to bind the realms together.

Let's take the scenario a step further. Without the bronze objects, and no collecting or dedicating to do, the treasurers have no purpose. Are they really treasurers without treasure? Eight men are individually named, with two presumably representing each of the four tribes. They are from the wealthiest class, and this is one of the ways to amass social capital and earn *kleos* by serving Athena in such a direct way. When the bronzes are removed, they each lose their place in the board of treasurers and sink back into the fabric of society from whence they came. So, what is then left, after we take away the bronzes, and therefore the collecting, the dedicating, and the treasurers? We can see, in the bottom diagram, figure 2C,

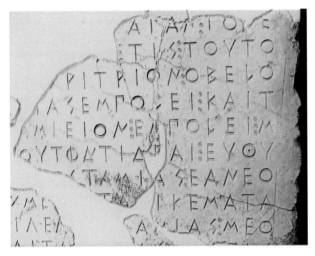

Fig. 3. Fragments of the Hekatompedon decree, metope B (IG I³ 4). Photo 20940, The Sara B. Aleshire Center for the Study of Greek Epigraphy, https://aleshire.berkeley.edu/holdings/photos/20940.

that when the role of the treasurers is hypothetically erased because there are no bronzes to take care of or dedicate, all that remains in the field map is the Acropolis, and the goddess, the "mighty-minded daughter of Zeus."

This is a clear example of the agency of the metal objects. We can see it best when we remove them. Without them, all that is left is the place, and its sacredness to Athena. But if we take away the bronze dedications, and perhaps also the sacrifices (since the bronze equipment needed for them would also have disappeared), it might not even seem like a sacred place anymore, in which case Athena might depart for Samos or Lindos or some other better-loved sanctuary. And then, as the final disappearing act, the inscription itself would go away as well, for it is not only written on a sheet of bronze but is a dedication in and of itself.

Of course, I do not mean to say that the treasurers had any of this in mind when they offered their dedication. I simply offer this thought experiment to show that entanglement and field maps are methods for us to model the interactions between the humans and the things with spatial and temporal contexts, and to really see the strength of their interconnections.

Hekatompedon Decree, IG I³ 4

About five years before the Persian destruction, the Athenians inscribed the "Hekatompedon inscription" or "Hekatompedon decrees" (IG I³ 4), ordering the treasurers to organize "the bronzes" (τὰ χαλκία). The consensus is that these

cult regulations were set up between the two Persian invasions, in 485 B.C.E., if one accepts that the restoration after the letter *phi* in line 27, Ph[ilokrates], gives the archon date. These regulations might have become necessary if the Athenians had dedicated an excessive number of thank offerings for the retreat of the Persians after the Battle of Marathon in 490 B.C.E., resulting in a state of disorder on the Acropolis.

The inscriptions were carved on two reused metopes (now labeled metope A and metope B) that came from an older temple, probably the old Athena temple (fig. 3).[32] The inscriptions convey from the Pnyx the consensus of the *demos*, instructing the people who are in charge of the Acropolis how to begin the reorganization, including how to handle material objects, and stating prohibitions and commands for behavior and activities.[33]

Actor-network theory has much to say about inscriptions, in that they are the material form of the consensus of a group of people conveyed in a medium that can travel. For ANT, however, "inscriptions" do not necessarily specifically mean inscriptions such as classical archaeologists study, that is, materials with ancient writing on them, but rather a means by which to translate remote affairs (considerations of ideas or practices that, after a process of sorting it all out, find compromise and come together) into a communication, enabling action at a distance. Actor-network theory scholars might study the package insert for how to assemble an office chair and see it as the result of a complex negotiation among committed people who agreed on its final form and disseminated it. I find that their ideas about the use of inscriptions are appealing, in the sense that the inscription acts as a mediator or translator between the originators' idea and the remote end-users. They see the messiness of the discussions at the front end as an important part of the process of producing an inscription, which Andrew Pickering called "the mangle," where material things, humans, and their cultural environment hash it out.[34] What ANT has just done is to remind us that the finished product, the marble metopes in this case, are the results of the mangle on the Pnyx. Finding consensus on decree after decree tied Athenians together; publishing inscriptions enabled their ideas to become real out in the world.

As for the Hekatompedon decrees, they appear to have been designed for oral performance. Literate readers would tend to vocalize those inscriptions which they could decipher, and these on metopes were carved with large legible letters

and had interpuncts to help the reader with breathing and comprehension.[35] The stone metopes' agency is how they catch one's eye with their attractiveness, to make people stop, look, and read the words out loud, with the words reaffirmed by the vocalization of each new reader, including our own. Inscriptions speak to the future—through inscriptions, messages of the day are passed forward to future readers. These inscriptions announce new activities, behaviors, rules, with their penalties, and specify how material objects should be cared for or used. The written records themselves are nonhuman objects in the field map; their agency is evident in the way humans acted before and after reading them, changing what they would have done prior to the decrees.

Both inscribed metopes regulate cult practices, including care for votives and ritual equipment, and they set "sacrificial and purificatory ritual norms" as their subject matter.[36] In this case, the first lines mention dedications and then sacrifices, which Bremmer points to as the two things that make a sanctuary sacred.[37]

Metope B is better preserved than metope A. The word for bronzes, τὰ χαλκία, has been restored in line 1 of metope B and is also present in lines 19–20 of metope A. The opening lines 1–3 of metope B say, "The bronze vessels (*ta chalkia*) on the Acropolis—all the vessels that they use, except those in the sealed houses (*oikemata*). If the vessels remain with each one [of the users?] upon the Acropolis, the treasurers are to make a record of them." Line 4 continues "...the sacrifices ⦂ let those [within] ⦂ performing the rites...:"

> Τὰ χαλκία τὰ ἐ[μ πόλει ⦂ hόσοις χρõνται
> ⦂ π[λ]ὲν hόσα [...6... σεσεμ]ασμένοις ⦂
> οἰκε͂μ[ασι ἐ]αμ παρ᾽ ἕκαστ-[....9..... κα]
> τὰ τὲν πόλιν ⦂ γρά[φσα]σθαι ⦂ τὸς ταμί[ας
> ⦂⦂⦂ hόταν δρ☒σι ⦂ τὰ ιερὰ ⦂ οι ἔ[νδο]ν ⦂ ιε[ρ]
> οργõντ[ες...

On metope A, line 19–20, we have another mention of bronze objects in a fragmentary text that reads, "chairman, and shall give to the - - - bronze vessels and spits except - - -".

> [τὸν πρύ] τανιν ⦂ καὶ διδ[όνα]ι ⦂
> τοῖσ[ι........16........χα]λκία ⦂ καὶ ὀβε[λὸς]

Silver and gold are not mentioned here; it is "the bronzes on the Acropolis," τὰ χαλκία τὰ ἐμ πόλει, that are the cen-

terpiece, and are an integral part of the required assemblage of people, places, activities, and things that make a sanctuary a sacred place. Interestingly, mentions of bronze objects are relatively rare in the later inventory lists, suggesting perhaps that bronzes were considered in a different category of things on the classical Acropolis than they were on the archaic Acropolis.[38]

The treasurers have the central role, but other authority figures are mentioned, such as the people who conduct the sacrifices, priestesses, attendants, the prytaneis, and the *demos* who authorized the decree.[39] The inscriptions tell them what they can and cannot do with material things and put restrictions, with threats of fines, on their own conduct. For example, the treasurers were under orders to open buildings three times a month or they would be fined. As for those doing the sacrifices, if they mishandled animal waste, that is, if the sacrificial animals left their droppings inside a sanctuary, they were fined. All of the activities that are prohibited have to do with material nonhuman things: the animals and their waste, an earthen pot, not to make fires, and even the fines to be collected are material coins.

Other activities were regulated as well; there are verbs in the decree that command them to mark, to record, to make use of, to move, to be present or absent, not to light a fire, and not to bake in an oven. This is a community, entangled and bound by sacred rituals, laws, customs, and cultural expectations, including people remote from the Acropolis who have a deep interest in these affairs.

The *demos* included in their decree the names of many structures on the Acropolis; they mentioned a place called the Hekatompedon, small buildings called *oikemata* (pl.), a place devoted to Kekrops, a temple, an altar, another storage house, and so on. The topography of the archaic Acropolis is an old chestnut, and it is still debated where these structures were and how they relate to the later Periclean buildings.[40] Indeed, this is the only contemporary evidence for the names Athenians gave to the zones and buildings on the Acropolis prior to the Persian destruction.[41] This inscription gives the reader a veritable tour of the Acropolis. Thousands of Athenians voted to approve this decree, which means that they knew the names of these places, too.

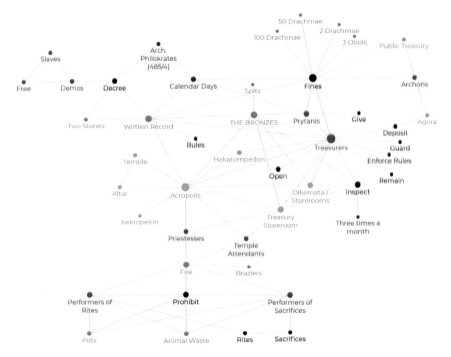

The Field Maps for the Hekatompedon Decrees

Fig. 4. Field map for the Heka-tompedon decree (IG I³ 4).

If we look at a field map for the Hekatompedon decrees (fig. 4), we can see that there are five different groups of actors: activities (dark blue), people (green), nonhuman (light blue), places (light green) and time (red). As with the previous example given above, here too the size of the nodes correlates to the number of direct ties for each actor.

As noted above, field maps can help us sort out which elements belong to which groups, and then see the entanglement through the edges between the nodes, for our interest lies in determining how these people, activities, nonhuman things (buildings, topographical spaces, and bronzes) are entangled. We can now see visually that the inscription is the result of debate and a vote of the people in deliberating about sacred regulations.

The treasurers, as humans, in dark green are the heart of figure 4. From there we can find the other humans, who are all officials with important cultic roles, distributed evenly throughout the network. The dark blue nodes are the nonhuman things. Of these, we are most interested in the bronzes toward the upper center, which have lines (edges) connecting

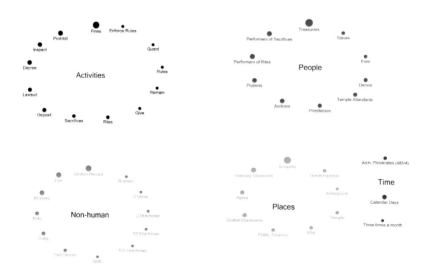

Fig. 5. Actors sorted by type, based on the Hekatompedon decree (IG I³ 4).

them to the Acropolis, the treasurers, and the written record. Other nonhuman things include coins, an earthen pot, and even animal droppings. In light green are the places, with the names of various landmarks on the Acropolis. Activities between people and bronze objects happened in physical places; spatial dynamics are actors in the networks, too.[42] The entanglement between the humans, things, and places may be best seen with the dark blue nodes, which are these activities. Periods of time are seen in dark red; the decree prescribes the frequency for when the humans should do these activities with the nonhuman things. In figure 5, where the various actors have been separated out, we can also see that, except for the mentions of time, the various groups have roughly an equal number of actors.

The bronze objects have first degree ties to the *oikemata*, the treasure storerooms, the Acropolis, and the treasurers, the written record, plus spits for sacrifices, and inspecting as a human activity. A special treasury, off limits to priestesses and attendants, is mentioned in lines 13–14: "the priestesses, those on the Acropolis, and the attendants … a storage house on the Acropolis…."

Τὰς hιερέα[ς] τὰς ἐμ πόλει ⫶ καὶ τὰς ζακόρος
[… 7… οἴ]κεμα ταμεῖον ⫶ ἐμ πόλει.[43]

Just by looking at the relative size of the nodes in the field map, we can summarize what the inscription is about: the Acropolis, the treasurers, the bronzes, the written records, and fines. This is a decree of the people, and their attention was focused on the proper care for their bronze votive offerings and behavior inside the sanctuary. The decree, and thus the *demos*, threatens the treasurers and other cult personnel with fines for not complying with the demands, which includes ordering the treasurers to be present for inventory days (to do their job), and performing actions regarding the bronzes: opening buildings, counting, showing, using, recording, and inspecting.

This inscription is an arrested moment where we can view human behavior and activities in relation with material and nonhuman things. Both have a kind of agency. The bronzes *make* all these people act differently than they would have before the decree; this is part of their agency. But the bronzes have their obligations, too. They are making the treasurers and other community members do things to them or with them. If the bronzes were not there, the treasurers would not have to open and close these doors. The treasurers would not have to record things about them. Their jobs would certainly be easier. Having the bronzes puts the humans in a bind. Because the bronzes exist, they have to be kept track of and sheltered. The more bronzes there were, the more work there was. The material things obligate the humans to constantly service the material things; they cannot stop. Once the treasurers are required to inventory, they have to keep doing it, and to do it properly required activities such as organizing, sorting, labeling, moving them, and counting.

We should also ask one final question: For the Hekatompedon decrees, which specific bronzes were they talking about? The answer is that they were talking about all of the bronze objects that had accumulated on the Acropolis by the year 485 B.C.E. The bronzes under discussion are many of the ones that archaeologists attribute to the destruction layers of the *Perserschutt*, six years later. These are the bronzes published by H. G. Lolling and P. Bather and A. De Ridder and displayed or stored in the National Archaeological Museum and Acropolis Museum (and other, mainly European, collections).[44] The bronzes mentioned in the Hekatompedon inscription are most of the ones presented in this volume, as well, studied by Makres and Scafuro, Amy Sowder Koch and Nassos Papalexandrou.[45]

Concluding Remarks

Every bronze object excavated on the Acropolis and that has physically survived 2500 years came from someplace else and was brought there for a reason. No one carried a bronze vessel or other bronze object up the hill and accidentally left it behind, having intended to bring it down again. The Athenians thought there was something these bronzes could do for them and set them up on the Acropolis to work as a device to communicate with the divine, and with future visitors. The act of coming up with a bronze offering, and leaving empty-handed, was intentional. Each worshiper trusted the bronze object to be a surrogate, acting on their behalf, to mediate between him or her and the gods. When the bronze object caught someone's attention on a future day, the passerby might read the inscription aloud, and the power of the object to communicate would be awakened and reperformed. Year after year, the accumulated wealth was greater than the sum of its parts.

Having read and tested many different ways of understanding the agency of nonhuman things, I find that Geoffrey Braswell's observation fits my way of thinking best. He says agency

> is an emergent property that is expressed in the real world through interaction among people, animals, objects, and concepts ... agency is a result of interaction, and the edges that link nodes in a material-semiotic network are abstract representations of how agency is created. Agency is expressed and emerges in the interactive edges of a network and cannot be possessed by any solitary, disconnected vertex, node, or actant. If you want to study agency, like so many archaeologists do, start thinking in terms of networks, start observing their edges, and stop focusing on isolated agents.[46]

The bronzes that have survived and are studied in this volume are miracles, gifts from the ancient Greeks to us today. Each one had a history, was manufactured, touched, and held by multiple people, passed down year to year to treasurers and priests, until 479 B.C.E. The scholars who have conserved, catalogued, measured, and puzzled over their faint and damaged inscriptions have breathed new life into the archaic bronzes of the Acropolis. How amazed the ancient Athenians

would be to discover that their dedicated hydriai, lebetes, tripods, and phialai are still cared for, curated, and treated with honor by the scholars in this volume, and the museums that serve as the last stop of their object itineraries.

Acknowledgments

I offer my sincere thanks to Nassos Papalexandrou and Amy Sowder Koch for their invitation to participate in the panel on "Hephaistos on the Acropolis" at the AIA meetings of January 2020 just before COVID-19, and for including me in this volume. This project was financially supported first with a Fulbright fellowship in spring 2019 to the University of Crete in Rethymno, where the initial research got under way, and then by my institution, George Washington University, with a fellowship for the GW Humanities Center 2020–2021 and a Humanities Facilitating Fund award for 2021–2022.

Notes

[1] The bibliography for ANT is vast and from diverse fields; here are a few overviews and examples I found useful. Bister 2021; Blok, Farias, and Roberts 2019; Bilodeau and Potvin 2018; Van Oyen 2015; Kipnis 2015; Sayes 2014; Hassard 2013; Hodder 2012, 91–94; Dolwick 2009; Knappett and Malafouris 2008; Latour 2005, 1996; Law 1999, 1–14; Law and Hassard 1999.

[2] Dolwick 2009, 39, 45.

[3] Antczak and Beaudry 2019.

[4] On object itineraries and object biography, see Hopkins et al. 2020; also the review article by Bauer (2019) with bibliography.

[5] For the treasurers of Athena, see Bubelis 2016; Marcaccini 2015; Hamilton 2000, 215–37; Hurwit 1999, 54–57; Lewis 1997; Samons 1996; Harris 1995, 1991, 1990, 1988; Jordan 1979; Linders 1975; Ferguson 1932.

[6] On entrapment, see Hodder 2012, 103–4, 206–16.

[7] On entanglement, see Harris Cline 2020; Crellin 2020, 146–53; Antczak and Beaudry 2019; Harris Cline 2018; Blakely 2017, 1–13; Hodder and Mol 2016; Stockhammer 2015, 271–80; Hodder 2014, 2012, and 2011.

[8] Hodder 2012, 88–103.

[9] Bremmer 2013, 7.

[10] Crellin 2020, 135–36.

[11] For assemblages, see Crellin 2020; Donnellan 2020; Crellin 2017; Müller and Schurr 2016; Joyce and Gillespie 2015; Müller 2015; Shaya 2014; Harrison 2011; Rice 2011; Hicks and Beaudry 2010; Joyce and Pollard 2010; Pickering 2010; Stahl 2010.

[12] Papalexandrou 2021; Scott 2010; Papalexandrou 2005.

[13] On material or object-based agency, separate from ANT, see Donnellan 2020; Lavis and Abbots 2020; Harrison-Buck and Hendon 2018, 147–66; Kipnis 2015; Bremmer 2013; Chaniotis 2011; Eck 2010; Hollenback and Schiffer 2010; Joyce and Pollard 2010; Alberti and Marshall 2009; Knappett and Malafouris 2008; Ingold 2007; Gell 1998.

[14] For samples of ANT, see Blok et al. 2019, xx–xxxv (esp. good historical overview with bibliography); Van Oyen 2016, 2015; Müller 2015; Stockhammer 2015; Sayes 2014; Hassard 2013; Pickering 2010; Dolwick 2009; Latour 2005; Pickering 1995.

[15] Avramidou (2015, 2–4) for her catalog of 16 inscribed bronzes dedicated by women.

[16] Day (2010, 3) notes that "dedications that stood outdoors had to be visually striking and handsome, raised up on platforms, with easily readable inscriptions, if they were to attract viewers, human or divine, and hold their attention long enough to read the texts."

[17] LSJ s.v. Μηχανάομαι, *sim* Latin *machinari* – to make by art, put together, construct, build; generally to prepare, make ready, to contrive, devise by art or cunning; also simply to cause, effect, to form designs to contrive to do this or that. Mayor 2018, 7–32 and 129–55; Hendon 2018; Cohen 2003; Morris 1992, 215–37. See also Lavigne (2019, 173) on Svenbro (1993), who saw funerary inscriptions as devices to generate sonorous renown or to celebrate in sound the inscribed name. In our case, this reader-inscription entanglement would generate the sounds of the names of the dedicant and the divinity, honoring them and causing everlasting κλέος ("remembrance") with each reperformance.

[18] Svenbro 1993, 44.

[19] Day 2010, 100–1 for the Greek text and translation.

[20] Day 2010, 85–129.

[21] Jordan 1979, 54.

[22] "Sacred law" is a legacy term being replaced with ritual regulations and other synonyms; see E. Harris 2015, 53–54; Petrovic 2015; Carbon and Pirenne-Delforge 2012; Chaniotis 2009; Parker 2004.

[23] See n. 1. Hodder (2012, 2011) provides the most thorough introduction.

[24] Makres and Scafuro 2019, 63; Sioumpara 2016, 204; Butz 2010, 154, as well as Sickinger 1999, 40–41; Jeffery 1961, 72, 77; and Raubitschek 1949, 352.

[25] Sickinger (1999, 40) translates συνλέχσαντες as "having gathered together". By interpreting τὰ δὲ χαλκία as τάδε χαλκία ("the bronzes" to "these bronzes"), he connects this plaque with the later phrasing used in the inventories of the treasurers of Athena (τάδε παρέδοσαν οἱ ταμίαι τῆς θεοῦ, "these are the things the treasurers handed over"), and so he suggests that an inventory list ought to have accompanied this dedicatory plaque here in the mid-

sixth century. I am not so sure; Harris 1992, 641.

²⁶ Greek text: Makres and Scafuro 2019, 63; adapted from the translation in Harris 1991, 19–20.

²⁷ Self-referentiality has been noted by Butz (2020, 155–56) and Meyer (2013, 464 n. 51).

²⁸ LSJ shows the epithet used for a wild beast, *Il.* 10.184; epithet of Heracles, *Il.* 14.324; Odysseus, in *Od.* 4.333; the Dioscuri, *Od.* 11.299; Hes. *Op.* 147.

²⁹ Makres and Scafuro 2019, 63. An inscribed potsherd (Akr. I.2570) reads [——]δες ἀ[νέθεκε][Διὸς κ]ρατερό[φρονι παιδί]. A marble pillar, IG I³ 773, says, Τίμαρχος · μ'ἀνέθεκε · Διὸς κρατερόφρ[ονι κόρει]. Μάντειον φρασμοσύναι μετρὸς ἐπ[ευχσαμένος] Ὀνάτος ἐποίεσεν, "Timarchos dedicated me to the mighty-minded daughter of Zeus; His mother made the vow in understanding of the oracles; Onatos made (me)."

³⁰ Sioumpara 2016, 202–5.

³¹ Hodder 2012, 180–85. Harris Cline 2020 for field maps.

³² Butz 2010, 155 nn. 23 and 24.

³³ Harris 1995, 17–18; 1991, 21–23. For the text and translations of metopes A and B, see Butz (2010, 161–67) and Paga (2021, 278) with full bibliography and commentary; for convenience, see the digital texts and translations at *Inscriptiones Graecae*, digital edition, http://telota.bbaw.de/ig/digitale-edition/inschrift/IG%20I%C2%B3%204(A) and http://telota.bbaw.de/ig/digitale-edition/inschrift/IG%20I%C2%B3%204(B).

³⁴ Pickering 2010, 195; 1995.

³⁵ Butz 2010; Day 2010, 73; cf. 2019.

³⁶ Carbon and Pirenne-Delforge 2012.

³⁷ Bremmer 2013, 7.

³⁸ Makres and Scafuro 2019, 64; Tarditi 2016, 15, 18, 321. See Harris (1991, 274–85) for the few bronzes inventoried.

³⁹ The treasurers are named in the text in metope A lines 11,16 and in metope B lines 3–4, 16–17, 18–19.

⁴⁰ Paga 2021, 278; M. Meyer 2017, 138–52, esp. 138 n. 1062; Sioumpara 2016; Ferrari 2002.

⁴¹ Bancroft 1979, 12.

⁴² The spatial field is particularly important for the viewer's experience of inscriptions; see Lavigne 2019; Day 2018, 74; Shaya 2014, 25; Day 2010, 64–75; Scott 2010, 103; Hurwit 1999, 54–57; and Svenbro 1993. For spatial dynamics, which has been applied to such diverse subjects as agriculture, crime, population growth, child-rearing, commerce, war, and the like, see Petrovic et al. 2018.

⁴³ The seven letters are usually restored with μὲ hέχεν, meaning that the priestesses and attendants were not to possess or have access to the storage house. Butz (2010, 164) does not accept the restoration. Cf. Bubelis (2016, 135) for scholarly discussion of this restoration.

⁴⁴ Lolling and Wolters 1899; De Ridder 1896; Bather 1893.

⁴⁵ Papalexandrou 2021, 2005; Makres and Scafuro 2019; Tarditi 2016; Sowder Koch 2009.
⁴⁶ Braswell 2019, 53.

Works Cited

Alberti, B., and Y. Marshall. 2009. "Animating Archaeology: Local Theories and Conceptually Open-Ended Methodologies." *CAJ* 19.3:344–56.

Antczak, K. A., and M. C. Beaudry. 2019. "Assemblages of Practice: A Conceptual Framework for Exploring Human-Thing Relations in Archaeology." *Archaeological Dialogues* 26.2:87–110.

Avramidou, A. 2015. "Women Dedicators on the Athenian Acropolis and Their Role in Family Festivals: The Evidence for Maternal Votives between 530–450 BCE." *Cahiers Monde Anciens* 6:1–29.

Bancroft, S. 1979. "Problems concerning the Archaic Acropolis at Athens." Ph.D. diss., Princeton University.

Bather, A. G. 1893. "The Bronze Fragments of the Acropolis." *JHS* 13:124–31, 232–71.

Bauer, A. A. 2019. "Itinerant Objects." *Annual Review of Anthropology* 48:335–52.

Bilodeau, A., and L. Potvin. 2018. "Unpacking Complexity in Public Health Interventions with the Actor–Network Theory." *Health Promotion International* 33.1:173–81.

Bister, M. 2021. "Moving and Mapping (with) Actor-Network Theory." *Ephemera* 21.1: 313–22.

Blakely, S. 2017. "Object, Image, and Text: Materiality and Ritual Practice in the Ancient Mediterranean." In *Gods, Objects, and Ritual Practice*, edited by S. Blakely, 1–13. Studies in Ancient Mediterranean Religions. Atlanta: Lockwood Press.

Blok, A., I. Farias, and C. Roberts, eds. 2019. *The Routledge Companion to Actor-Network Theory*. New York: Routledge.

Braswell, G. E. 2019. "From Vertices to Actants: Two Approaches to Network Analysis in Maya Archaeology." *Studien zur Wirtschaftsarchäologie* 3:51–66.

Bremmer, J. N. 2013. "The Agency of Greek and Roman Statues: From Homer to Constantine." *OpAthRom* 6:7–21.

Bubelis, W. S. 2016. *Hallowed Stewards: Solon and the Sacred Treasurers of Ancient Athens*. Societas. Ann Arbor: University of Michigan Press.

Butz, P. A. 2010. *The Art of the Hekatompedon Inscription and the Birth of the Stoikhedon Style*. Monumenta Graeca et Romana 16. Leiden: E. J. Brill.

Carbon, J.-M., and V. Pirenne-Delforge. 2012. "Beyond Greek 'Sacred Laws.'" *Kernos* 25:163–82.

Chaniotis, A. 2009. "The Dynamics or Ritual Norms in Greek Cult."

In *La norme en matière religieuse en Grèce ancienne: Actes du XIIe colloque international du CIERGA (Rennes, septembre 2007)*, edited by P. Brulé, 91–105. Liège: Université de Liège.

———, ed. 2011. *Ritual Dynamics in the Ancient Mediterranean: Agency, Emotion, Gender, Representation.* Alte Geschichte 49. Stuttgart: F. Steiner.

Cohen, J. J. 2003. *Medieval Identity Machines.* Medieval Cultures 35. Minneapolis: University of Minnesota Press.

Crellin, R. 2017. "Changing Assemblages: Vibrant Matter in Burial Assemblages." *CAJ* 27.1:111–25.

———. 2020. *Change and Archaeology.* Themes in Archaeology. London: Routledge/Taylor & Francis Group.

Day, J. W. 2010. *Archaic Greek Epigram and Dedication: Representation and Reperformance.* Cambridge: Cambridge University Press.

———. 2018. "The 'Spatial Dynamics' of Archaic and Classical Greek Epigram: Conversations among Locations, Monuments, Texts, and Viewer-Readers." In *The Materiality of Text – Placement, Perception, and Presence of Inscribed Texts in Classical Antiquity*, edited by A. Petrovic, I. Petrovic, and E. Thomas, 73–104. Brill Studies in Greek and Roman Epigraphy 11. Leiden: E. J. Brill.

———. 2019. "Reading Inscriptions in Literary Epigram." In *Greek Epigram from the Hellenistic to the Early Byzantine Era*, edited by M. Kanellou, I. Petrovic, and C. Carey, 19–34. Oxford: Oxford University Press.

De Ridder, A. 1896. *Catalogues des Bronzes trouvés sur l'Acropole d'Athènes.* Paris: E. Thorin.

Dolwick, J. S. 2009. "'The Social' and Beyond: Introducing Actor-Network Theory." *Journal of Maritime Archaeology* 4:21–49.

Donnellan, L. 2020. "Objects That Bind, Objects That Separate." In *Archaeological Networks and Social Interaction*, edited by L. Donnellan, 116–45. New York: Routledge.

Eck, C. van. 2010. "Living Statues: Alfred Gell's Art and Agency, Living Presence Response and the Sublime." *Art History* 33.4:642–59.

Ferrari, G. 2002. "The Ancient Temple on the Acropolis at Athens." *AJA* 106.1:11–35.

Ferguson, W. S. 1932. *The Treasurers of Athena.* Cambridge: Harvard University Press.

Gell, Alfred. 1998. *Art and Agency: An Anthropological Theory.* Oxford: Clarendon Press.

Hamilton, R. 2000. *Treasure Map: A Guide to the Delian Inventories.* Ann Arbor: University of Michigan Press.

Harris, D. 1988. "Nikokrates of Kolonos, Metalworker to the Parthenon Treasurers." *Hesperia* 57.4:329–37.

———. 1990. "Gold and Silver on the Athenian Acropolis:

Thucydides 2.13.4 and the Inventory Lists." *Horos* 8–9:75–82.

———. 1991. "The Inventory Lists of the Parthenon Treasures." Ph.D. diss., Princeton University.

———. 1992. "Bronze Statues on the Athenian Acropolis: The Evidence of a Lycurgan Inventory." *AJA* 96.4:637–52.

———. 1995. *The Treasures of the Parthenon and Erechtheion.* Oxford Monographs on Classical Archaeology. Oxford: Oxford University Press.

Harris Cline, D. 2018. "Entanglement, Materiality, and the Social Organisation of Construction Workers in Classical Athens." In *Ancient Greek History and Contemporary Social Science*, edited by M. Canevaro, A. Erskine, B. Gray, and J. Ober, 512–28. Edinburgh Leventis Studies. Edinburgh: Edinburgh University Press.

———. 2020. "A Field Map for Untangling the Entangled Sea." *Journal of Eastern Mediterranean Archaeology & Heritage Studies* 8.3–4:226–49.

Harris, E. 2015. "Toward a Typology of Greek Regulations about Religious Matters." *Kernos* 28:53–83.

Harrison, R. 2011. "Surface Assemblages: Towards an Archaeology in and of the Present." *Archaeological Dialogues* 18.2:141–61.

Harrison-Buck, E., and J. A. Hendon, eds. 2018. *Relational Identities and Other-than-Human Agency in Archaeology*. Louisville: University Press of Colorado.

Hassard, J. 2013. "Actor-Network Theory." In *Encyclopedia of Management Theory*, edited by E. H. Kessler, 19–22. Thousand Oaks: SAGE Publications.

Hendon, J. 2018. "Can Tools Have Souls? Maya Views on the Relations between Human and Other-than-Human Persons." In *Relational Identities and Other-than-Human Agency in Archaeology*, edited by E. Harrison-Buck and J. A. Hendon, 147–66. Louisville: University Press of Colorado.

Hicks, D., and M. C. Beaudry. 2010. *The Oxford Handbook of Material Culture Studies*. Oxford: Oxford University Press.

Hodder, I. 2011. "Human-Thing Entanglement: Towards an Integrated Archaeological Perspective: Human-Thing Entanglement." *Journal of the Royal Anthropological Institute* 17.1:154–77.

———. 2012. *Entangled: An Archaeology of the Relationships between Humans and Things*. Malden, MA: Wiley-Blackwell.

———. 2014. "The Entanglements of Humans and Things: A Long-Term View." *New Literary History* 45.1:19–36.

Hodder, I., and A. Mol. 2016. "Network Analysis and Entanglement." *Journal of Archaeological Method and Theory* 23.4:1066–94.

Hollenback, K., and M. B. Schiffer. 2010. "Technology and Material Life." In *The Oxford Handbook of Material Culture Studies*,

edited by D. Hicks and M. C. Beaudry, 313–32. Oxford: Oxford University Press.

Hopkins, J. N., S. K. Costello, and P. R. Davis. 2020. *Object Biographies: Collaborative Approaches to Ancient Mediterranean Art.* Houston: The Menil Collection.

Hurwit, J. M. 1999. *The Athenian Acropolis: History, Mythology, and Archaeology from the Neolithic Era to the Present.* Cambridge; New York: Cambridge University Press.

Ingold, T. 2007. "Materials against Materiality." *Archaeological Dialogues* 14.1:1–16.

Jeffery, L. H. 1961. *The Local Scripts of Archaic Greece: A Study of the Origin of the Greek Alphabet and Its Development from the Eighth to the Fifth Centuries B.C.* Oxford Monographs on Classical Archaeology. Oxford: Clarendon Press.

Jordan, B. 1979. *Servants of the Gods: A Study in the Religion, History and Literature of Fifth-Century Athens.* Hypomnemata 55. Göttingen: Vandenhoeck & Ruprecht.

Joyce, R. A., and S. D. Gillespie. 2015. *Things in Motion: Object Itineraries in Anthropological Practice.* Santa Fe, NM: SAR Press.

Joyce, R. A., and J. Pollard. 2010. "Archaeological Assemblages and Practices of Deposition." In *The Oxford Handbook of Material Culture Studies,* edited by D. Hicks and M. C. Beaudry, 291–309. Oxford: Oxford University Press.

Kipnis, A. B. 2015. "Agency between Humanism and Posthumanism: Latour and His Opponents." *HAU: Journal of Ethnographic Theory* 5.2:43–58.

Knappett, C., and L. Malafouris, eds. 2008. *Material Agency: Towards a Non-Anthropocentric Approach.* New York: Springer.

Latour, B. 1996. "On Actor-Network Theory: A Few Clarifications." *Soziale Welt* 47.4:369–81.

———. 2005. *Reassembling the Social: An Introduction to Actor-Network-Theory.* Oxford: Oxford University Press.

Lavigne, D. E. 2019. "The Authority of Archaic Greek Epigram." In *The Materiality of Text – Placement, Perception, and Presence of Inscribed Texts in Classical Antiquity,* edited by A. Petrovic, I. Petrovic, and E. Thomas, 169–86. Brill Studies in Greek and Roman Epigraphy 11. Leiden: E. J. Brill.

Lavis, A., and E. J. Abbots. 2020. "Corporeal Consumption: Materiality, Agency, and Resistance in Body/World Encounters." *Cultural Politics* 16.3:340–45.

Law, J. 1999. "After ANT: Complexity, Naming and Topology." *The Sociological Review* 47.1 Supplement:1–14.

Law, J., and J. Hassard, eds. 1999. *Actor Network Theory and After.* *The Sociological Review* 47.1 Supplement.

Lewis, D. M. 1997. "Temple Inventories in Ancient Greece." In *Selected Papers in Greek and Near Eastern History,* edited by P. J. Rhodes, 40–50. Cambridge: Cambridge University Press.

Linders, T. 1975. *The Treasurers of the Other Gods in Athens and Their Functions*. Beiträge zur Klassischen Philologie 62. Meisenheim am Glan: Hain.

Lolling, H. G., and P. Wolters. 1899. Κατaλόγος τοῦ ἐν Ἀθήνας Ἐπιγραφικοῦ Μουσείου. Athens: Ἀρχαιολογικὴ Εταιρεία.

Makres, A., and A. Scafuro 2019. "The Archaic Inscribed Bronzes on the Acropolis of Athens: Some Remarks." In *From Hippias to Kallias: Greek Art in Athens and Beyond 527–449 BC*, edited by O. Palagia and E. Sioumpara, 63–77. Athens: Acropolis Museum Editions.

Marcaccini, C. 2015. "The Treasurers of Athena in the Late 5th Century B.C.: When Did They Take Office?" *Hesperia* 84.3:515–32.

Mayor, A. 2018. *Gods and Robots: Myths, Machines, and Ancient Dreams of Technology*. Princeton: Princeton University Press.

Meyer, E. A. 2013. "Inscriptions as Honors and the Athenian Epigraphic Habit." *Historia* 62.4:453–505.

Meyer, M. 2017. *Athena, Göttin von Athena: Kult und Mythos auf der Akropolis bis in klassische Zeit*. Wiener Forschungen zur Archäologie 16. Vienna: Phoibos-Verlag.

Morris, S. P. 1992. *Daidalos and the Origins of Greek Art*. Princeton: Princeton University Press.

Müller, M. 2015. "Assemblages and Actor-Networks: Rethinking Socio-Material Power, Politics and Space; Assemblages and Actor-Networks." *Geography Compass* 9.1:27–41.

Müller, M., and C. Schurr. 2016. "Assemblage Thinking and Actor-Network Theory: Conjunctions, Disjunctions, Cross-Fertilisations." *Transactions of the Institute of British Geographers* 41.3:217–29.

Paga, J. 2021. *Building Democracy in Late Archaic Athens*. New York: Oxford University Press.

Papalexandrou, A. C. 2005. *The Visual Poetics of Power: Warriors, Youths, and Tripods in Early Greece*. Greek Studies. Lanham, MD: Lexington Books.

———. 2021. *Bronze Monsters and the Cultures of Wonder Griffin Cauldrons in the Preclassical Mediterranean*. Austin: University of Texas Press.

Parker, R. 2004. "What Are Sacred Laws?" In *The Law and the Courts in Ancient Greece*, edited by E. Harris, E. Monroe, and L. Rubinstein, 57–70. London: Duckworth.

Petrovic, A. 2015. "Sacred Law." In *The Oxford Handbook of Ancient Greek Religion*, edited by E. Eidinow and J. Kindt, 339–52. Oxford Handbooks. Oxford: Oxford University Press.

Petrovic, A., I. Petrovic, and E. Thomas. 2018. *The Materiality of Text – Placement, Perception, and Presence of Inscribed Texts in Classical Antiquity*. Brill Studies in Greek and Roman Epigraphy 11. Leiden: E. J. Brill.

Pickering, A.1995. *The Mangle of Practice: Time, Agency, and Science.* Chicago: University of Chicago Press.

———. 2010. "Material Culture and the Dance of Agency." In *The Oxford Handbook of Material Culture Studies*, edited by D. Hicks and M. C. Beaudry, 191–208. Oxford: Oxford University Press.

Raubitschek, A. 1949. *Dedications from the Athenian Akropolis: A Catalogue of the Inscriptions of the Sixth and Fifth Centuries B.C.* Cambridge, MA: Archaeological Institute of America.

Rice, C. 2011. "Ceramic Assemblages and Ports." In *Maritime Archaeology and Ancient Trade in the Mediterranean*, edited by D. Robinson and A. Wilson, 81–92. Oxford Centre for Maritime Archaeology Monograph 6. Oxford: Oxford Centre for Maritime Archaeology, Institute of Archaeology.

Samons, L. J. 1996. "The 'Kallias Decrees' (*IG* I^3 52) and the Inventories of Athena's Treasure in the Parthenon." *CQ* 46.1:91–102.

Sayes, E. 2014. "Actor-Network Theory and Methodology: Just What Does It Mean to Say That Nonhumans Have Agency?" *Social Studies of Science* 44.1:134–49.

Scott, M. 2010. *Delphi and Olympia: The Spatial Politics of Panhellenism in the Archaic and Classical Periods.* Cambridge: Cambridge University Press.

Shaya, J. 2014. "Greek Temple Treasures and the Invention of Collecting." In *Museum Archetypes and Collecting in the Ancient World*, edited by M. Wellington Gahtan and D. Pegazzano, 24–32. Monumenta Graeca et Roman 21. Leiden: E. J. Brill.

Sickinger, J. P. 1999. *Public Records and Archives in Classical Athens.* Studies in the History of Greece and Rome. Chapel Hill: University of North Carolina Press.

Sioumpara, E. 2016. "A New Reconstruction for the Archaic Parthenon, the Archaic Acropolis and the Evolution of Greek Architecture Revisited." *RA* 61.1:196–205.

Sowder Koch, A. 2009. "Greek Bronze Hydriai." Ph.D. diss., Emory University.

Stahl, A. B. 2010. "Material Histories." In *The Oxford Handbook of Material Culture Studies*, edited by D. Hicks and M. C. Beaudry, 150–72. Oxford: Oxford University Press.

Stockhammer, P. W. 2015. "Lost in Things: An Archaeologist's Perspective on the Epistemological Potential of Objects." *Nature and Culture* 10.3:269–83.

Svenbro, J. 1993 [1988]. *Phrasikleia: An Anthropology of Reading in Ancient Greece.* Translated by J. Lloyd. Ithaca, NY: Cornell University Press.

Tarditi, C. 2016. *Bronze Vessels from the Acropolis: Style and Decoration in Athenian Production between the Sixth and Fifth Centuries BC.* Thiasos Monografie 7. Roma: Edizioni Quasar.

Van Oyen, A. 2015. "Actor-Network Theory's Take on Archaeologi-

cal Types: Becoming, Material Agency and Historical Ex-
planation." *CAJ* 25.1:63–78.

———. 2016. "Historicising Material Agency: from Relations to
Relational Constellations." *Journal of Archaeological Method
and Theory* 23:354–78.

Archaic Inscribed Bronze Dedications on the Acropolis: Thoughts on a New Edition

Andronike Makres and Adele Scafuro

Abstract

A full corpus of the inscribed bronze dedications from the Acropolis at Athens, approximately 100 in number, is a desideratum. Almost all date before 480 B.C.E.; most are in fragmentary condition: e.g., statuettes and bases, small objects such as heads of animals, and many basins and phialae. The most recent systematic publication on the subject, by Chiara Tarditi, focuses on bronze vessels, excludes other objects, and puts emphasis on stylistic analysis.[1] Our focus is more epigraphic and emphasizes the social context of the dedications. Here we examine the problems we foresee in making our edition, especially regarding dating the objects by the letter forms of the texts and by their location on the dedication; by the identification of workshops (if possible); and by the identification of the statuettes or other sculptured figures that may have been attached to dedication bases. We also look at the complicated dialogue among earlier scholars, especially between Raubitschek and Jeffery in DAI and between Lewis and Jeffery in IG I³. We add new entries to our catalogue while contextualizing the social and political background of these dedications, maintaining that many dedicants will have been neopolitai of Cleisthenic tribal reforms (Arist. Pol. 1275b).

MORE THAN 1,000 BRONZE OBJECTS—SOME INSCRIBED, but many more uninscribed—have been found on the Acropolis at Athens.[2] Most are in fragmentary condition: they are statuettes and bases, small objects such as heads of animals, small shields, disks, mirrors, phialae, handles and feet of tripods and vessels, and especially basins. Fewer than 150 of these objects preserve inscriptions. Many were discovered during the excavations of the Acropolis directed by Panagiotis Kavvadias (1885–1890). Epigraphic publications soon bore the fruits of his efforts, but the bronze inscriptions were not among the first to be given proper scholarly attention; indeed, Kavvadias himself published five texts—but only those

inscribed in stone—along with drawings of the dedicatory artifacts in the 1886 reports on the finds from the Acropolis.[3] The subject of our project is the inscribed bronze dedications. These inscribed objects were almost totally neglected at the time of Kavvadias's excavations amidst the more monumental finds that fundamentally changed our knowledge of late archaic and early classical sculpture. While most of the inscribed texts were included in David Lewis's and Lilian Jeffery's section on dedications in *IG* I[3], a more comprehensive and updated edition of these dedications that is more accessible to nonexperts is highly desirable. Here we provide a review of earlier editions of the dedications and then offer our prospectus for a new one.

About three-quarters of the approximately 122 inscribed bronze dedications (or, more precisely, dedicatory fragments) in the most recent *IG* I[3] edition are assigned rough dates (e.g., 600–550, 500–480) that antedate 480 B.C.E. Indeed, those rough dates may well be true, though almost all are followed by question marks and the three without them are assigned to the fifth century at large. The question marks are not surprising; precise findspots from early excavation reports are often absent or vague and 19th-century attributions to the *Perserschutt* (see infra) are problematic. *IG* I, edited by Adolf Kirchhoff and published in 1873 before Kavvadias's excavations, offered no bronze dedications, but the supplement to that volume (with fascicles published in 1877, 1886, and 1889, also edited by Kirchhoff), included several.[4] With Kavvadias's permission, Habbo G. Lolling copied most of the dedications that appear in the second fascicle (not all, e.g., Ulrich Koehler copied some) and also drew them with accompanying notes in German.[5]

While somewhat idiosyncratically arranged, Kirchhoff's supplementary edition (sometimes referred to as "*IG* I s" or simply "I s") was also exemplary, especially given the speed of publication so close in time to the excavations;[6] in a way, it is an early adumbration of *SEG*, with drawings added. Previously published texts were now given new readings, citing the page and number of the first edition followed by the revised text, and many of the texts were completely new.[7] Thus, for example, *IG* I Supplement, 80 no. 373[12] is a text transcribed in Attic Greek by Koehler inside a drawing of the surface of a bronze pedestal, described in German by Lolling, and given its epigraphical information (measurements, findspot, iden-

Fig. 1. Bronze statuette of Athena Promachos (NM 6447). © *Hellenic Ministry of Culture and Sports, National Archaeological Museum/ Archaeological Resources Fund.*

tification of the transcriber) in Latin by Kirchhoff. Koehler's text (as presented by Kirchhoff in the Ionic alphabet beneath the drawing), runs as follows: Μελησὼ ἀνέθηκεν | [δεκά|τ]ην τὰ[θη]ναίαι. The same dedication appears twice more in I s: Lolling's revised transcription in the Attic alphabet (I s:130, no. 373[12]) added three letters that had not been visible to his predecessor and Franz Studniczka (I s:180, no. 373[12]) added others (fig. 1).[8] More significantly, the editor announced the exciting news that Studniczka had discovered that a bronze Athena Promachos "quae a. 1887 in arce eruta est e fundamentis Tholis quae vocabatur" had at one point been attached to the bronze base (in fact, a plinth) that carries

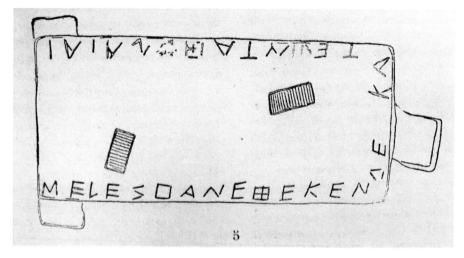

5

Fig. 2. Drawing of inscribed base of NM 6447. Reproduced from Studniczka 1887, no. 5.

the inscribed text (fig. 2). The plinth, the text, and the statuette itself combine to make this an important (and controversial) artifact that illustrates many of the problems inherent in a corpus of inscribed dedications—which we shall consider shortly.[9] In subsequent *IG* publications, the plinth is designated as *IG* I² 426 and *IG* I³ 540.

As a publication, *IG* I s was a sumptuous volume—even if difficult to navigate—in the information it relayed on findspot (when possible), in description, and illustration. Subsequent editions were sometimes less generous, though important advances were made. Friederich Hiller was the first *IG* editor (*editio minor*, 1924) to separate the bronze and stone dedications. No doubt Hiller was influenced by three catalogues that had already appeared after the supplement to *IG* I. The first is A.G. Bather's publication in 1892, with accompanying drawings, of 65 fragmentary dedicatory (all bronze) inscriptions from the Acropolis excavations, small bits and pieces that had been neglected because of their apparent insignificance among the monumental finds.[10] These inscriptions were mostly incised, with some letters "punched" (see, e.g., *IG* I³ 520 a–d, *litt. punctis factae*) onto the bronze objects. The second is André de Ridder's catalogue of bronze dedications found on the Acropolis, published in 1896, and arranged according to shape, inscribed and uninscribed mixed together, for a total of some 835 objects, with only 46 inscriptions noted in the index. In his second preface, he remarks that he had not been given access to Lolling's unpublished work. The third is a catalogue of the dedicatory

inscriptions from the Acropolis in the Epigraphic Museum in Athens written in modern Greek by Lolling and completed by Paul Wolters in 1899 after the former's death in 1894.[11] The catalogue is divided in two parts: the first are the texts inscribed on bronze artifacts (nos. I–CXXIX) and the second those on stone (nos. 1–398).[12] There is great attention to letter forms—the final page of the volume provides a chart of all the types of individual letters that appear in the texts, and a key to the chart appears beneath each text. Hiller's volume in 1924 included some 85 entries of early bronze dedications (included under nos. 401–462, dated roughly to 480 B.C.E.).[13] He relied almost solely upon the three works just mentioned, and especially the last; *IG* I s is mentioned sparingly; there are no drawings. Nonetheless, strides were made in the organization of the dedications. Not only were bronze dedications separated from stone, but now for the first time, dedications from the Acropolis were separated from others located elsewhere in Athens and Attica. Dedicatory statues with names (of dedicants and artists) were given a separate section (pp. 198–204); basins (*pelves*) and similar vessels were classified separately as well (pp. 221–22); and "Donari Arcis Reliqua" (pp. 205–20), following Lolling, were given an alphabetic ordering—whether to advantage or not is unclear.

In *IG* I³, some 122 early bronze dedications from the Acropolis are included.[14] The majority are "Donaria privata," nos. 526–588, arranged by shape. The first 15 are "Minervae sigilla et bases" (nos. 526–540). Most are bases that formerly carried small statues of Athena, as indicated by two holes on the surface that once were used for holding the statuette in place (526, 527, 533, 537, 538, 540). The last (no. 540) is Meleso's dedication for which Studniczka in 1887 had identified a particular Athena (fig. 2). Number 530 now has a bronze Athena Promachos affixed to the bronze plinth. Number 532 is a bronze base that carries the remnant of the statuette's feet. Number 539 is a fragmentary Athena missing feet and base— a bit of text (three letters) is visible on her chest. The next two dedications (nos. 541–542) are statuettes and bases of male figures. Various small objects follow (nos. 543–549 bis: e.g., a sheep, a pomegranate, a tiny shield decorated with Medusa's face in its center, a wonderful lamp in the shape of a ship). After this assortment, vessel types follow (nos. 550–588, e.g., "pelves et paterae, oenochoae, hydriae").[15] The last five entries (nos. 584–588) make up a separate category of prize bowls

won by Athenians in private contests in Boeotia, inscribed with Boeotian letters, and dedicated on the Acropolis in Athens. The lettering of the first four appears quite archaic, from ca. 700–550 (with Jeffery's comments in *LSAG*, 91, 94, catalogue nos. 3a–e). Most entries include a brief description of the object (written in Latin) and its measurements, unique or diagnostic letters, earlier editions, an uncertain date; the text is also included as well as a minimal *apparatus criticus* and further notes of various lengths. Significantly, many descriptions include remarks about the surfaces of fragmentary bases and other objects, reporting, for instance, whether there are dowels for affixing a statuette or not (as in no. 526), remarks on dialect forms (no. 553), and the (mis)identification of letter shapes (nos. 544, 554). There are references to photos and drawings, but none are included.

Two more catalogues focus on dedications but have different goals. In 1949, between the publication of *IG* I² in 1924 and *IG* I³ in 1994, A. E. Raubitschek with Jeffery (some 15 years before the commencement of her collaboration with Lewis) produced the monumental work, *Dedications of the Athenian Acropolis* (*DAA*), which focuses primarily on stone dedications.[16] This comprehensive study of the Acropolis dedications, categorized on the basis of the type of monument (that is, on strictly archaeological criteria), has been the cornerstone for all subsequent archaeological and more specialized epigraphical studies.[17] Nonetheless, while almost all scholars have humbly acknowledged the magnificent comprehensiveness of *DAA* and the boldness of the main author who produced it, they have also offered serious critiques of the overreadiness of its acceptance of restorations into the inscribed texts and the consequent fragile status not only of the texts themselves but also of the objects that have been fitted together based on them. Moreover, subsequent autopsies have questioned readings and interpretations of surface grooves and holes. The dual task of any subsequent edition, then, is not only to provide a careful and accurate text but also to re-examine the inscribed objects, especially for the integrity of fragment collocations. Certainly, Lewis and Jeffery took this task seriously. A quick glance brings characteristic examples to the fore. A telling one is *IG* I³ 637 (= NM 6244; see figs. 3 and 4), which is the left-hand part of a marble base with a three-line dedicatory text and a fourth line naming the artist [Γ]οργίας. On the surface of the base, there remains, accord-

ing to Lewis and Jeffery, *pars sinistra excavationis quadratae*
(*oblongae?*), "the left-hand portion of a squared (or oblong?)
hollowed space"—that is, a socket. Raubitschek's description
is slightly different—the socket is unambiguously rectangu-
lar, and "a rectangular socket indicates that a base supported
a marble statue" (*DAA*, 69, no. 65, photograph p. 68). Lewis
and Jeffery object: at least two of Gorgias's works (*IG* I³ 638,
639) were bronze, "Quamobrem coniicimus excavationem
(vid. supra) non equi marmorei plinthum sed basum aliam
quae equum sustineret accepisse." Succinctly put, the later ed-
itors do not unequivocally accept a rectangular socket. They
think it was more likely squared, and more likely to have car-
ried a smaller base, appropriate for a bronze horse, which is
more appropriate for the artist Gorgias—bronze rather than
marble.[18] While the precise shape of the socket was one clue,
the other—and a very important one—was the identification
of the *officina* (workshop) of the artist. Most often (for there
are numerous *officinae* identified both in *DAA* and *IG* I³), the
identification is achieved by noting the similarity of lettering
among different inscribed texts. The identification of the art-
ist's *officina*, then, is an important part of the entries both in
DAA and in *IG* I³, and sometimes can become helpful in dat-
ing dedications.[19] For the expert reader, there is an intense
dialogue taking place between *IG* I³ and *DAA*, with Lewis
apparently teasing a critique of Raubitschek's methods and
results from the notes that Jeffery left behind.[20] The entries in
IG I³ are intimately engaged with *DAA*.

A second and smaller catalogue of dedications must also
be mentioned, Tarditi's *Bronze Vessels from the Acropolis*, the
most relevant and systematic publication in recent years.[21]
The work is pioneering and exciting in its inclusion of often
ignored artifacts, but it focuses on bronze vessels to the exclu-
sion of other bronze artifacts. Indeed, due to the scope of the
work, it omits from its catalogue more than 60 of the bronze
inscribed dedicatory fragments that can be found in *IG* I³.
Moreover, with its emphasis on stylistic analysis (with contri-
butions to a chronology based on style), the inscriptions are
not given a thorough study.[22]

We plan to combine the best of both worlds (epigraphic
and archaeological) in making a new edition of the inscribed
bronze dedications from the Acropolis. We will include texts
that have been published since Lewis's edition and also dis-
cussions of texts on objects that have been made known but

not yet published.[23] The entries for each text will be in English. We plan to contextualize the dedications with drawings, photographs, and accompanying essays. Like Raubitschek, Lewis and Jeffery, and Tarditi, our arrangement will be according to shape (beginning our catalogue of private dedications with statues and bases) and where applicable, we will follow Tarditi's stylistic chronology. We plan to maintain the distinction between inscriptions on bronzes and inscriptions on stone that has been observed since Lolling's catalogue and Hiller's *IG* I². Since our edition focuses on bronze artifacts, the distinction between bronze and stone is mainly relevant to bases that may have carried bronze dedications. That phenomenon elicits questions: Why are bronze dedications made instead of stone? And why hybrid dedications (i.e., marble bases supporting bronze objects)? Like Raubitschek, Jeffery, and Lewis (as well as earlier scholars like Studniczka and subsequent scholars like Konstantinos Kissas, Catherine Keesling, and Gianfranco Adornato), we are interested in the surfaces of the bases or plinths for indications of the material of attached dedications, whether bronze or stone.[24] Accordingly, we will add an appendix on stone bases and plinths.

To this end, Keesling's observations about bases and plinths found on the Acropolis are of great assistance. She has carefully identified:[25]

1. At least 15 inscribed bronze plinths (*IG* I³ 526–538, 540, and 541), some without preserved statuettes (these were mentioned earlier: nos. 526, 527, 533, 537, 538, 540—the last is Meleso's dedication for which a particular Athena Promachos has been identified), and some with statuettes or parts of a statuette preserved (e.g., 530, 532, 541);

2. Twenty-seven uninscribed bronze plinths;

3. Eighteen inscribed stone statue bases with bronze plinths small enough to carry statuettes;[26]

4. Another 5 inscribed stone bases that carried bronze statuettes attached by foot dowels without bronze plinths.

A careful study of the objects (even if not made of bronze) that are likely to have carried bronze dedications will augment the corpus, and not only numerically. By providing more sample lettering, more names of dedicants, and more names of artists, and by opening the possibility of identifying their workshops, we may enhance the possibility of deriving dates for the dedications.

Chronology remains a problem, especially whether the dedications are to be dated before the Persian Wars or after them and whether the Persian destruction layer has any impact on this discussion. As for the *Perserschutt* (by which we and other scholars mean a deposit of debris that was leveled right after the second occupation of Athens by the Persians), scholars still disagree but have moved largely in the direction of thinking that there may have been only one such homogenous deposit.[27] When findspot is controversial or unknown (as is the case for many of our dedications), attention to letter forms becomes all-important. We mentioned at the outset that the dates of almost all the bronze dedications in *IG* I³ are followed by question marks: "500–480" is most frequent, but "525–500" also appears, and occasionally: "490–480?," or "480?," or "475?" One really wonders how these slight shifts were determined—the *IG* I³ lemmata are of little assistance to the nonspecialized reader. Indeed, while both findspot and the evolution of archaic letter forms are crucial to dating, for this set of texts they can sometimes be extremely baffling. Once again, we might turn to the Meleso dedication (*IG* I³ 540) for illustration. Studniczka thought that the statuette, discovered in the *Perserschutt* (Lewis is skeptical and parenthetically adds "ut sibi persuasus est"), was made before 480/479.[28] Jeffery (as Lewis reports), thought that the lettering and statuette belonged to a somewhat later period. Studniczka's and Jeffery's remarks are without accompanying arguments. Subsequent pathways to a solution for this particular statuette have been to study early notices of findspot and excavation reports and also attributes of sculptural artistry as well as of plinths and proposed bases. Another possible route is to give a more expansive consideration to letter forms, comparing archaic bronze letters to stone letters. While different claims for this particular piece have been made, and while the date remains somewhat controversial, a consensus seems to have formed that it does *not* predate 480.[29] Finally, we hope to carry on Jeffery's identifications of workshops (through attention to lettering) and to explore what contributions these considerations may bring to dating.

Additionally, we will also explore the sociological significance of the dedications. In an earlier study, we focused on bronze *aparchai* and *dekatai* dedications.[30] *Aparchai* and *dekatai* were mechanisms governing votive dedications, portions of one's property or income or any kind of revenue dedicated

to the gods. They might be given by individuals (e.g., the dedication of Antenor's *kore* on the Acropolis by Nearchos) or by city states (e.g., the bronze statue of Athena Promachos on the Acropolis which, according to Pausanias 1.28.2, was made from the *dekate* of the Persian booty from the Battle of Marathon). A *dekate* was always one-tenth of the revenue or the property in question and was certainly dedicated in retrospect, that is, after this revenue was made. An *aparche* was a smaller amount than a *dekate* and may on some occasions have had more of a preliminary character, that is, it was dedicated as soon as the first (and not the whole) revenue was made. *Aparchai* were more common in sacrificial and agricultural contexts. Both *aparchai* and *dekatai* may have been realized as a fulfillment of a vow or simply as a thank offering to the gods.[31]

Our main conclusion, as presented in an earlier study, was that the bronze dedications, suggestive of a widespread practice of dedication and thanksgiving, were probably neither the gifts of poor Athenians, who would probably have dedicated *pinakes* or other humbler votives, nor were they the gifts of the elites. Instead, their skillful craftsmanship and inscriptions indicate they were dedications of a middle class of craftsmen, of merchants and traders, of moderately prosperous farmers, and also of professional women, metics, and foreigners. We argued that this middle economic class must have been prominent at the time.[32] In drawing these conclusions, we used both stone and bronze *aparchai* and *dekatai*; combining both materials together (stone and bronze), then a full 10.26% of these offerings were dedicated by women. But if we separate them, then it is worth noting that a far higher percentage of women made bronze rather than stone dedications, and most of these (six of the seven) were *dekatai*, perhaps the more burdensome to one's property unless one was rather wealthy. We think these are interesting phenomena, which is why in the essays attached to our corpus we plan to pursue discussion of sociological phenomena associated with both stone and bronze inscribed dedications from the Acropolis.[33]

In sum, we foresee a new edition of the Acropolis dedications inscribed on bronze objects that includes discussions of the stone bases that carried bronze objects with photos and up-to-date descriptions of all the objects in English. Essays on the following (often interrelated) topics will also be

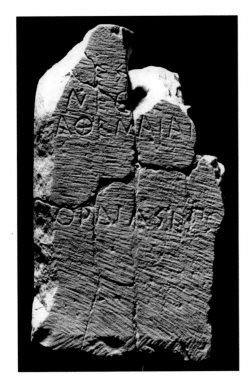

included: (1) chronology, letter forms, workshops, (2) bases and plinths and the objects that may have been attached to them;[34] (3) in the case of fragmentary pieces, a discussion of the objects to which they may have belonged, for example, a mirror or a basin of some sort, and in the case of integral objects, such as phialae or hydriai or kylikes whether they were for display or sacral use, (4) their sociological significance. In all cases, we shall keep our eye on the possible combination of bronze and stone. We shall always be concerned with the text, including the form of letters and where they appear: on the base, on the plinth, or on the dedicatory object itself. Recall once again *IG* I^3 540 (*IG* I Supplement 373^{12} and *IG* I^2 426 in earlier manifestations): the bronze statuette of Athena Promachos on a bronze plinth that (following Lolling's description; see fig. 1 supra) has three short feet (pegs), one under one side and the other two under the opposite narrower side, the feet being destined for the fitting of the plinth into a larger (hypothesized) stone base (in *IG* I^3 this is designated as a "capitulum pilae marmoreae"). The inscription appears on the upper surface of the bronze plinth. The rather complicated construction, with its combination of bronze and stone

Fig. 3 (left). Inscribed marble base from the Acropolis (NM 6244) preserving the name of artist Gorgias. © Hellenic Ministry of Culture and Sports, Epigraphic Museum/ Archaeological Resources Fund.

Fig. 4 (right). Inscribed marble base from the Acropolis (NM 6244) showing the rectangular cutting for the insertion of a now missing bronze work. © Hellenic Ministry of Culture and Sports, Epigraphic Museum/Archaeological Resources Fund.

Fig. 5. Bronze statuette of athlete from the Acropolis (NM 6614). © Hellenic Ministry of Culture and Sports, National Archaeological Museum/ Archaeological Resources Fund.

is interesting. It may suggest a step in the evolution of statuettes with inscribed bases, for it does not seem absolutely necessary that the inscribed text should appear on the bronze plinth rather than on the hypothesized stone base. Perhaps the inscriptions traveled (at least notionally—we cannot say chronologically) from the body of the dedicated statuette (as in *IG* I³ 542, a statuette of an athlete, where inscriptions appear on each side of its body; fig. 5) to the bronze plinth (as in *IG* I³ 540), and then from there to a stone base (as in NM 6244; figs. 3 and 4). The appearance and position of the artist's name are also important. In a private communication, D. Sourlas has suggested that when inscribed on the body of the statuette or the bronze object itself the inscriptions may

Fig. 6. Bronze base from the Acropolis (NM 6944). © Hellenic Ministry of Culture and Sports, National Archaeological Museum/ Archaeological Resources Fund.

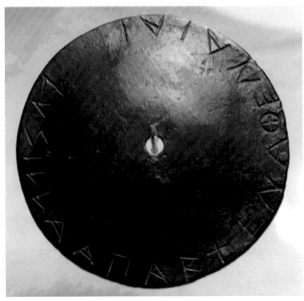

Fig. 7. Bronze cymbal from the Acropolis dedicated by Lysilla (NM 17525). © Hellenic Ministry of Culture and Sports, National Archaeological Museum/ Archaeological Resources Fund.

have been inscribed by the artist himself, whereas the inscriptions on stone bases were certainly the work of specialized professionals, the letter cutters.

We conclude our essay with sample images of specific examples of bronze dedications. The first three are by women, two *dekatai* (figs. 1, 2, and 6) and one *aparche* (fig. 7).

IG I³ 540 (Athens, NM 6447, now in the Acropolis Museum; figs. 1, 2). Bronze Athena Promachos statuette (H: 0.265 m). Its bronze plinth was originally fastened at three points to the capital of a pillar-shaped marble base (as hypothesized by Lewis and Jeffery).

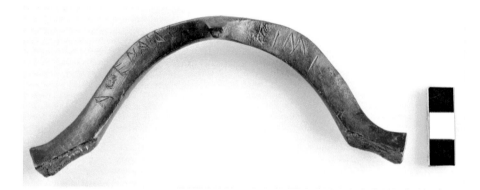

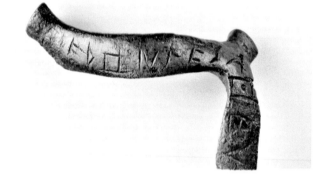

Fig. 8 (above). Inscribed bronze handle from the Acropolis preserving inscription IG I³ 580 (NM 17517). © Hellenic Ministry of Culture and Sports, National Archaeological Museum/ Archaeological Resources Fund.

Fig. 9 (right). Inscribed bronze handle from the Acropolis preserving inscription IG I³ 579 (NM 17520). © Hellenic Ministry of Culture and Sports, National Archaeological Museum/Archaeological Resources Fund. Photo E. Galanopoulos.

Dimensions of plinth: H 0.02 m; W 0.117 m; Th. 0.05 m; LH 0.004 m–0.005 m.

Date: 480–470? B.C.E.

Transcribed text: Μελεσὸ ἀνέθεκεν | δεκά | τεν τἀθεναίαι.

IG I³ 536 (Athens, NM 6944; fig. 6). Bronze base preserved in good condition. The top surface has two rectangular holes (0.012 m × 0.05 m) that may have received the feet of a statuette of Athena in hoplite armor or perhaps the statuette of an athlete? (The incised line 0.04 m long may have received the bottom part of Athena's shield.) The inscription runs along the two sides of the base. The name of the dedicator of the *dekate*, Γλύκε is no longer visible. For another *dekate* dedication of Γλύκε, this time a bronze hand mirror, see *IG* I³ 548bis.

Dimensions of plinth: H 0.02 m; W 0.11 m; Th. 0.086 m; LH 0.01 m.

Date: 480? B.C.E.

Transcribed text: Γλύκε δεκά | τεν τἀθεναία|<ι>.[35]

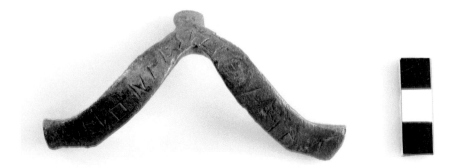

Fig. 10. Detail of inscribed bronze handle from the Acropolis preserving inscription IG I³ 579 (NM 17520). Letters H and I visible on the left. © Hellenic Ministry of Culture and Sports, National Archaeological Museum/ Archaeological Resources Fund. Photograph by E. Galanopoulos.

IG I³ 547 (Athens, NM 17525; fig. 7). Bronze cymbal, a musical percussion instrument dedicated as *aparche* by a woman named Lyssila.[36]

The cymbal is a hammered disk of bronze sheet slightly convex at the center. The inscription with carefully incised letters circles round the edge of the convex surface. The cymbals were presumably fastened to both hands by a leather thong that passed through the hole and were clashed together by the cymbalist.[37]

Diameter of cymbal: 0.07 m; LH 0.005 m–0.007 m.

Date: 500–475 B.C.E.

Text: Λύσιλλα ἀπαρχὲν Ἀθεναίαι.

The last two bronze items are inscribed handles of vessels kept in the National Archaeological Museum. The first one *IG* I³ 580 (fig. 8) is inscribed: Ἀθεναίας | εἰμί ("I belong to Athena"); the other *IG* I³ 579 (figs. 9, 10) is inscribed: [ℎι] ερὸν τῆς | Ἀθεναίας ("sacred [object] of Athena" i.e., sacred to Athena). Let us note here that the first two letters of 579, the H and the I (of HIERON), are in square brackets in the *IG* I³ edition; however, we were able to discern the two letters so that the square brackets should be removed (fig. 10). The two inscribed handles are not standard dedications in the style, "X dedicated Z to Athena," but declare that they are the property of the goddess in different ways. Even simple formulas and their nuances need to be studied carefully.[38]

Acknowledgments

We are grateful to Diane Harris Cline and Nassos Papalexandrou for encouraging our contribution to the AIA panel; we are also grateful to the anonymous referees for their constructive and helpful remarks on the essay; and we are especially grateful to Voula Bardane, Charles Crowther, and Angelos Matthaiou for answering que-

ries and supplying materials. Additionally, we thank the staff of the Epigraphical Museum (EM), the National Archaeological Museum (EAM), and the Acropolis Museum for providing photographs and assisting our work.

Notes

[1] Tarditi 2016.

[2] The total number of the Acropolis bronzes is unknown. The fragmentary pieces of bronze vessels in Tarditi's (2016) recent catalogue alone number 1135 pieces, and she does not include, e.g., fragments of stand-alone statues and statuettes.

[3] Kavvadias 1886, 79–82, and pl. 6. Although each of the five texts is an *editio princeps* and while all are cited in *IG* I³ (nos. 618, 628, 699 and 787; no. 618 consists of four fragments, including Kavvadias's nos. 1 and 3; see *DAA*, 6+ for references), nonetheless, only one in that edition includes Kavvadias's name in the entry (*IG* I³ 699, a dedication of Onesimos to which a later dedication was added by his son). The first epigraphic finds (excluding those of early travelers) on the Acropolis were made by K. S. Pittakis in 1833 (Kavvadias and Kawerau 1906, 1 and 2; Ross 1863, 237–38); these were subsequently published in the first edition of *IG*.

[4] Of the 100 public and private dedications in *IG* I (none dated), a very few do not mention the material, whether stone or bronze (367, 368, 405, 414, 420, 421). The stone dedications included among the "Monumenta Privata" (nos. 341–431, not all from the Acropolis) are of great interest, not least for the transcriptions of Velsen, Koehler, Pittakis, Ross, Rangabé and others, but also for the notes of findspots (and references to earlier reports) before the excavations of the late 1880s. The first bronze dedication appears in the first fascicle of *IG* 1 Suppl., 41, 373a in 1877; it is a bronze figure of a ram with the text inscribed on its belly.

[5] Kirchhoff 1887a, 289–90 describes both the somewhat interrupted progress of *IG* and also the imminent publication of the next fascicle of *Supplementum* with Lolling's transcriptions of texts from the most recent Acropolis excavations; in Kirchhoff 1887b, he also provided a provisional publication of many of the texts from the recent excavations (43 in the first segment, 1059–74; and 67 in the second, 1185–205), with Lolling's notes but not his commentary, since "im Interesse der Wissenschaft liegt, dass die aufgesammelten Materialien möglichst bald und möglichst vollständig zu allgemeinster Kenntniss gelangen." The texts were of all categories, all inscribed on stone; the absence of bronze texts from the publication perhaps is due not only to the small percentage of texts inscribed on bronze in comparison with those on stone, but also to their lack of monumentality.

[6] This speed would appear to match Kavvadias's own *modus operandi* as he describes it in 1906, 21: Εἰδήσεις περὶ τῆς πορείας τῶν ἀνασκαφῶν, ἄρθρα καὶ ἐκθέσεις περὶ τῶν εὑρημάτων,

ἐδημοσίευον τότε ἐν τῇ Ἀρχαιολογικῇ Ἐφημερίδι, ἀπὸ τοῦ 1886 κ.ἑ. καὶ ἰδίᾳ ἐν τῷ Ἀρχαιολογικῷ Δελτίῳ, ἀπὸ τοῦ 1888 κ.ἑ. Ἐν τῷ Δελτίῳ τούτῳ ἐδημοσιεύοντο μηνιαῖαι ἐκθέσεις ὑπ' ἐμοῦ μὲν περὶ τῆς πορείας τῶν ἀνασκαφῶν καὶ περὶ τῶν γινομένων εὑρημάτων, ὑπὸ δὲ τοῦ Λόλλιγκ περὶ εὑρισκομένων ἐπιγραφῶν. Κατὰ ταῦτα δὲ τὰ δημοσιεύματά μου, ἅτινα γινόμενα τότε, συγχρόνως ταῖς ἀνασκαφαῖς, παριστῶσι κατ' ἐμὴν γνώμην τὴν ἱστορικὴν ἀλήθειαν, καθ' ἣν ἐγὼ ἔσχον τότε ἀντίληψιν τῶν πραγμάτων, ἐκθέτω ἐνταῦθα τὰ τῆς πορείας τῶν ἀνασκαφῶν' [emphasis added].

[7] A great many of these appear under "Donariorum Tituli" in the second fascicle (1877–1886), especially those inserted after text no. 373 (i.e., the text that bore the no. 373 in IG I in 1873): here, an adscript number was added to no. 373, so that a series begins from 373[1] and runs through 373[227], with each adscript numeral indicating a new object with an inscribed text or a revised text with additional letters. In the first fascicle, under the same category, the numeral 373 is followed by an adscript alphabetic letter, a–z; and when these letters run out, adscript "a" is followed by adscript "1" and so on. This system is presented in the "Conspectus titulorum," 211–12.

[8] The reader must go to ArchEph 1887 to find Studniczka's additional letters; they are printed in the subsequent IG editions, IG I[2] 426 and IG I[3] 540.

[9] The plinth is described in great detail in Studniczka 1887.

[10] Readers may be confused by the differing number of bronze dedicatory objects in different editions (IG I s; IG I[2]; and IG I[3]) and catalogues (Bather 1892; de Ridder 1896; and L-W). Bather's "65" fragments were previously unpublished and so were added to new editions—but would be dispersed differently. Editors sometimes have counted multiple fragments from different artifacts as "one entry number," sometimes when they are of the same type (e.g., fragments of helmets), or sometimes because there are very few inscribed letters; and sometimes fragments, previously separate, have been joined together as one object; see nn. 11, 13, 14, and 15 below.

[11] The catalogue is often abbreviated, as here, "L-W."

[12] See n. 8 above.

[13] Nos. 460–462 include ca. 26 quite small and fragmentary pieces.

[14] Jeffery died in 1986. Lewis, who wrote an informative obituary in 1987 (Lewis 1987), reports that he asked her to collaborate on the private inscriptions after he had been asked to organize a new edition of IG in 1962; she was attracted to the project by the possibility of extending her study of workshops to the dedications: "Raubitschek had arranged his catalogue by types of monument; she would order the texts chronologically and by workshops" (Lewis 1987, 514). Her work on the problem about dating texts before and after the Persian sack of the Acropolis in 480 was not resolved before her death; we see remnants of her views (esp. regarding officinae), left behind in

unpublished notes, in IG I³. The number 122 includes some 64 quite fragmentary pieces, sometimes under numerals to which a "bis" is attached or otherwise indicated by adscript alphabetic letters under one numeral—e.g., no. 570 bis includes 6 fragmentary pieces and no. 583 includes 32. There are very few bronze pieces among the Donaria publica, only nos. 510 and 517–521, with the latter group designated as "Spolia" and nos. 520 and 521 consisting of fragments from multiple objects—no. 520, consisting of fragments of 4 inscribed helmets and no. 521, of 9 inscribed spear butts.

[15] The objects are generally the same as those in Hiller's edition (IG I²), though differently arranged (see, e.g., IG I³ 583 a–z and aa–ff, all in Bather [1892–1893], L-W, and Hiller [IG I²]).

[16] Jeffery's contribution to DAA should not be underestimated; Raubitschek characterized it this way: "Miss Jeffery's main task, and thus her contribution to this publication, was the taking of photographs, and the checking of measurements and descriptions. In addition to that she contributed many suggestions, and the section containing the marble basins is almost exclusively based on information furnished by her; she is, therefore, well entitled to share full credit that may be given to this publication, but she must not be made responsible for any of its mistakes."

[17] Our concern with DAA, perhaps not immediately obvious since it focuses on stone monuments, is especially with its arguments for the attachment of bronze dedications to stone bases; and also with its important appendix on artists (479–525) with many attributions to workshops.

[18] The critique of DAA by the editors of IG I³ is constantly in evidence; among the notable, see, e.g., IG I³:826 and DAA, 21; in the latter entry, Raubitschek had suggested that the "Kritios Boy" was fixed atop the marble column of the dedicant/victor Kallias … Didymou; IG I³:826 reports this but refers the reader to Ridgeway's rejections; see also Hurwit 1989, 52–53 n. 34. Other critics of DAA for its arguments of attached dedications include Keesling 2003 (n. 24 below); also Kissas 2000, 219.171 with n. 446 (p. 299) on Kiron's dedication, IG I³ 787, created by the sculptor Evenor; Raubitschek (DAA, 14) thought the cuttings were suitable for a kore statue (Acr. Mus. Inv. 497); Kissas thinks they are too small and would fit a bronze statuette.

[19] See n. 14 above. References to officinae in IG I³: before no. 620, Lewis comments that nos. 620–626 bis (C 1) and also nos. 632–645 (C 2), on account of the similarity of lettering, originated for the greater part in "officina vel officinis statuariorum." At C (2) before no. 632, he mentions an "officina statuariorum (ut Gorgiae)." Before D 627, he writes that the tituli under D (1): nos. 627–629 and D (2) "exarati sunt in officina vel officinis ubi haud solum opera Eumaris filiique eius Antenoris sed aliorum fortasse (Euthyclis, Thebadis, Herippi, Polliae) creata sunt."

[20] See n. 14 above.

[21] Tarditi 2016.

[22] See Papalexandrou 2018.

[23] There are few such additions; SEG 58.55 (Palaiokrassa 2008) and Βλασσοπούλου 2017 belong to the first category and one new inscribed vessel belongs to the second: a phiale found in the Parthenon's west-side entablature and presented by E. Karakitsou (in this volume). More additions belong to a third category: the association of bronze dedications (sometimes hypothesized, sometimes identified) with stone bases; see, e.g., SEG 50.79; SEG 38.21; SEG 32.20.

[24] Kissas 2000; Keesling 2003; and Adornato 2019.

[25] For 1, see Keesling 2003, 84 with n. 104; for 2–4, Keesling 2003, 84 with n. 106.

[26] Keesling (2003, 84 with n. 106) further notes that "as many as ten of the inscribed stone statue bases from the Acropolis supported bronze statuettes with their left foot advanced and their feet far apart, which should probably be identified as Athenas in the Promachos pose."

[27] Especially important in the long discussion of the Perserschutt are Sioumpara 2019; Stewart 2008; Steskal 2004, Lindenlauf 1997; Hurwit 1989; Bundgaard 1974; Kavvadias and Kawerau 1906; Kavvadias 1888, 1886.

[28] Studniczka 1887.

[29] E.g., Stewart (2008, 388; also cat. no. 16, fig. 14) argues for a date in mid-to-late 470s on the basis of findspot (not Perserschutt), late archaic drapery, sculptural comparanda (the Athena head from the east pediment of the temple of Aphaia at Aigina and the Tyrannicides of Kritios and Nesiotes); Adornato (2019) follows Stewart; others have dated it somewhat later (e.g., Niemeyer 1964); see Stewart 2008, cat. 16.

[30] Photos of these objects were not included in our earlier publication; Makres and Scafuro 2019, 63–77.

[31] For a comprehensive study on aparchai and dekatai, see Jim 2014.

[32] As far as metics are concerned, we think that the Cleisthenic reforms are an important landmark since, as we know from the literary evidence (Arist. Politics 1275b), many aliens were incorporated into the ten Cleisthenic tribes and thus became Athenian citizens. In other words, individuals who made dedications as metics before 508 B.C.E., became citizens after this date and this may have affected their dedicatory habit.

[33] For female dedicants on the Acropolis, see Χωρέμη 2019; Avramidou 2015.

[34] See n. 17 above.

[35] In our 2019 article, we discussed whether conclusions on the social status of the woman can be drawn from the name Glyke.

[36] On the professional status of female music players, see Lewis 2002, 95–96.

[37] See commentary and photograph in Zafeiropoulou 2008.

[38] Lazzarini 1976.

Works Cited

DAA Raubitschek, A., and L. Jeffery. *Dedications of the Athenian Akropolis: A Catalogue of the Inscriptions of the Sixth and Fifth Centuries B.C.* Cambridge: Archaeological Institute of America, 1949.

IG I Kirchoff, A. *Inscriptiones Atticae Anno Euclidis vestutiores.* Consilio et Auctoritate Academiae Litterarum Regiae Borussicae 1. Berlin: George Reimer, 1873.

IG I Suppl. (also abbreviated "I s")
 Kirchoff, A. *Supplementa Consilio et Auctoritate Academiae Litterarum Regiae Borussicae.* Berlin: George Reimer, 1877, 1886, 1889.

IG I² De Gaertringen, F. H. *Inscriptiones Atticae Euclidis Anno Anteriores.* Consilio et Auctoritate Academiae Academiae Litterarum Borussicae, 1 editio minor. Berlin: Walter de Gruyter, 1924.

IG I³ Lewis, D., and L. Jeffery. *Inscriptiones Atticae Euclidis Anno Anteriores.* 3rd ed. Consilio et Auctoritate Academiae Scientiarum Berolinensis et Bradenburgensis editae, fasc. 2. Berlin: Walter de Gruyter, 1994.

LSAG Jeffery, L. H. *The Local Scripts of Archaic Greece: A Study of the Origin of the Greek Alphabet and Its Development from the Eighth to the Fifth Centuries B.C.* Rev. ed. Oxford: Clarendon Press, 1990.

L-W Lolling, H. G., and P. Wolters. Κατάλογος του εν Αθήναις Επιγραφικού Μουσείου, Επιγραφαί εκ της Ακροπόλεως. Τεύχος ι. Αρχαϊκαί αναθηματικαί επιγραφαί. Athens: τυπ. Αφοί Περρή, 1899.

Adornato, G. 2019. "The Invention of the Classical Style in Sculpture." In *Volume 1 Handbook of Greek Sculpture*, edited by O. Palagia, 296–327. Berlin and Boston: Walter de Gruyter. https://doi.org/10.1515/9781614513537-011.

Avramidou, A. 2015. "Women Dedicators on the Athenian Acropolis and Their Role in Family Festivals: The Evidence for Maternal Votives between 530–450 BCE." *Cahiers "Mondes anciens"* 6:1–27. https://doi.org/10.4000/mondesanciens.1365.

Bather, A. G. 1892–1893. "The Bronze Fragments of the Acropolis." *JHS* 13:124–30, pls. 6, 7. https://doi.org/10.2307/623898.

Βλασσοπούλου, Χ. 2017. "Χάλκινη ενεπίγραφη κύλιξ από την Ακρόπολη." *GRAMMATEION* 6:33–41.

Bundgaard, J.A. 1974. *The Excavation of the Athenian Acropolis 1882–1890.* 2 vols. Copenhagen: University of Copenhagen, Institute of Classical and Near Eastern Archaeology.

Hurwit, J. M. 1989. "The Kritios Boy: Discovery, Reconstruction, and Date." *AJA* 93.1:41–80. https://doi.org/10.2307/505398.

Jim, T. 2014. *Sharing with the Gods: Aparchai and Dekatai in Ancient*

Greece. Oxford Classical Monographs. Oxford: Oxford University Press.

Kavvadias, P. 1886. "Ἀνασκαφαὶ ἐν τῇ Ἀκροπόλει." *ArchEph* 1886:73–132.

———. 1888. "Ἀνασκαφαὶ ἐν τῇ Ἀκροπόλει." *ArchDelt* 1888:10–13, 30–32, 54–55, 81–83, 101–5, 180–81, 201–4.

Kavvadias, P. and Kawerau G. 1906. *Die Ausgrabung der Akropolis vom Jahre 1885 bis zum Jahre 1890/Ἡ Ἀνασκαφὴ τῆς Ἀκροπόλεως ἀπὸ τοῦ 1885 μέχρι του 1890*. Athens: ΕΣΤΙΑ.

Keesling, C. M. 2003. *The Votive Statues of the Athenian Acropolis.* Cambridge: Cambridge University Press.

Kirchhoff, A. 1887a. "Jahresberichte." *SBBerl* 1:289–90.

———. 1887b. "Inschriften von der Akropolis zu Athens aus der Zeit nach dem Jahre des Archon Eukleides." *SBBerl* 2:1059–74, 1185–205.

Kissas, K. 2000. *Die attischen Statuen- und Stelenbasen archaischer Zeit.* Bonn: Dr. Rudolf Habelt.

Lazzarini, M. L. 1976. *Le formule delle dediche votive nella Grecia arcaica.* MemLinc 8/19. Rome: Accademia dei Lincei.

Lewis, D. M. 1987. "Lilian Hamilton Jeffery, 1915–1986." *ProcBritAc* 73:505–16.

Lewis, S. 2002. *The Athenian Women: An Iconographic Handbook.* London and New York: Routledge.

Lindenlauf, A. 1997. "Der Perserschutt der Athener Akropolis." In *Kult und Kultbauten auf der Akropolis: Internationales Symposion vom 7 bis 9 Juli 1995 in Berlin*, edited by W. Hoepfner, 46–115. Berlin: Archölogisches Seminar der Freien Universität Berlin.

Makres, A., and A. Scafuro. 2019. "The Archaic Inscribed Bronzes on the Acropolis of Athens: Some Remarks." In *From Hippias to Kallias: Greek Art in Athens and beyond 527–449 BC*, edited by O. Palagia and E. Sioumpara, 63–77. Athens: Acropolis Museum Editions.

Niemeyer, H.-G. 1964. "Attische Bronzestatuetten der spätarchaischen und frühklassischen Zeit." *AntP* 3:7–31.

Palaiokrassa, N. 2008. "Inscribed Lekanis-Shaped Vase." In *Worshiping Women: Ritual and Reality in Classical Athens*, edited by N. Kaltsas and A. Shapiro, 54. New York: Alexander S. Onassis Public Benefit Foundation.

Papalexandrou, N. 2018. Review of *Bronze Vessels from the Acropolis*, by C. Tarditi. *AJA* 122.4. https://doi.org/10.3764/ajaonline1224.papalexandrou.

de Ridder, A. 1896. *Catalogue des bronzes trouvés sur l' Acropole d' Athènes.* Paris: E. Thorin.

Ross, L. 1863. *Erinnerungen und Mittheilungen aus Griechenland.* Berlin: Verlag von Rudolph Gaertner.

Sioumpara, E. 2019. "Managing the Debris: Spoliation of Architec-

ture and Dedications on the Athenian Acropolis after the Persian Destruction." In *From Hippias to Kallias: Greek Art in Athens and beyond 527–449 BC*, edited by O. Palagia and E. Sioumpara, 31–51. Athens: Acropolis Museum Editions.

Steskal, M. 2004. *Der Zerstörungsbefund 480/79 der Athener Akropolis: Eine Fallstudie zum Chronologiergerüst*. Hamburg: Kovac.

Stewart, A. 2008. "The Persian and the Carthaginian Invasions of 480 B.C.E. and the Beginning of the Classical Style, 1. The Stratigraphy, Chronology and Significance of the Acropolis Deposits." *AJA* 112:377–412. https://doi.org/10.3764/aja.112.3.377.

Studniczka, F. 1887. "Ἀγαλμάτια Ἀθηνᾶς ἐκ τῆς τῶν Ἀθηνῶν Ἀκροπόλεως." *ArchEph* 1887:133–54.

Tarditi, C. 2016. *Bronze Vessels from the Acropolis: Style and Decoration in Athenian Production Between the Sixth and Fifth Centuries BC*. Thiasos Monografie 7. Rome: Edizioni Quasar.

Χωρέμη, Εἰ. Λ. 2019. "Οἱ γυναῖκες στὶς ἀναθηματικὲς ἐπιγραφὲς τῆς Ἀκροπόλεως τοῦ 4ου αἰ. π.Χ." In ΣΤΕΦΑΝΩΙ ΣΤΕΦΑΝΟΣ Μελέτες εἰς μνήμην Στεφάνου Ν. Κουμανούδη, edited by Ἄ. Π. Ματθαίου and Β. Ν. Μπαρδάνη, 131–56. Athens: Ἑλληνικὴ Ἐπιγραφικὴ Ἑταιρεία.

Zafeiropoulou, M. 2008. "Cymbal." In *Worshiping Women: Ritual and Reality in Classical Athens*, edited by N. Kaltsas and A. Shapiro, 53. New York: Alexander S. Onassis Public Benefit Foundation.

Hephaistus in Athens: Bronze Hydriai from the Acropolis and Beyond

Amy Sowder Koch

Abstract

Greek bronze hydriai were made in plentiful numbers and have survived in (relatively) great quantities—parts of over 600 have been identified to date. Decorative elements on their cast handles have allowed typological assessments and an understanding of chronological developments in shape, technique, style, and ornament. Inscriptions on at least 70 surviving vessels, together with ancient artistic representations, literary references, and epigraphic mentions have broadened our understanding of the functions of the shape, particularly in bronze. Documented provenances have facilitated discussions of use and exchange across a wide geographic area. Pinpointing bronze production centers has proven difficult, which has left questions of manufacture unresolved. While Athens's preeminent role in painted pottery production is well-attested, its position as a metalworking center is less clear. Stylistic recognition of Laconian and Corinthian products has been possible in some cases, but the lack of a comprehensive account of bronze hydria fragments from Athens has hindered our understanding of Athenian production. Drawing on Tarditi's 2016 publication, this chapter evaluates bronze hydria fragments from the Athenian Acropolis to identify local preferences in style, techniques, and iconographic motifs, as well as consider patterns of exchange.[1]

GREEK BRONZE WATER JARS WERE MADE IN PLENTIFUL numbers and have survived in great quantities. Complete examples and fragments of over 600 bronze hydriai and their curvier counterparts known as kalpides have been recovered, ranging in date from the early Archaic to the Hellenistic periods, although the primary phase of production seems to have been the sixth and fifth centuries B.C.E. At least 500 of the extant vessels were made during that time. While discussions of shape, typologies of added ornaments, iconography, style, and use have interested scholars for the last century and have

allowed for fruitful conclusions in those areas, questions of manufacture have been more elusive.

Obstacles in identifying specific production sites include their wide circulation as desirable and portable luxury objects along trade routes to both the east and west, far from their centers of origin, and a preference for use and reuse both in life and death, above the ground and in the grave, sometimes at great distances from where they began. With these difficulties in mind and no good solution for them, up to this point I have attempted to circumvent this tricky question of locating centers of manufacture by reframing inquiries in what seemed to be two more productive directions: first, tracking where they ended up (tracing circulation routes and changes in trading patterns over time even if the starting points remained unclear); and second, grouping objects based on affinities in decorative elements, stylistic preferences, and/or details of manufacture such as how and where the cast and hammered parts were affixed to one another. At least I could suggest which vessels may have been made together or with awareness of each other, even if I have not so far been able to pinpoint the locations of those workshops very precisely. For example, it seems fairly likely that even though they aren't identical, an Archaic hydria from Pydna and one from Paestum both of which feature a sculpted vertical handle in the zoomorphic shape of a lion, a feature that is not otherwise common but looks stylistically similar in both of these objects, should have been made around the same time, in or near the same place, despite their considerably distant final resting places.[2]

Both approaches were informative but left open the nagging and important question of where specifically the vessels were produced. Other scholars have dealt more directly with identifying centers of manufacture, particularly for the earlier, more decorative bronze hydriai from the sixth and early fifth centuries. Claude Rolley considered the origins of Magna Grecian finds in 1965; Marlene Herfort-Koch argued for an identifiable Laconian style in 1986; and Werner Gauer's discussion of Archaic bronze vessels from Olympia in 1991 was seminal in offering a large body of evidence for hydriai clearly from numerous production centers all made around the same time.[3] In a series of essays exploring Archaic bronze hydriai in the 1990s and early 2000s, Conrad Stibbe convincingly identified stylistic characteristics of Laconian and Corinthian bronzes of this shape.[4]

Doing the same for vessels from Athens, however, has not until very recently been possible. In contrast to the wealth of evidence in other arts from Athens during the Archaic and early Classical periods, the material record of bronze vessels is severely deficient. Not a single complete bronze hydria has been excavated from the Athenian Acropolis, but several dislocated handles and other parts were recovered from the Persian debris, demonstrating their presence in this sacred place. These fragments offer an extremely limited view of Athenian productions; anything worth salvaging was likely removed, recycled, and/or used elsewhere before the remains were deposited alongside other objects in the Persian debris pits. In addition to the extremely fragmentary state of the evidence, the small finds, including bronzes, were not cataloged or studied until decades after their excavation, leaving precise (and valuable) findspots almost entirely unrecorded. In 1896, Andre de Ridder inventoried the most artistically accomplished examples, leaving the other fragments uncatalogued, unpublished, and languishing in storage.[5]

By receiving permission to study previously published fragments and also to access many of the still-unpublished pieces in the storerooms of the National Archaeological Museum in Athens for the first time in over a century, Tarditi's 2016 publication has changed the landscape significantly for Athenian bronze vessel studies, now allowing for renewed and meaningful assessments of locally produced products and styles.[6] With a newly expanded corpus available for study, we are able to evaluate for the first time Athens's role in the ancient bronze vessel industry relative to other known centers and to understand some characteristic features of Athenian technique and style in the production of bronze hydriai, enabling the identification of bronzes made in Athens found both on the Acropolis and farther afield.

Over the last decade, I have catalogued upward of 600 surviving bronze hydriai, kalpides, and/or fragments thereof made between the Archaic and Hellenistic periods.[7] Prior to Tarditi's 2016 volume, parts of approximately 45 hydriai held in Athenian collections were known, most not recorded as having been excavated specifically from the Acropolis. Elsewhere, one handle now in Vienna was recorded as coming from Athens (but not specifically the Acropolis) and one in Mariemont (Belgium) was said to have come from the Acropolis excavations.[8] Of the 31 hydria fragments invento-

ried from the National Museum in Athens, only 11 were re-
covered from the Acropolis itself, in addition to 1 now in the
Agora Museum and the 1 in Mariemont.[9] So until 2016, our
sum total of bronze hydriai documented to have come from
the Athenian Acropolis numbered approximately 13 of the
surviving 600 vessels of this shape and material. Neither the
small number nor the fragmentary condition made for fruit-
ful study or contextual assessments of these objects.

With unprecedented access to the published finds and the
storerooms, Tarditi was able to catalogue a total of 54 frag-
ments of hydriai and kalpides unearthed during the 19th-
century excavations on the Acropolis, more than quadrupling
the number known from the site previously.[10] Although this
quantity is still relatively limited, such a discovery allows us
to reevaluate Athens's place in the production of Greek met-
alwork, to recognize characteristics of Athenian style, and to
compare with similar products known to have come from
other bronze centers.

The scarcity of the material record for bronze vessels in
Athens is surprising, especially given our wealth of evidence
in other media from the Archaic and Classical periods. Me-
tallic hydriai almost certainly were used on the Athenian
Acropolis. The (apparently heavy) water jars carried by the
four strong, male watercarriers on the north side of the Par-
thenon frieze commonly are understood as referring to me-
tallic objects, providing at least one key artistic reference to
the shape on this important site, reminding us of the signifi-
cant role water played in cult activities, including sacrifices
and processions.[11]

No golden hydriai survive (in Athens or anywhere in the
Greek world, to my knowledge) but at least 8 were recorded
in the Hekatompedon inventories from the fourth century
B.C.E., along with at least 60 silver ones, about half of which
were dedicated to Athena Polias and the others to various
male and female deities on the Acropolis.[12] Bronzes are not
mentioned in the inventory lists, perhaps because, as Tarditi
suggests, they were considered functional objects more than
treasure.[13] At least one fragmentary inscribed bronze hydria
lip survives from the Acropolis, recording an extraordinary
offering to Zeus Herkeios on behalf of a mother and her sons,
testifying to the presence of bronze water jars as votive gifts
even if the inscribed records do not record them as such.[14]

Fig. 1. Athens NM 7140; photograph by author. The rights on the depicted monuments herein belong to the Hellenic Ministry of Culture and Sports (Law 4858/2021). The monument belongs to the responsibility of the National Archaeological Museum. Hellenic Ministry of Culture and Sports/Hellenic Organization of Cultural Resources Development.

Fig. 2. Athens NM 6584; photograph by author. © Hellenic Ministry of Culture and Sports/Ephorate of the City of Athens, Acropolis Restoration Service.

Prior to Tarditi's 2016 publication of the Acropolis bronzes, the catalogue of bronze hydria parts from the Acropolis was extremely limited in scope. Over a century ago in the initial publications of the Acropolis bronze finds, de Ridder catalogued just two lateral handles once appended to Archaic hydriai, one (Athens 7140; fig. 1) with an articulated swan's head and beak facing inward, which is a common decorative type for early Archaic hydria handles and the other (Athens 6584; fig. 2) an extraordinary find with two kouroi bent backward over the strap of the handle, their heads meeting at the center.[15] Along with these he mentions four vertical handle fragments, all ornamented with figural, animal, and/or floral appendages. First, Athens 6588, 6650, which is an anthropomorphic example with a youth between pairs of lions and

rams that can be associated with a group of at least 25 other known examples found elsewhere (fig. 3).[16] Second, Athens 6781 (fig. 4), a small piece of the lower end of a handle showing two human feet in between a pair of hooves (on the model of the well-known "show handle" type known from spectacular finds in Switzerland and central Italy).[17] Athens 7135 (fig. 5) preserves the upper part of a handle with a sculpted lion's head facing over the mouth of the vessel, which is part of a decorative type that many scholars have suggested originated in Athens, but this is the only such example excavated specifically from the site.[18] Finally, Athens 7111 (fig. 6) contains only a flat, engraved palmette from the lower terminus of a handle that once was appended to the hammered body in the center of the now-empty volutes.[19] He also included one miniature bronze hydria, which might be understood as a votive gift, given its diminutive size.[20] To this list of previously known hydria parts from the Acropolis prior to 2016, we can add the one in Mariemont, similar in its decorative elements to several others from the mid-sixth century B.C.E. with lions at the upper terminus and rams at the lower, above a palmette, but unique in its positioning of the lions facing inward and attacking a ram.[21]

With Tarditi's new evidence, we can now catalogue in total 14 horizontal handles from Archaic bronze hydriai, and 9 vertical ones from the same period (based on the angular shape of the vessels' shoulders common to that period), along with 1 cast foot with a ribbed pattern in low relief.[22] Even more surprisingly, she also identifies 21 horizontal handles from the rounder kalpis shape begun in the late Archaic period that continues into the fifth century and beyond, and 9 vertical handles of the kalpis's short, bent type; none of these had been catalogued previously.[23] These new kalpis fragments, in particular, represent a tremendous advance in understanding Athens's position as a center of manufacture for bronze water jars, both in terms of quantity and chronology. The greatly increased quantity of both hydria and kalpis handles alone is important and the introduction of the kalpis handles suggests the continued use of bronze water jars on the Acropolis after the Persian invasion but before the final burial of the debris.[24]

Beyond the quantities, Tarditi's stylistic analyses also are significant because they rely on, for the first time, evidence specifically and exclusively from Athens, and the Acropolis more specifically. Her work challenges previously proposed

Fig. 3 (opposite). Athens NM 6588, NM 6650; photograph by author. © Hellenic Ministry of Culture and Sports/Ephorate of the City of Athens, Acropolis Restoration Service.

73

*Fig. 4. Athens NM 6781;
photograph by author. © Hellenic Ministry of Culture and
Sports/Ephorate of the City of
Athens, Acropolis Restoration
Service.*

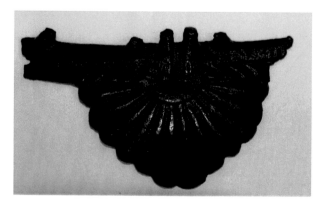

*Fig. 5. Athens NM 7135;
photograph by author. © Hellenic Ministry of Culture and
Sports/Ephorate of the City of
Athens, Acropolis Restoration
Service.*

*Fig. 6. Athens NM 7111;
photograph by author. © Hellenic Ministry of Culture and
Sports/Ephorate of the City of
Athens, Acropolis Restoration
Service.*

*Fig. 7. Athens NM 7158;
Tarditi 2016, 185; photograph
courtesy C. Tarditi. © Hel-
lenic Ministry of Culture and
Sports/Ephorate of the City of
Athens, Acropolis Restoration
Service.*

Athenian characteristics and allows for new comparisons with known finds from across the Greek world.

Tarditi's list adds 12 horizontal bronze hydria handles to the 2 de Ridder had identified. In terms of stylistic and datable features, the newly identified parts of lateral handles all fit into established typologies from other vessels of the same types, including terminals sculpted in the forms of open-palmed hands (e.g., Athens 7158; fig. 7) swan's heads (e.g., Athens 19875; fig. 8) and palmettes (e.g., Athens 19870, 19871, 19876, 19869, 19874, 19872, 19873, 2174, 7149, and 7150); the objects introduce no new decorative elements that are not known from previously catalogued finds. The earliest of the new handles can be dated to the first half of the sixth century B.C.E. based on their flattened/rectangular handle section profiles (e.g., Athens 7158; fig. 7; 19870, 19876, 19871, 7140, and 19875). The swan's head handles with half round-spools on either side of Athens 7140 (previously known to de Ridder) and 19875 (newly identified by Tarditi; figs. 2 and 9) belong to a very common Archaic type (of which at least 10 other vessels with similar decoration on the horizontal handles are known and at least 6 with the same ornament on the vertical handle).[25] With the different treatments of the heads and varying depths and roundness of the swan's elements, these two lateral handles are unlikely to belong to the same vessel, so we have evidence for at least

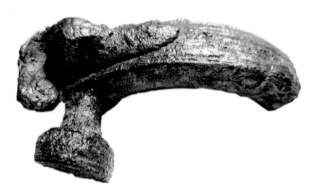

*Fig. 8. Athens NM 19875;
Tarditi 2016, 185; photograph
courtesy C. Tarditi. © Hel-
lenic Ministry of Culture and
Sports/Ephorate of the City of
Athens, Acropolis Restoration
Service.*

*Fig. 9. Athens NM 19869;
Tarditi 2016, 186; photograph
courtesy C. Tarditi. © Hel-
lenic Ministry of Culture and
Sports/Ephorate of the City of
Athens, Acropolis Restoration
Service.*

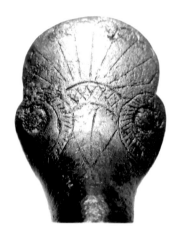

2 hydriai of this decorative type from the Archaic Acropolis,
all made by different hands. Based on comparable finds ex-
cavated elsewhere (including Athens 6406, from Olympia),
Stibbe has effectively suggested that this swan's head handle-
type originated in Laconia, and consequently its deposition
on the Acropolis offers evidence for the circulation and use
of Laconian products in Athens in the early Archaic period.[26]

While the earliest lateral handles belonging to bronze hy-
driai from the Acropolis may have been imports, many of
the later ones, particularly those with shorter, rounder, more
steeply curved handle straps may represent local Athenian
productions from the later sixth century B.C.E. This is sug-
gested by the stylistic comparison of the shape and decoration
of the palmette design at the termini of their handles with
other bronze vessel shapes also discovered in the Acropolis
excavations. Rather than long, extended handle ends like the
swan's heads flanked by half-spools, above, this later type fea-
tures rounded, flattened disks at the ends, either left undeco-
rated entirely, given simple fluting patterns, or decorated with
simple palmettes, such as Athens 19869 (fig. 9) and 19874.[27]
Numerous rounded leaves on the palmette, usually but not
always engraved, and a central (sometimes extended) leaf may
allow us to propose Athens as a point of origin for this later,
simpler approach to handle ornamentation.[28] As we will see,
the round, flattened disks at the ends of the handles most of-
ten correspond to the curvier kalpis form of the Greek water
jar, rather than the earlier shoulder hydria profile; these be-
come the most favored form of the shape by the last quarter
of the sixth century B.C.E. and are well represented in bronze

hydria handles from the Acropolis, possibly indicating Athens as a point of origin for the type. Multiple workshops and/ or craftsmen might account for the variations in the shapes of the disks and engraved leaves among the palmette disks. These certainly warrant further study beyond this cursory examination of the Acropolis finds as a whole in this essay.

To the five known fragments of Archaic vertical bronze hydria handles described above Tarditi adds 4 more (none quite as elaborately sculpted as the ones catalogued by de Ridder, not surprisingly).[29] Like their horizontal counterparts, the earliest vertical handles suggest nonlocal production based on their shape and ornamental types. Tarditi, following Stibbe, suggests that Athens 6588, 6650 (fig. 3) may be attributed to a Laconian workshop from the second half of the sixth century.[30] Athens 6781 (fig. 4), of the so-called show handle type is the first example of this kind found in mainland Greece; parts of at least 20 others of this very distinctive type are known, mostly found in central and north Italy.[31] This Athenian find could suggest, as Tarditi proposes, a Greek origin of the series, or alternatively, direct evidence of communication and/ or trade between Greece and the Italic peninsula in the first quarter of the sixth century B.C.E. Also from the early Archaic period, Athens 7111 (fig. 6) is comparable in the style of its engraved palmette to others that Stibbe assigns to Laconian production in the late seventh or early sixth century B.C.E. (although I do wonder if we might revisit that Laconian identification in this case now that we have tentatively identified the engraved palmette on slightly later handles as a potential marker of a local Athenian preference).[32]

While these early hydriai enrich our understanding of bronze hydriai and Athens's relationships to other production centers and add to the record of previously known finds, it may be the late Archaic and early Classical hydriai found on the Acropolis that truly alter our view of Athenian bronzeworking styles. Athens 19883 (fig. 10), for instance, is among our earliest evidence found anywhere for the transition from the angular hydria to the rounded kalpis shape, based on the steeper curve of its handle strap. Tarditi identifies 9 further examples of this shorter, steeper, more rounded type of vertical handle belonging to late Archaic/early Classical bronze kalpides from the Acropolis (Athens 19884, 24961, 24962, 24963, 24964, 24965, 24966, 24967, 24968), as well as 21 curved lateral handles with round section profiles and simple

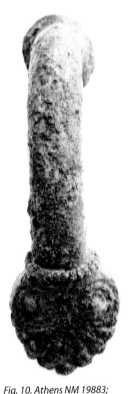

Fig. 10. Athens NM 19883; Tarditi 2016, 189; photograph courtesy C. Tarditi. © Hellenic Ministry of Culture and Sports/Ephorate of the City of Athens, Acropolis Restoration Service.

Fig. 11. Athens NM 24976;
Tarditi 2016, 192; photograph
courtesy C. Tarditi. © Hel-
lenic Ministry of Culture and
Sports/Ephorate of the City of
Athens, Acropolis Restoration
Service.

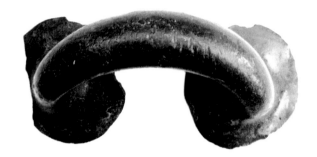

flattened disks at the ends from kalpides of the same period (Athens 7136, 19879, 19880, 19881, 24969, 24970, 24971, 24972, 24973, 24974, 24975, 24976 [fig. 11], 24977 24978, 24979, 24980, 24981, 24982, 24983, 24984, 24986).[33] These new finds are extremely important in understanding the development of the shape as a whole; the rounded kalpis becomes characteristic of bronze hydria production after about 525 B.C.E., all but replacing the earlier shoulder hydria profile in the Classical period. Nearly 200 bronze kalpides are known, made between the late sixth and fourth centuries B.C.E.[34]

In the case of Athens 19883 and some of the newly iden-tified handles, the volutes of the lower palmette ornament disguise the heads of the two rivets that mechanically joined the handle to the vessel wall, but in the slightly later kalpides that follow, the palmettes become flatter and eventually are replaced by round, flat disks that are soldered to the body. If Athens led the way in shifting the shape, then Athenian craftsmen may also have pioneered the technological change and its accompanying decorative choices as well, with flat-tened disks ornamented with palmettes sculpted in low relief and individual petals indicated through incision. In fact, Tar-diti suggests that many of these more rounded, less sculptur-ally decorative kalpis handles, as a group, may be attributed to Athenian origins and that the kalpis shape was a key part of Athenian bronze hydria production in the late Archaic and early Classical periods.[35] If so, Athens's role as a center of production for bronze hydriai (and presumably other ves-sel shapes) is much more central to not only the manufacture but the development of the shape and ornament of the shape than has been previously understood.[36]

In this short chapter, what we have been able to (re)estab-lish is the presence of Athens in the local and distant ancient

bronze vessel industry. The Athenian Acropolis was a desti-
nation for the use and/or display of bronze hydriai of both lo-
cal and nonlocal origins in the early Archaic period. In terms
of decoration and style, Athenian shoulder hydriai tended to
include palmettes at the ends of the handles, often engraved
with many rounded leaves. Distinguishing that treatment
helps us to potentially identify at least some vessels made in
Athens that eventually made their way elsewhere. Some as-
sumptions that have been accepted about bronze hydria pro-
duction in Athens have not been borne out by the evidence
now available. For example, scholars have presumed that the
lion's head type was an Athenian hallmark but if that is the
case it is surprising that only one handle bearing such deco-
ration was found here.[37] This may perhaps be a problem of
survival, but certainly a presumption that can now be ques-
tioned. Finally, judging from the available evidence, Athens
may have been a key center in the production of late Archaic
and early Classical kalpides, which came to dominate the
market later in the fifth century. The greatly expanded evi-
dence from Athens afforded by Tarditi's new work may now
allow us to reevaluate the entire corpus of surviving Archaic
and early Classical bronze hydriai and rethink the security of
our identifications from other production centers. We have
not solved the problems fully, but we at least have put Ath-
ens (back) on our map and (partially) restored the glories
of Athena and her dedicated metalworkers to the Athenian
landscape, both artistically and economically.[38] The new finds
from Athens offer a unique chance to restore Hephaistos's
work to the Acropolis.

Notes

[1] Tarditi 2016.
[2] Thessalonike, Archaeological Museum Py 601, from
Makrygialos, ancient Pydna (Grave 109); Sowder 2009, cat. 10.1
(with full bibliography); Rolley 2004, 125–27, figs. 80, 82; 135–37,
fig. 93; 140, fig. 99; Stibbe 2004b, 5.37, fig. 44; 2000, 102–11, figs.
63–66; Vokotopoulou 1997, 117–19, 246–47, pls. 105–108; Rol-
ley 1995, 245–46. Paestum, Archaeological Museum 49801, from
Paestum (subterranean shrine): Sowder 2009, cat. 10.2 (with full
bibliography); Rolley 2004, 123–43, figs. 79, 81, 86; 143, fig. 105;
274–76, table 6; Stibbe 2004b, cat. 5.38; fig. 45; 1997, cat. 25, fig. 2;
1992, 30, 56, cat. G 11 fig. 39; Gauer 1991, 108; Rolley 1982, 19, no.
5, figs. 5, 14, 59–61, 65, 67, 70, 154; Hill 1967, 40, cat. I.B.1; Diehl
1964, 22, cat. B 73; Sestieri 1956, 29, figs. 11–12; 1955, 53–54, figs.
1, 11, 13.

[3] Gauer 1991; Herfort-Koch 1986; Rolley 1965.

[4] Stibbe 2004b, 1997, 1992.

[5] Tarditi 2016; de Ridder 1896.

[6] Tarditi 2016.

[7] Sowder 2009.

[8] Vienna, Kunsthistorisches Museum VI 2271: Sowder 2009, cat. 20.5 (with full bibliography); Diehl 1964, 34, 37, 39, cat. B 169. Mariemont, Musée B 201 (ex-Warrocqué collection): Tarditi 2016, 272, fig. 57; Sowder 2009, cat. 4.31; Stibbe 2004a, 28, 34, cat. 7.56; 1997, cat. 50, fig. 2; 1994a, 98–99, fig. 19; 1992, 16, 55, cat. E 3; Lévèque 1967, 49, no. 14; Diehl 1964, 17, cat. B 46; Lerat 1952, G.88; Politis 1936, 159, type III, no. 3.

[9] Agora Museum acc. no. 21: Sowder 2009, cat. 9.10 (with full bibliography); Stibbe 2000, 50–51, cat. 20; Diehl 1964, 20, 22, cat. B 71.

[10] Tarditi 2016, 184–94, 265–77.

[11] See, e.g., Neils 2001, 146–50 (with further bibliography).

[12] Harris 1995, 158 (V.244–249), 162 (V.261).

[13] Barr-Sharrar 2019, 88–89; Tarditi 2016, 15.

[14] Athens, NM 7294: Tarditi 2016, 184, 266; Avramidou 2015, 9-9 (fig. 1), 19; Sowder 2009, cat. 19.40; Kaltsas and Shapiro 2008, 53.

[15] Athens, NM 7140: Tarditi 2016, 187, 270; Sowder 2009, cat. 2.11; Stibbe 2004a, 25–26, 34, cat. 6.47, fig. 51; 2003, 93, no. 4, fig. 59; Herfort-Koch 1986, K0; Diehl 1964, 10–11, cat. B 22; de Ridder 1896, 56, no. 166, fig. 30. Athens, NM 6584: Tarditi 2016, 187–88, 271; Sowder 2009, cat. 9.15; Stibbe 2000, p. 110 n.46; de Ridder 1896, 56–57, cat. 168, fig. 32.

[16] Athens, NM 6588, 6650: Tarditi 2016, 189, 274; Sowder 2009, cat. 9.3; Stibbe 2008, 39 no. 5; Kaltsas 2006, 176, cat. 79; Stibbe 2000, 46, cat. 16; 1992, 36, 58, H 7; Herfort-Koch 1986, K 99, pl. 14.2; Diehl 1964, 20–22, cat. B 61; Hill 1958, 193, cat. 4, 198; Young 1937, 124, pl. 5; de Ridder 1896, no. 468, no. 705, fig. 222. Cf., e.g., Berlin 8467: Stibbe 1992, fig. 44. Boston, MFAA 85.515: https://collections.mfa.org/objects/153050/handle-of-a-water-jar-hydria-or-pitcher?ctx=e5b8da90-7b94-4fb5-bf13-d287a4a0f64a&idx=1 (with bibliography); Boston 99.460: Stibbe 1992, fig. 47. Oxford 1890.221: Stibbe 1992, fig. 45. Paris, Louvre Br 2785: Hill 1958, 194, cat. 12, pl. 50.3.

[17] Athens, NM 6781: Tarditi 2016, 189, 273–74; Sowder 2009, cat. 12.3; Stibbe 2008, 39; 2004b, 5.33; 1997, cat. 6; 1995, 71–72, pl. 17.3; 1992, 56, cat. G 4; Gauer 1991, 102; Jucker 1972, 55–56, pl. 14.7; Diehl 1964, 20, 22, cat. B 64; Hill 1958, 193–94, cat. 7; Neugebauer 1923, 402–3; de Ridder 1896, 58, fig. 33.

[18] Athens, NM 7135: Tarditi 2016, 188–98, 273; Sowder 2009, cat. 15.3; Diehl 1964, 25, cat. B 95; de Ridder 1896, 55, no. 165, fig. 29;. At least 30 vessels preserve handles (or fragments of handles) of this type; see Sowder 2009, Group 15 for further discussion and bibliography; as well as Tarditi 2016, 188, 273.

[19] Athens, NM 7111: Tarditi 2016, 188, 272; Sowder 2009, cat. 19.22; de Ridder 1896, 58, cat. 174, fig. 34. Munich Br 183 is very similar, e.g., among others. See Tarditi 2016, 188, 272; Sowder 2009, cat. 19.22; de Ridder 1896, 58, cat. 174, fig. 34.

[20] Athens, Acropolis Museum 7039: Sowder 2009, cat. 19.1; Diehl 1964, 28, 30, cat. B 105a; de Ridder 1896, cat. 162, fig. 26.

[21] Mariemont, Musée B 201 (ex-Warrocqué collection): Tarditi 2016, 272, fig. 57; Sowder 2009, cat. 4.31; Stibbe 2004a, 28, 34, cat. 7.56; 1997, cat. 50, fig. 2; 1994a, 98–99, fig. 19; 1992, 16, 55, cat. E 3; Lévêque 1967, 49, no. 14; Diehl 1964, 17, cat. B 46; Politis 1936, 159, type III, no. 3.

[22] Horizontal handles: Athens NM 7158, 19870, 19876, 1987, 19869, 19874, 19872, 19873, 21474, 7149, 7150, 19875. Vertical handles: Athens NM 19877, 19833, 19882 and Mariemont B201. Foot: Athens NM 21769. See Tarditi 2016, 185–190 (with bibliography), 266–74.

[23] Horizontal handles: Athens NM 19880, 24972, 24973, 24974, 24975, 24979, 24980, 24986, 7136, 19879, 19881, 24976, 24978, 24981, 24982, 24977, 24984, 24983, 24969, 24970, 24971. Vertical handles: Athens NM 19884, 24961, 24962, 24963, 24964, 24965, 24966, 24967, 24968. For all, see Tarditi 2016, 190–94, 247–77.

[24] Tarditi 2017, 205.

[25] Tarditi 2016, 270–71, following Sowder 2009, Group 2; and Stibbe 1992.

[26] Stibbe 2000, 155; 1997, 40–41; 1992. Tarditi follows Stibbe's Laconian identifications; Tarditi 2016, 185–87 and 266, See also Stibbe 2004a, 24, 34.

[27] Tarditi 2016, 267.

[28] Tarditi 2016, 267. Comparable examples include Munich Br 183, Paris Br 2646, Baltimore 54.776, and one fragmentary handle in Delphi.

[29] Athens NM 19877, 19883, and19882. See Tarditi 2016, 188–89, 275–76.

[30] Tarditi 2016, 273–74.

[31] On these highly ornamental show handles and their relationship to Italic traditions, see Tarditi 2016, 273–74; Sowder 2009, Group 12; Stibbe 2000, 114–15; 1992, esp. 26–27; Jucker 1976, 1966.

[32] Tarditi 2016, 274–76.

[33] Tarditi 2016, 109–94, 276. She further distinguishes between these 21 lateral handles, proposing two distinct groups from the Acropolis finds based on the slight bend in the handle and expanded disks on some (e.g., Athens NM 24980 and similar), a type so far only known from the Acropolis finds, and those with a more regular, wider disk at the terminals and a more regular arc across the strap of the handle, (e.g., Athens NM 42976 and similar) which find parallels elsewhere and may indicate that Athens was but one of multiple production centers for these vessels.

[34] It should be noted that the profile and decoration both change distinctively after the mid-fifth century to a slimmer, more elongated shape with sculpted, often figural, plaques at the lower ends of the vertical handles, a type that is not represented here in the excavations of the Acropolis found with the Persian debris. The kalpides from the Acropolis represent the late Archaic and early Classical kalpis type with a round, full profile and short, curved handles once appended to the neck and shoulder of the vessels. At least 180 examples of the these are known from across the Greek world, over 100 of which have winged sirens sculpted at the ends of the vertical handles (not represented among the Acropolis finds so far) and the remaining of which appear to be simply treated with the flattened, disk-shaped terminals such as are seen here. In both the siren and plain kalpides, the horizontal handles are either left plain as flattened disks (primarily what we see here in Athens) or fairly simply treated with the disks given a convex form and fluted or palmette decorations; the Athenian vessels potentially could represent either type.

[35] Tarditi 2016, 276. These less ornamental kalpides from the late Archaic and Classical periods have been relatively less studied, since Stibbe and others have focused primarily on the more decorative handles from the earlier Archaic period.

[36] Tarditi 2016, 190–94, 275.

[37] Tarditi 2016, 270.

[38] Papalexandrou 2018.

Works Cited

Avramidou, A. 2015. "Women Dedicators on the Athenian Acropolis and Their Role in Family Festivals: The Evidence for Maternal Votives between 530–450 BCE." *Cahiers Mondes Anciens* 6: 1–29.

Barr-Sharrar, B. 2019. Review of *Bronze Vessels from the Acropolis*, by C. Tarditi. *Gnomon* 91:88–90.

Diehl, E. 1964. *Die Hydria: Formgeschichte und Verwendung im Kult des Altertums.* Mainz am Rhein: Philipp von Zabern.

Gauer, W. 1991. *Die Bronzegefässe aus Olympia I.* OlForsch 20. Berlin: Walter de Gruyter.

Harris, D. 1995. *The Treasures of the Parthenon and the Erechtheion.* Oxford Monographs on Classical Archaeology. Oxford: Oxford University Press.

Herfort-Koch, M. 1986. *Archaische Bronzeplastik Lakoniens.* Boreas Beiheft 4. Münster: Archäologisches Seminar der Universität.

Hill, D. K. 1958. "A Class of Bronze Handles of the Archaic and Classical Periods." *AJA* 62:193–201. https://doi.org/10.2307/502354.

———. 1967. "Palmette with Snakes: A Handle Ornament on Early Metalware." *AntK* 10:39–47.

Jucker, H. 1966. *Bronzehenkel und Bronzehydria in Pesaro.* Studia Oliveriana 13/14. Pesaro: Ente Olivieri.

Jucker, H. 1972. "Altes und Neues zur Grächwiler Hydria." *Zur Griechischen Kunst: Hansjörg Bloesch zum sechzigsten Geburtstag am 5. Juli 1972,* edited by H. P. Isler and G. Seiterle, 42–61. AntK Supplement 9. Bern: Francke.

———. 1976. "Figürlicher Horizontalgriff einer Bronzehydria in Pesaro." *AntK* 19:88–91.

Kaltsas, N., ed. 2006. *Athens-Sparta: Exhibition "Athens-Sparta" Held at the Onassis Cultural Center, New York, December 6, 2006–May 12, 2007.* New York: Alexander S. Onassis Public Benefit Foundation.

Kaltsas, N., and H. A. Shapiro, eds. 2008. *Worshipping Women: Ritual and Reality in Classical Athens.* New York: Alexander S. Onassis Public Benefit Foundation.

Lerat. L. 1952. *Les Locriens de l'Ouest.* Paris: Editions de Boccard.

Lévêque, P. 1967. *L'Art Grec du Musée de Mariemont, Belgique.* Bordeaux: Musée d'Aquitaine.

Neils, J. 2001. *The Parthenon Frieze.* Cambridge: Cambridge University Press.

Neugebauer, K. 1923. "Reifarchaische Bronzevasen mit Zungenmuster." *RM* 38: 341–440.

Papalexandrou, N. 2018. Review of *Bronze Vessels from the Acropolis,* by C. Tarditi. *AJA* 122.4. https://doi.org/10.3764/ajaonline1224.papalexandrou.

Politis, L. 1936. "A Bronze Hydria from Eretria." *ArchEph* 1936:147–74.

de Ridder, A. 1896. *Catalogue des Bronzes trouvés sur l'Acropole d'Athènes.* Paris: E. Thorin.

———. 1915. *Les Bronzes Antiques du Louvre II: Les Instruments.* Paris: Ernst Leroux.

Rolley, C. 1965. "Review of E. Diehl, Die Hydria: Formgeschichte und Verwendung im Kult des Altertums." *Revue des études grecques* 78: 602–609.

———. 1982. *Les vases de bronze de l'archaïsme recent en Grande-Grèce.* Naples: Centre Jean Berard.

———. 1995. "Production et circulation des vases de bronze, de la Grande Grèce à l'Europe hallstattienne." *Ocnus* 3:163–78.

———. 2004. *La Tombe Princière de Vix.* Paris: Picard.

Sestieri, P. C. 1955. "Il Sacello-Heroon Posidoniate." *BdA* 40:53–64.

———. 1956. "An Underground Shrine at Paestum." *Archaeology* 9:22–33.

Sowder, A. 2009. "Greek Bronze Hydriai." Ph.D. diss., Emory University.

Stibbe, C. M. 1992. "Archaic Bronze Hydriai." *BABesch* 67:1–62.

———. 1994a. "Between Babyka and Knakion: Three Addenda." *BABesch* 69:63–102.

———. 1994b. "Eine archaische Bronzekanne in Basel." *AntK* 37:108–20.

———. 1995. "Lakonische bronzene Hopliten, die erste Generation." *AntK* 38:68–80.

———. 1997. "Archaic Greek Bronze Palmettes." *BABesch* 72:37–64.

———. 2000. *The Sons of Hephaistos: Aspects of the Archaic Greek Bronze Industry*. Rome. Rome: "L'Erma" di Bretschneider.

———. 2003. *Trebenishte: The Fortunes of an Unusual Excavation*. Rome: "L'Erma" di Bretschneider.

———. 2004a. "Eine Bronzehydria mit Menschlichen Protomen." *BMusHongrois* 101:31–56.

———. 2004b. "The Goddess at the Handle: A Survey of Laconian Bronze Hydriae." *BABesch* 79: 9–47.

———. 2008. "Laconian Bronzes from the Sanctuary of Apollo Hyperteleatas near Phoiniki (Laconia) and the Acropolis of Athens." *BABesch* 2008:17–45.

Tarditi, C. 2016. *Bronze Vessels from the Acropolis: Style and Decoration in Athenian Production between the Sixth and Fifth Centuries BC*. Thiasos Monografie 7. Rome: Edizioni Quasar.

———. 2017. "Bronze Vessels from the Acropolis and the Definition of the Athenian Production in Archaic and Early Classical Periods." In *Artistry in Bronze: The Greeks and Their Legacy: XIXth International Congress on Ancient Bronzes*, edited by J. M. Daehner, K. Lapatin, and A. Spinelli. Los Angeles: J. Paul Getty Center. http://www.getty.edu/publications/artistryinbronze/vessels/24-tarditi/.

Vokotopoulou, I. 1997. *Ellenike techne: Argyra kai Chalkina Erga Technes*. Athens: Ekdotike.

Young, G. 1937. "Archaeology in Greece, 1936–37." *JHS* 57:119–46.

The Monumental Tripod-Cauldrons of the Acropolis of Athens between the Eighth and Seventh Centuries B.C.E.

Germano Sarcone

Abstract

This paper reexamines bronze tripod-cauldrons from the Athenian Acropolis between the eighth and seventh centuries B.C.E. This category is attested by several fragmentary sheets from legs and handles discovered by Panagiotis Kavvadias during the excavations of the site in the late 1800s. These fragments testify that large tripod-cauldrons were dedicated at the sanctuary of Athena Polias from ca. 750 B.C.E. They were made with various techniques and decorated with geometric or figured patterns. The detailed study of the evidence and comparisons with better-documented specimens from Delphi and Olympia enable new graphic reconstructions of tripod-cauldrons, a few among which attained monumental dimensions. The findspots of the fragments and the examination of the original topographical context of tripod-cauldrons provide insights on their original location as well as their importance in the shaping of the sacred landscape of the Acropolis during the Archaic period. The chapter concludes by addressing the political, symbolic, and religious significance of tripod-cauldrons.

The Archaeological Findspot and the History of Research

THE EXCAVATIONS ON THE ATHENIAN ACROPOLIS CARRIED out by Kavvadias between 1885 and 1890 C.E. brought to light several fragments of bronze sheets (fig. 1). A good number of these came from large, deep basins (i.e., from tripod-cauldrons) and from their supports, which were straight vertical legs. These objects were found in the deep deposits of soil and debris located on top of the Acropolis's bedrock and on the inner side of the fortification walls erected after the Persian sack of the Acropolis in 480/479 B.C.E. The exact point of their discovery is generally unknown except for

Fig. 1. The excavations of the Acropolis of Athens between 1885 and 1890. ©D-DAI-ATH-Akropolis 101.

a fine circular sheet with a gorgon (EAM X 13050), which was found in the filling ground near the southern wall of the Acropolis, between the enclosure of Artemis Brauronia and the Propylaea.[1] However, it is likely that these materials were destroyed during the Persian sack and buried during the works of reconstruction of the Acropolis between 478 and 450 B.C.E., when the new fortification was also built.[2]

The materials discussed here have been analyzed by several scholars in the last hundred years.[3] This does not mean that the research on the bronzes from the Athenian Acropolis has been exhausted, since a renewed analytical and systematic study of the pieces may still give new results. My interest in this class of bronzes stems precisely from my detailed reexamination of the bronze circular sheet of bronze with a gorgon (EAM X 13050), for which I have recently been able to propose a new reconstruction.[4] This enables me to undertake a new study of the large bronze tripod-cauldrons from the Acropolis between the eighth and seventh centuries.

Analysis and Reconstruction of the Artifacts

The surviving parts of the tripods from the Acropolis of Athens, currently displayed in the exhibition galleries of the Acropolis Museum and the National Archaeological Mu-

16812

16801

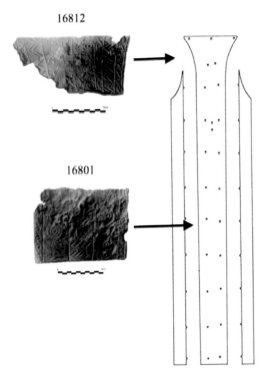

Fig. 2. Bronze legs of tripods
EAM 16812 and 16801.
National Archaeological
Museum of Athens; author's
reelaboration from Touloupa
1972.

seum or deposited in their storehouses, consist of about 70 fragments belonging to circular handles and legs. Among the numerous fragments we can distinguish some characteristics that allow some of them to fall into the category of monumental tripod-cauldrons.

First of all, the fragments of the legs, in particular EAM 16801 and 16812 (fig. 2), can be considered monumental in scale.[5] These supports, which are not particularly thick, made up the front part of the leg while at the back there were two other bronze supports positioned vertically to the front one to increase its stability.[6] There was no fixed correlation between the dimensions of the legs and the other parts of the tripod, that is, the cauldron and the handles, but it is very likely, based on the width of the legs preserved, that the ratio was 1 to 10 in height.[7] In some cases, therefore, such as the aforementioned examples of legs, it has been possible to reconstruct huge tripods, dating from the middle of the eighth century onward, which were more than two meters high.[8]

The decoration on the legs consisted essentially of a simple repeated engraved geometric ornament, applied to the front plate of the hammered legs. This type of decoration was the

87

Athens

13050: Ø 76,2 cm

16807: Ø 70 cm

16806a: Ø 60 cm

16808a: Ø 45 cm

Olympia

610: Ø 48 cm

7483: Ø 35 cm

607: Ø 31 cm

Fig. 3. Synoptic table of the bronze handles of tripods from the Athenian Acropolis and Olympia; drawing by the author.

product of a local workshop and compares with numerous examples from the sanctuary of Zeus at Olympia.[9] The same decoration can be seen on the flat sheet handles from the Acropolis of Athens (fig. 3). Like the legs, these are made of bronze hammered sheets: they are no more than three-to-five millimeters thick and could only be decorative in function. They had no practical use at all given that they could not have been used for lifting the cauldron.[10] The monumentality of these Athenian votive objects seems to be unmatched in other parts of the Greek world. Some examples of sheets from the Athenian Acropolis are well documented and they can be examined in detail. Their identification as handles of tripod-cauldrons is based on a number of technical aspects still visible on the lower part and the sides of the ring. The lower part, where the mounting plaque is located, consists of at least three layers of overlapping bronze foil, fastened together with a few rivets. The first two layers are the result of the two ends of the long narrow bronze sheet that overlap to form the circumference of the ring; the third layer is another laminal support used to fix the handle to the vessel.[11] This mounting system is common on the bronze tripod-cauldrons of the mid-eighth and seventh centuries found on the Athenian Acropolis and the sanctuary of Olympia.[12]

The Acropolis handle EAM 16806a (fig. 4), dating from the second half of the eighth century B.C.E., has an outside diameter of 60 cm.[13] It is an enormous ring given that its best-known *comparanda* from Olympia are in fact no more

than 50 cm in diameter.[14] Its mounting device is also similar to specimens found at Olympia, and consists of a mounting plaque and rivets that are also used to secure two thinner 1 mm plates. The first of these plates is slightly curved and applied to the outside, while the second plate is on the inside, allowing the handle to be riveted on the cauldron.

Fig. 4. Reconstructive drawing of the bronze handle EAM 16806a from the Acropolis of Athens. National Archaeological Museum of Athens; drawing by the author.

Another handle from the Acropolis, EAM 16807 (fig. 5), is even more massive and has an external diameter of 70 cm.[15] The ornament is identical to those found on tripod-cauldrons from Olympia and has been applied both at the front and back. For this specimen, the mounting system has not been preserved, and there is only one hole, which would have originally been covered by a rivet attaching a metallic strip or a human figure that would have connected the ring to this huge tripod basin. The same applies to the handle EAM 16808a (fig. 6), with an outside diameter of 45 cm, also of late geometric style (750–700 B.C.E.).[16]

From this analysis we can deduce that the round handles of monumental tripod-cauldrons had diameters ranging from 45 and 70 cm. But another object worthy of note from the Athenian Acropolis, which certainly represents the largest artifact of the specimens analyzed, is the bronze ring with a gorgon, NM X 13050.[17] It has an external diameter of about

89

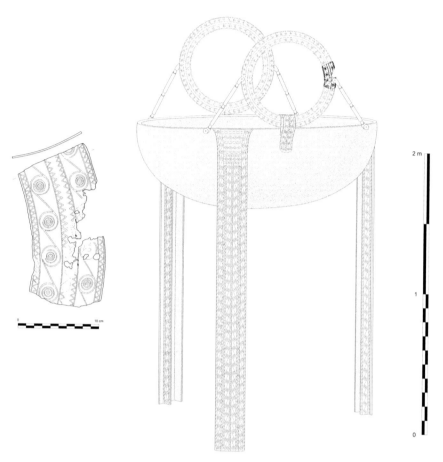

Fig. 5. Reconstructive drawing of the bronze handle EAM 16807 from the Acropolis of Athens. National Archaeological Museum of Athens; drawing by the author.

77 cm and is made of hammered thin foil articulated in three concentric bands at the front (fig. 7). It features a number of small holes slightly out of axis on top and in the middle of the sides. These holes were used for riveting two narrow bronze strips arranged in a cross pattern inside the ring. This technical device, only partially preserved, was used for attaching the central figural sheet, which represented a gorgon.

As with the other examples from the Acropolis of Athens and Olympia, the ring has a connecting point at the bottom, rendered by overlapping the two ends of the bronze ring and then joining them with rivets. On the back another sheet is folded at the bottom. The feet of the engraved winged gorgon in the appearance of Potnia are riveted on her body. They have no anatomical details and they are turned to the spectator's left, suggesting movement. She wears a long chiton covered

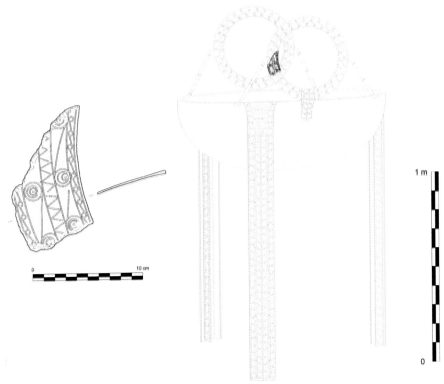

Fig. 6 (above). Reconstructive drawing of the bronze handle EAM 16808a from the Acropolis of Athens. National Archaeological Museum of Athens; drawing by the author.

Fig. 7 (below). Drawing front and back of the bronze handle with gorgon EAM X 13050 from the Acropolis of Athens. Acropolis Museum; drawing by the author.

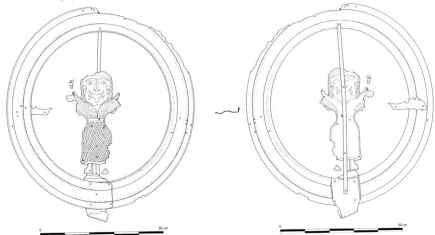

from the waist up by her wings, which emerge from the front of her torso. The gorgon would not have been the only figurative element on the ring: at skirt level and on the gorgon's head, in fact, there were other figures, today lost, that is, animals, in keeping with the iconographic type of the *potnia theron*.[18] Based on the style and iconography of the gorgon, the ring can be dated to the second quarter of the seventh century B.C.E.[19] This object was initially interpreted by Kavvadias as the emblem of the decorative cover of a large shield.[20] It has attracted a great deal of interest and has become the focus of several reconstructive hypotheses.

The first and most complete analysis of the piece was published by Evi Touloupa.[21] She identified it as a large decorative element, an acroterium or central element of a tympanum, belonging to a small building on the Acropolis in the seventh century, perhaps the first temple of Athena Polias.[22] Among the alternative hypotheses formulated more recently, two are worth mentioning here: one, by Elena Partida, places it as a decoration on a wall of one of the minor buildings of the Acropolis;[23] the other, by Annarita Doronzio, considers it an attribute of a large statue of Athena.[24]

All these hypotheses are interesting but not devoid of significant problems. The shield-emblem thesis is unacceptable as the artifact has a number of characteristics that are incompatible with this type of object. For example, the sheet sticks out from the interior circular plane whereas the holes do not line up neatly along the edges of the ring. Moreover, the metallic strips riveted at the gorgon's back would have no use as a support or reinforcement if the gorgon originally decorated the front of a shield. Also, there is not a single shield of Greek tradition that has a similar type of mounting plaque at the bottom.[25]

The hypothesis of the sheet as an architectural element is also somewhat unconvincing. Its mounting on a tympanum or on the wall of a building would have been impossible as there would not have been enough holes or in the right position allowing the ring to be securely attached on a support of wood, *poros* or marble; for such a function, in fact, it would have made more sense to insert evenly spaced rows of rivets all the way around the edge of the ring. What is more, the mounting plaque at the bottom would not have been very functional in an architectural use. The suggestion that it is an acroterium is not very plausible either; in fact, the thin sheet would not

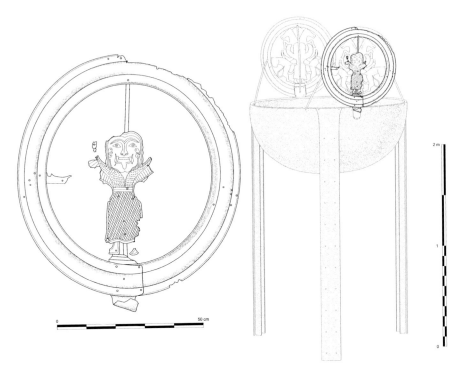

have been strong enough to attach the ring to the top of a roof. In addition, apart from poor visibility from below, such an acroterium would be an isolated case in the earliest history of Greek acroteria.[26] Metal decorations are attested in early Greek temple architecture.[27] However, this seems not to have been the function of this artifact.

Instead, in light of the technical characteristics discussed above, this ring should be ascribed to a handle of a tripod-cauldron as well, of the same type as the Acropolis tripod-cauldron handles from the Geometric period analyzed above in this chapter (fig. 8). In my opinion, it is comparable both because of its technical characteristics and because of its overall size.

The size of this object is indeed unusually impressive considering that it has another equally peculiar characteristic: In addition to the ornamentation of the ring itself it also features ornamentation in its interior.[28] The tripod ring with a gorgon is, in fact, both the largest and the most decorated of all the round handles found on the Acropolis. The outstanding size of some handles certainly played a role in the visual perception of the tripod-cauldrons exhibited on the Acropolis. The

Fig. 8. Reconstructive drawing of the bronze handle with gorgon EAM X 13050; drawing by the author.

Fig. 9. Eleusis, Archaeological Museum. Clay pinax (inv. 2513) with the representation of a tripod-cauldron of the seventh century B.C.E. ©Hellenic Ministry of Culture and Sports, Ephorate of Antiquities of West Attica.

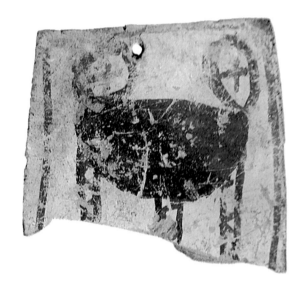

lack of a fixed ratio between the handles and the basins is evident in some examples painted on terracotta plaques from Athens and Eleusis (fig. 9), which show circular handles decorated with central diagonal strips.[29]

The decorative apparatus of tripod-cauldrons also includes the human supports attached to the sides of the rings, which are used as reinforcement (fig. 10). These human supports fixed to the side of the ring only appeared in the eighth century following the monumentalization of the tripod-cauldrons, and their usage continued to the seventh century B.C.E.[30] In many cases they were warriors in heroic nudity, armed with helmets; in some cases, they may also have coexisted with figural attachments placed on the upper section of the round handle (e.g., groups comprising a man and a horse).[31] These bronze figures were very popular in most sanctuaries in Greece, such as Olympia, Delphi, and Isthmia.[32] On the Acropolis there is documentation of a series of anthropomorphic bronzes that acted as lateral supports to the very thin handles of the tripods. Of variable dimensions, some are more than 20 cm high and are datable to the seventh century.[33] The chronology, technical characteristics, and height of these figures mean that they can be attributed to monumental tripods.

As Nassos Papalexandrou discusses in this volume, in the seventh century the griffin cauldron, a type of vessel different from the traditional tripod-cauldron, was introduced on the Acropolis following a trend attested in many other sanctu-

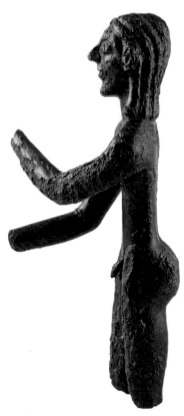

Fig. 10. Acropolis Museum, bronze human support of tripod EAM X 6617 from the Acropolis of Athens. © Acropolis Museum; photograph by Yannis Koulelis.

aries in the Greek world. Griffin cauldrons had erect griffin protomes riveted on the exterior of the basin just below the rim. The oriental influence is clear.[34] These coexisted with tripod-cauldrons on the Acropolis and other sanctuaries. In Athens, the individual parts of the tripod-cauldrons became very thin, probably to allow them to be attached to supports made of wood or stone. The ten large *poros* blocks with a triangular section from the Acropolis, also dating back to seventh century, have been interpreted as supports for bronze basins; in this case, the bronze legs were not free-standing, but fixed to the corners of the bases.[35]

The Tripods on the Early Archaic Acropolis between Archaeological Evidence and Literary Sources

Between the eighth and seventh century, tripod-cauldrons could reach a height of almost three meters and were products of high craftsmanship, made by melting and hammering the individual components.[36] The technical specialization and

95

artisanal refinement required in the manufacturing of tripod-cauldrons became the pride of local workshops. The contemporary reception of such valuable artifacts resonates in a famous passage from book 18 of the *Iliad*, when Thetis goes to Hephaestus to ask for new weapons for her son Achilles.[37] At that time the god was busy making "20 tripods" (τρίποδας … ἐείκοσι). They were not ready yet, because "the finely crafted handles were still missing: he was shaping them, cutting the straps" (οὔατα … κόπτε δὲ δεσμούς).[38] The technique used to make the tripod-cauldrons can be deduced from the last sentence: the handles were produced separately and later attached by means of riveted straps, a detail that seems to be in accordance with the evidence found on tripod-cauldrons from the Athenian Acropolis.

Attempting to identify their location makes us consider the physiognomy of the Acropolis between the Geometric and Orientalizing period, when the most prestigious dedications, including the tripod-cauldrons, were votive expressions of the elites or polis groups and were probably arranged in the close proximity of the most important architectural landmark on the hill: the temple of Athena Polias in its early phase.[39]

The Athenian documentation of the eighth and seventh centuries is on the same level as that from the great contemporary sanctuaries, both the Panhellenic ones at Delphi and Olympia as well as the regional and local sanctuaries of continental and insular Greece.[40] The size of the tripod-cauldrons and the slimness of some support elements allow us to deduce that they were products made only for ostentatious display in the sanctuary. These objects, in fact, were included in a long tradition that had its roots in the Aegean Bronze Age and were hugely popular in the Greek world due to their symbolic and religious value.[41] They were associated with the prestigious sphere of awards for success in sports, poetry, or music competitions, but they were also given as prizes to celebrate military victories.[42] In Homeric epics the value of the tripod-cauldron as a luxury good is mentioned in the games organized by Achilles in honor of Patroclus, when the winner of the chariot race is given a tripod-cauldron valued at 12 oxen.[43] In the *Odyssey*, Alcinous, king of Scheria, requires the members of the council of the Phaeacians to donate a tripod-cauldron and a cauldron to Odysseus.[44] In this case the tripod-cauldron represents a prestigious gift, part of the practice of exchange between aristoi, to both symbolically affirm

the leadership of two prominent figures and confirm recognition of their privileged status.[45] An important literary passage in this respect is a fragment of the *Women's Catalogue* by Hesiod that refers precisely to Athens. In the list of Helen's numerous suitors appears the Athenian Menestheus, king of the city at the time of the war of Troy. Inside the palace belonging to Menestheus and his father, King Peteus, an abundance of beautiful and valuable items were kept (κειμήλια), including objects of gold, cauldrons, and tripod-cauldrons (χρυσόν τε λέβητάς τ[ε τρίποδάς τε: the emendation can be considered certain).[46] From the point of view of the ancients, starting with Homer, the residence of the mythical Athenian kings was established on the Acropolis, therefore Hesiod's mention of the tripod-cauldrons in the king's palace can be read as a reference to the Acropolis, which was in reality characterized by the presence of these votive dedications.[47]

Conclusions

During the Late Geometric period, we witness the appearance and intensification of votive dedications on the Athenian Acropolis. The tripod-cauldrons attest to the transformation of the Acropolis from a residential space to a sanctuary, probably the result of the cohesion between the various communities of Attica, which came together to become a single political body under the aegis of a common divinity.[48] The life of the sanctuary and the proliferation of bronze dedications go hand in hand with the increase in number and size of tripod-cauldrons, revealing a strong monumental taste at work on the Acropolis. The installation of these large bronzes represents the ostentation of considerable economic investment and satisfies the need for self-representation by eminent social groups of the polis.[49] The colossal dimensions of these tripod-cauldrons rule out any practical use; they were products made specifically for the sanctuary, and in the eyes of the gods and the general public who frequented the Acropolis they were exceptionally refined and valuable votive gifts.

Notes

[1] Kavvadias and Kawerau 1906, col. 42.

[2] For the post-Persian reconstruction of the Acropolis, see Di Cesare 2015, 119–40; Stewart 2008; Di Cesare 2004.

[3] Scholl 2006; Touloupa 1991; 1972; de Ridder 1896.

[4] Di Cesare and Sarcone 2019, 351–54; Sarcone 2018.

[5] Touloupa 1972, 61–62.

[6] For the conformation of the structure and legs of the tripod, see the reconstructive model in Maass 1978, 64, fig. 3.

[7] Touloupa 1972, 58.

[8] Di Cesare and Sarcone 2019, 352; Doronzio 2018, 35–38 (the author has a complete discussion of the tripods of the seventh century); Sarcone 2018, 24–26; Scholl 2006, 49–64; 90–99; Coldstream 1977, 320. On increase of size of tripods after 750 and technique and ornamentation, see Morgan 1990, 31; Maass 1978, 228.

[9] Willemsen 1957, tab. 68.

[10] Papalexandrou 2014, 127–37; 2008, 256–57.

[11] For joining techniques of hammered sheets, see Giardino 2010, 76–77; Coghlan 1975, 116–21; Maryon-Plenderleith 1966, 659–64.

[12] For the fixing systems of the tripods of the Acropolis of Athens and the sanctuary of Olympia of eighth and seventh centuries, see Sarcone 2018, 15–21.

[13] The sheet is 8.2 cm wide and 0.3 cm thick; Sarcone 2018, 17, fig. 10, 31, tab. 2.

[14] Like the specimens nn. 607, 610, and 7843 presented in Sarcone 2018, 30, tab. 1.

[15] The bronze sheet is 9 cm wide and 0.3 cm thick; Sarcone 2018, 18–19.

[16] The sheet is 7.1 cm wide and 0.3 cm thick; Sarcone 2018, 18–21, figs. 15–16.

[17] Di Cesare and Sarcone 2019, 351–54; Doronzio 2018, 46–47; Sarcone 2018; Scholl 2006, 20–21; Touloupa 1969.

[18] *LIMC* 4:310, no. 279.

[19] A direct iconographic comparison is found on a vase from Kamiros (Rhodes); Bianchi Bandinelli and Paribeni 1976, no. 77.

[20] Kavvadias 1888, 219.

[21] Touloupa 1969.

[22] On the first temple of Athena and generally on the Acropolis of the eighth and seventh century, see Doronzio 2018, 12–54; Meyer 2017, 95–96; Monaco 2010, 57; Scholl 2006; Holtzmann 2003; Hurwit 1999, 94–98.

[23] Partida 2000, 118, no. 64.

[24] Doronzio 2018, 46–47.

[25] For a study on shields from Olympia, see Philipp 2004; Bol 1989; for Delphi see Colonia 2006, 68.

[26] Reinhardt 2018; Glowacki 1998; Högemann, 1996, 413; Danner 1989.

[27] On the use of bronze hammered or embossed sheets in Greek architecture, see Glowacki 1998; Philipp 1994, 489–98; Mallwitz 1968; Drerup 1952, 7–38.

[28] As in Papalexandrou 2005, 71–72; Willemsen 1957, 34, tab. 31, no. B 2040.

[29] Sarcone 2018, 24, figs. 25–26.

[30] See Papalexandrou 2005, 70–75; see also Rolley 1983, 56–58; Heilmeyer 1979, 19–24.

[31] Colonia 2006, 42–43 (Delphi); Maass 1978, tav. 40, n. 154; Chatzi 2008, 77 (Olympia); Coldstream 1977, 129, fig. 41; Pandermalis et al. 2016, 91 (Athens).

[32] Holtzmann 2010, 36; Papalexandrou 2005.

[33] As the bronze EAM X 6617 from the Acropolis of Athens; Scholl 2006, 91–92, figs. 26–28.

[34] Studies on the tripods of the seventh century from the Acropolis of Athens are published in Doronzio 2018, 35–41; Scholl 2006, 90–105. For griffin cauldrons in the preclassical Mediterranean see Papalexandrou 2021.

[35] Papalexandrou 2005, 196–99; Korres 1994, 38; Stevens 1951.

[36] Morgan 1990, 31; Maass 1978, 228.

[37] Hom. Il. 18.368–379.

[38] Hom. Il. 18.378–379.

[39] Doronzio 2018, 44–45; Meyer 2017, 95–96; Monaco 2010, 54–56; Scholl 2006, 18–23; Hurwit 1999, 109–11; Nylander 1962.

[40] Kiderlen 2010, 96; for Olympia see Kyrieleis 2013; Maass 1981, 6–20; Heilmeyer 1979; Maass 1978; Willemsen 1961, 1957; for Delphi see Maass, 2002, 830–31; Rolley 1977; 1969.

[41] On the use of the tripod-cauldron from the Bronze Age see Kiderlen 2010, 93; Papastamati-von Moock 1996, 95; Bol 1985, 30–31; Matthäus 1980, 114–15; Maass 1978, 5.

[42] Hom. Il. 23.702; Hdt. 1.144. For the concept of tripod-cauldrons as a prize in sports competitions, see Papalexandrou 2005, 28–30; Morgan 1990, 207; Coldstream 1977, 335; Vanderpool 1969. For tripod-cauldrons as votive objects for military victories, see Scott 2010, 88–91; Kyle 1987, 16–17; Amandry 1958.

[43] Hom. Il. 23.262–265; Bol 1985, 30.

[44] Hom. Od. 13.5–13.

[45] Papalexandrou 2005, 33.

[46] Most 2007, 224 (fr. 154e, l. 5[45]).

[47] Hom. Il. 2.546–548; Od. 7.81; Di Cesare and Sarcone 2019, 354.

[48] Di Cesare 2016, 712; Parker 1996, 10–28; de Polignac 1995, 81–88; also Scholl 2006, 76; Sourvinou-Inwood 1993, 1–17. For the Acropolis in the Geometric Age, see further Meyer 2017; Scholl 2006; Korres 1994, 37–38; Touloupa 1972, 1969; Nylander 1962.

[49] Rönnberg 2021, 217-258; Papalexandrou 2014, 127–37; 2008, 256–57.

Works Cited

LIMC *Lexicon Iconographicum Mythologiae Classicae*. Zürich-München: Artemis 1981–1999.

Amandry, P. 1958. "Objets orientaux en Grèce et en Italie aux VIIIᵉ et VIIᵉ siècle avant J.C." *Syria* 35:73–109.

Bianchi Bandinelli, R., and R. Paribeni. 1976. *L'arte dell'antichità classica* 1: *Grecia.* Torino: Utet.

Bol, P. C. 1985. *Antike Bronzetechnik: Kunst und Handwerk antiker Erzbildner.* Munich: C. H. Beck.

———. 1989. *Argivische Schilde.* OlForsch 17. Berlin: Walter de Gruyter.

Chatzi, G. E. 2008. Τo Αρχαιολογικό Μουσείο Ολυμπίας. Athens: Κοινωφελές Ίδρυμα Ιωάννη Σ. Λάτση.

Coghlan, H. H. 1975. *Notes on the Prehistoric Metallurgy of Copper and Bronze in the Old World.* 2nd ed. Oxford: Pitt Rivers Museum.

Coldstream, J. N. 1977. *Geometric Greece.* London: Methuen.

Colonia, R. 2006. *The Archaeological Museum of Delphi.* Athens: John S. Latsis Foundation.

Danner, P. 1989. *Griechische Akrotere der archaischen und klassischen Zeit.* RdA Suppl. 7. Rome: Giorgio Bretschneider.

Di Cesare, R. 2004. "La storia murata: Note sul significato del riutilizzo di materiali architettonici nel muro di cinta dell'Acropoli di Atene." *NumAntCl* 33:99–134.

———. 2015. *La città di Cecrope: Ricerche sulla politica edilizia cimoniana ad Atene.* SATAA 11. Atene, Paestum: Pandemos.

———. 2016. "L'Acropoli e i re di Atene." In ΔΡΟΜΟΙ: *Studi sul mondo antico offerti a Emanuele Greco dagli allievi della Scuola Archeologica Italiana di Atene,* edited by F. Longo, R. Di Cesare, and S. Privitera, 711–30. Atene, Paestum: Pandemos.

Di Cesare, R., and G. Sarcone. 2019. "L'Acropoli di Atene: Memoria, storia e attualità nel centro di una *polis.*" In *Scienze umane tra ricerca e didattica: Atti del convegno internazionale di studi (Foggia, 24–26 settembre 2018),* edited by G. Cipriani, and A. Cagnolati, 345–69. Foggia: Il Castello Edizioni.

Doronzio, A. 2018. *Athen im 7. Jahrhundert v.Chr. Räume und Funde der frühen Polis.* Berlin: Walter de Gruyter.

Drerup, H. 1952. "Architektur und Toreutik in der griechischen Frühzeit." *AM* 5.1:7–38.

Giardino, C. 2010. *I metalli nel mondo antico: Introduzione all'archeometallurgia.* Bari: Laterza.

Glowacki, K. T. 1998. "The Acropolis of Athens before 566 B.C." In ΣΤΕΦΑΝΟΣ: *Studies in Honor of Brunilde Sismondo Ridgway,* edited by K. J. Hartswick and M. C. Sturgeon, 79–88. University Museum Monographs 100. Philadelphia: University Museum Monograph.

Heilmeyer, W. D. 1979. *Frühe olympische Bronzefiguren: Die Tiervotive.* OlForsch 12. Berlin: Walter de Gruyter.

Högemann, P. "Akroter." *DNP* 1:413.

Holtzmann, B. 2003. *L'Acropole d'Athènes: Monuments, cultes et histoire du sanctuaire d'Athèna Polias.* Paris: Picard.

———. 2010. *La sculpture grecque: Une introduction.* Paris: Librairie générale française.

Hurwit, J. M. 1999. *The Athenian Acropolis: History, Mythology, and Archaeology from the Neolithic Era to the Present.* Cambridge: Cambridge University Press.

Kavvadias, P. 1888. "Ἀνασκαφαὶ καὶ εὑρήματα." *ArchDelt* 1988: 219.

Kavvadias, P., and G. Kawerau. 1906. *Die Ausgrabung der Akropolis vom Jahre 1885 bis zum Jahre 1890/Ἡ ἀνασκαφὴ τῆς Ἀκροπόλεως ἀπὸ τοῦ 1885 μέχρι τοῦ 1890.* Athens: ΕΣΤΙΑ.

Kiderlen, M. 2010. "Zur Chronologie griechischer Bronzedreifüße des geometrischen Typs und den Möglichkeiten einer politisch-historischen Interpretation der Fundverteilung." *AA* 1:91–104. https://doi.org/10.34780/16sz-aycr.

Korres, M. 1994. "The History of the Acropolis Monuments." In *Acropolis Restoration: The CCAM Interventions,* edited by R. Economakis, 35–52. London: Academy Editions Ltd.

Kyle, D. G. 1987. *Athletics in Ancient Athens.* Mnemosyne Suppl. 95. Leiden: Brill.

Kyrieleis, H. 2013. "Archaische Dreifüsse in Olympia." In *13. Bericht über die Ausgrabungen in Olympia. 2000 bis 2005,* edited by H. Kyrieleis, 182–227. Tübingen: Ernst Wasmuth Verlag.

Maass, M. 1978. *Die geometrischen Dreifüsse von Olympia.* OlForsch 10. Berlin: Walter de Gruyter.

———. 1981. "Die geometrischen Dreifüsse von Olympia." *AntK* 24:6–20.

———. 2002. "Tripus." *DNP* 12:830–31.

Mallwitz, A. 1968. "Ein Scheibenakroter aus Olympia." *AM* 83:124–46.

Maryon-Plenderleith, H. J. 1966. "Arte del metallo." In *Storia della tecnologia 1: Dai tempi primitivi alla caduta degli antichi imperi : fino al 500 a.C.,* edited by C. Singer, E. J. Holmyard, A. R. Hall, and T. I. Williams, 633–72. Torino: Boringhieri.

Matthäus, H. 1980. *Die Bronzegefäße der kretisch-mykenischen Kultur.* Prähistorische Bronzefunde 2.1. Munich: C. H. Beck.

Meyer, M. 2017. *Athena, Göttin von Athen: Kult und Mythos auf der Akropolis bis in klassische Zeit.* Vienna: Phoibos Verlag.

Monaco, M. C. 2010. "L'Acropoli e le pendici: Quadro generale storico-topografico." In *Topografia di Atene: Sviluppo urbano e monumenti dalle origini al III secolo d.C.* Vol. 1: *Acropoli – Areopago – Tra Acropoli e Pnice,* edited by E. Greco, F. Longo, and M. C. Monaco, 53–73. SATAA 1.1. Atene-Paestum: Pandemos.

Morgan, C. 1990. *Athletes and Oracles: The Transformation of Olympia and Delphi in the Eighth Century BC.* Cambridge: Cambridge University Press.

Most, G. 2007. *Hesiod: The Shield, Catalogue of Women, Other Fragments.* Loeb Classical Library. Cambridge: Harvard University Press.

101

Nylander, C. 1962. "Die sog. mykenischen Säulenbasen auf der Akropolis in Athen." *OpAth* 4:31–77.

Pandermalis, D., S. Eleftheratou, and C. Vlassopoulou, 2016. *Acropolis Museum: Guide.* Athens: Acropolis Museum Editions.

Papalexandrou, N. 2005. *The Visual Poetics of Power: Warriors, Youths and Tripods in Early Greece.* Greek Studies. Lanham, MD: Lexington Books.

———. 2008. "Boiotian Tripods: The Tenacity of a Panhellenic Symbol in a Regional Context." *Hesperia* 77:251–82.

———. 2014. "Messenian Tripods: A Boiotian Contribution to the Symbolic Construction of the Messenian Past?" In *Attitudes towards the Past in Antiquity Creating Identities: Proceedings of an International Conference Held at Stockholm University (15–17 May 2009)*, edited by B. Alroth and C. Scheffer, 127–37. Stockholm: Stockholm University.

———. 2021. *Bronze Monsters and the Cultures of Wonder: Griffin Cauldrons in the Preclassical Mediterranean.* Austin: University of Texas Press.

Papastamati-von Moock, C. 1996. "Der Dreifuß: Zeugnis kultischer und sozialer Wandlungen während der Geometrischen Zeit." In *Kult und Funktion griechischer Heiligtümer in archaischer und klassischer Zeit: Archäologisches Studentenkolloquium Heidelberg (18–20 Februar 1995)*, edited by F. Bubenheimer, J. Mylonopoulos, B. Schulze, and A. Zinsmaier, 95. Mainz: Deutscher Archäologen-Verband.

Parker, R. 1996. *Athenian Religion: A History.* Oxford: Clarendon Press.

Partida, E. C. 2000. *The Treasuries at Delphi: An Architectural Study.* Aström: Jonsered.

Philipp, H. 1994. "Χάλκεοι τοῖχοι – Eherne Wände." *AA*:489–98.

———. 2004. *Archaische Silhouettenbleche und Schildzeichen in Olympia.* OlForsch 30. Berlin: Walter de Gruyter.

de Polignac, F. 1995. *Cults, Territory, and the Origins of the Greek City-State.* Chicago: University of Chicago Press.

Reinhardt, C. 2018. *Akroter und Architektur: Figürliche Skulptur auf Dächern griechischer Bauten vom 6. bis zum 4. Jahrhundert v. Chr.* Berlin: de Gruyter.

de Ridder, A. 1896. *Catalogue des bronzes trouvés sur l'Acropole d'Athènes.* Paris: E. Thorin.

Rolley, C. 1969. *Les statuettes des bronze.* FdD 2. Paris: Éditions de Boccard.

———. 1977. *Les trépieds à cuve cloué.* FdD 3. Paris: Éditions de Boccard.

———. 1983. *Les bronzes grecs.* Paris: Office du livre Éditions Vilo.

Rönnberg, M. 2021. *Athen und Attika vom 11. bis zum frühen 6. Jh. v. Chr. Siedlungsgeschichte, politische Institutionalisierungs- und gesellschaftliche Formierungsprozesse.* Tübinger Archäologische Forschungen 33. Rahden/Westf.: Marie Leidorf GmbH.

Sarcone, G. 2018. "Un grande tripode con gorgone dall'Acropoli di Atene." *ASAtene* 96:9–33.

Scholl, A. 2006. "ΑΝΑΘΗΜΑΤΑ ΤѠΝ ΑΡΧΑΙѠΝ: Die Akropolisvotive aus dem 8. bis frühen 6. Jahrhundert v.Chr. und die Staatswerdung Athens." *JdI* 121:1–172.

Scott, M. 2010. *Delphi and Olympia: The Spatial Politics of Panhellenism in the Archaic and Classical Periods.* Cambridge: Cambridge University Press.

Sourvinou-Inwood, Ch. 1993. "Early Sanctuaries, the Eighth Century and Ritual Space: Fragments of a Discourse." In *Greek Sanctuaries: New Approaches*, edited by N. Marinatos, and R. Hägg, 1–17. London: Routledge.

Stevens, G. P. 1951. "The Poros Tripods of the Acropolis of Athens." In *Studies Presented to David Moore Robinson on His Seventieth Birthday*, edited by G. E. Mylonas, 1:331–35. 2 vols. Saint Louis: Washington University.

Stewart, A. 2008. "The Persian and the Carthaginian Invasions of 480 B.C.E. and the Beginning of the Classical Style, 1: The Stratigraphy, Chronology and Significance of the Acropolis Deposits." *AJA* 112:377–412. https://doi.org/10.3764/aja.112.3.377.

Touloupa. E. 1969. "Une Gorgone en bronze de l'Acropole." *BCH* 93:862–84.

———. 1972. "Bronzebleche von der Akropolis in Athen: Gehämmerte geometrische Dreifüße." *AM* 87:57–76.

———. 1991. "Early Bronze Sheets with Figured Scenes from the Acropolis." In *New Perspectives in Early Greek Art*, edited by D. Buitron-Oliver, 240–71. Studies in the History of Art 32. Washington DC, National Gallery of Art.

Vanderpool, E. 1969. "Three Prize Vases." *ArchDelt* 24:1–5.

Willemsen, F. 1957. *Dreifusskessel von Olympia.* OlForsch 3. Berlin: Walter de Gruyter.

———. 1961. "Ein früharchaisches Dreifussbein." In *7. Bericht über die Ausgrabungen in Olympia*, edited by E. Kunze, 181–95. Berlin: Walter de Gruyter.

Monsters on the Athenian Acropolis: The Orientalizing Corpus of Griffin Cauldrons

Nassos Papalexandrou

Abstract

The corpus of seventh-century bronzes from the Acropolis comprises a small number of significant remnants of the so-called orientalizing cauldrons. These artifacts are ten griffin protomes and four "siren" attachments. Although almost all of them were found during controlled excavations in the 19th century, they are insufficiently published and scholars have analyzed them exclusively in stylistic terms. This paper attempts to restore these artifacts to their immediate functional relationships (as appendages to vessels) and on the basis of this methodological step, reevaluates their original significance and their role in the sacred ambience of the Acropolis. The diverse nature of this corpus in conjunction with evidence from contemporary pictorial media in Athens suggests that the traditional interpretation of these cauldrons as showy dedicatory objects needs a thorough reconsideration. I argue that the griffin cauldrons of the Acropolis were collected by sanctuary authorities primarily as cultic equipment for performative events characterized by a high level of restricted physical and cognitive accessibility. Although the dedicatory function cannot be altogether excluded, the deposition of griffin cauldrons on the Acropolis was motivated by a local need to attune the sanctuary's symbolic behavior to that of other sanctuaries, for example, the Samian Heraion, Delphi, and Olympia.

IN THE EIGHTH AND SEVENTH CENTURIES THE ATHENIAN Acropolis was the most important urban sanctuary of the developing state of Athens. The artifactual record of the eighth and seventh centuries is now meager in numbers and contains only fragmentary remnants, the result of intentional or accidental destruction. A few of these artifacts are comparable in type and quality with those deposited at Olympia and Delphi.[1] In this essay, I review the existing record of griffin cauldrons in terms of their excavated remnants on the Acropolis, griffin protomes and human-headed birds. The

Fig. 1. Hammered griffin protome allegedly from the Acropolis; Ashmolean Museum 1895.171; with permission of Ashmolean Museum, Department of Antiquities.

cauldrons themselves have long perished, which is why the original monuments can be reconstructed on the basis of better-preserved specimens elsewhere. The function of these visually and technologically intricate artifacts is not certain, but I argue that in the seventh century they were treasured on the Acropolis as cultic apparatus, not as dedicatory objects. At any rate, the surviving record of griffin cauldrons is random but still affords insights about the social life and radiance of the sanctuary during a poorly understood period of its life.

In this random record, orientalizing cauldrons are attested by ten griffin protomes and four siren attachments.[2] These artifacts have never been fully published, mainly because since the 19th century attention on the finds from the Acropolis has been lavished disproportionally on architectural or free-standing sculpture in stone (see introduction to this volume). The protomes represent 10 different cauldrons, a few among which may have featured a combination of griffin protomes with siren attachments. Of the four human-headed bird attachments ("sirens"), one is reported as found near the Erechtheion (see below).[3] Of the 10 protomes, part of the head of a hammered protome (fig. 1), the earliest in date among this group, was not found in controlled excavations and has been in Oxford since the late nineteenth century (Ashmolean Museum 1895.171).[4] The rest are all hollow cast and have been retrieved in controlled excavations. Panagiotis Kavvadias reports the retrieval of 5 protomes in excavations conducted in 1888 in the area east, southeast, and south of the Parthenon.[5] One more miniscule protome is reported by Kyriakos Mylonas.[6] They all come from layers dating either to the period immediately after the Persian destruction or after the comple-

tion of the Parthenon. It is possible that a few cauldrons, or their remnants, were treasured as relics in the Acropolis until the Persian destruction or even after it.[7]

If indeed the Ashmolean protome derived from the Acropolis, it would represent by far the earliest surviving and perhaps one of the most impressive griffin cauldrons in this sanctuary.[8] Both Hans-Volkmar Herrmann and Ulrich Gehrig have rightly discussed this fragment in relation to more fully preserved products of what Gehrig has dubbed as the "Bernardini workshop," which was active until late in the first quarter of the seventh century.[9] Its amphibian air with rudimentary head-knob and low ears, yet fully delineated scales, anticipates the ferocity of griffins later in the century. As it currently stands, this griffin protome preserves only the upper part of its head, which measures 10 cm. Originally, it would have measured up to 25 cm and could well have been one of six protomes attached to a cauldron, the size and splendor of which would have rivaled the monumental tripod-cauldrons of the late eighth century on the Athenian Acropolis, discussed in this volume by Germano Sarcone.[10] However, the plastic attachments of these behemoths would have provided no match for the sensory effect of the aggressive monsters. It should be reconstructed to a cauldron slightly smaller than Olympia Br 4224 but it would be a decade earlier than it.[11]

With one notable exception (NM 6636), all surviving griffin cauldrons with hollow-cast protomes from the Athenian Acropolis were manufactured in Samos, whose cosmopolitan sanctuary at the Heraion has yielded numerous and better preserved *comparanda* for all of them.[12] The protome NM 6634 (fig. 2) represents one of the earliest generations of hollow-cast protomes and belongs to the earliest products of a workshop active from 680 onward ("Stirnstachel").[13] It is now badly damaged and irreversibly transformed by fire but originally it would have been as impressive as the protomes Samos B 2088 or Olympia Br. 2575.[14] Its height now is 21.8 cm (ears, head knob, and attachment ring are broken off) but originally it would have been ca. 25 cm—that is, its parent cauldron would have been only slightly smaller than the cauldron Olympia B 4224 and the cauldron of the Ashmolean hammered one. With its bulging sack, rigid beaks, wide open, slightly bulging eyes, carefully punched scales on its proud neck, and volute in relief, this protome would have offered a novel embodiment of the ferocious griffin.

Fig. 2. Bronze griffin protome NM 6634; © Hellenic Ministry of Culture and Sports, National Archaeological Museum/Archaeological Resources Fund.

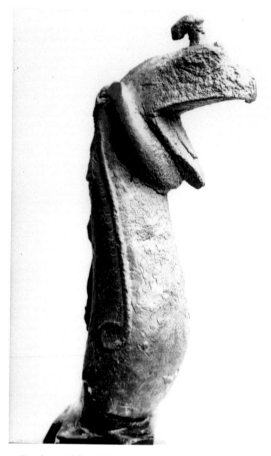

By the middle of the century, a few cauldrons on the Athenian Acropolis would have reached monumental dimensions rarely experienced before on Athena's rock. This period witnessed the manufacture of composite protomes. These comprise a long, sinuous neck made of hammered bronze and filled with bitumen or clay topped by a hollow-cast head rendered with exaggerated versions of the established diagnostic traits of griffins. The large head NM 6635 is a particularly impressive embodiment of the category (fig. 3).[15] Its height is 20 cm but we have to imagine it at the top of a hammered neck 50 to 60 cm high. Voluminous protomes like the parent of NM 6635 would have belonged to sizeable, heavy cauldrons whose diameter at the belly would have measured up to 1.5 to 2 m. Each one of them would have been perceived as a multiheaded monster, a veritable *pelor* in bronze that cast a penetrating gaze on its surroundings. The once inlaid eyes of

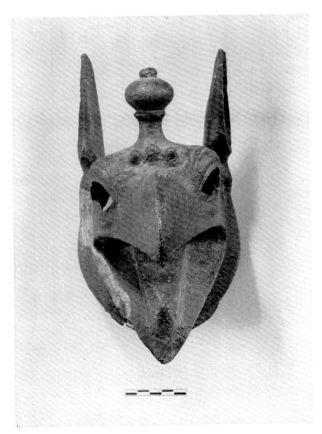

Fig. 3. Bronze griffin protome head NM 6635; photograph by Hermann Wagner (D-DAI-ATH-NM 4155); © Hellenic Ministry of Culture and Sports, National Archaeological Museum/Archaeological Resources Fund.

NM 6635 are now lost. They would have been made of bone or ivory for the white of the bulb and a dark stone for the pupil. The beaming quality of their gaze could have inspired the gorgons' almond-shaped eyes on the proto-Attic amphora of Eleusis.[16] The protome and the gorgons share the same shape of eyes. In both they are crowned by wrinkled brows rendered with carefully drawn lines on the amphora and with plastically rendered folds on the protome. These are not avian eyes though. Judging from protomes that preserve their inset eyes, I propose that there is a human quality in these eyes and the way they look at their surroundings.[17] I argue elsewhere that because of sensory qualities like these the griffins cauldrons were originally perceived by their viewers or users as living monsters.[18]

The remaining griffin cauldrons date from the latter half of the seventh century. There are four protomes attributed by Gehrig to the prolific Samian workshop Gruppe 6 (NM 6637, NM 6638, NM 6640, and NM 6633) which was active in the

Fig. 4. Bronze griffin protome NM 6633 (in the Acropolis Museum since 2009); photograph by Yannis Koulelis; ©Acropolis Museum 2018.

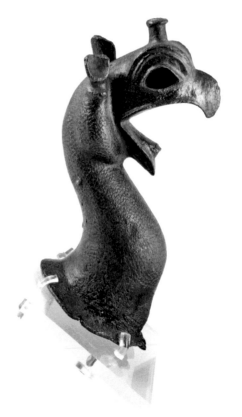

decade 640–630.[19] Three of them are very fragmentary (NM 6637, NM 6638, and NM 6640). The best preserved is NM 6633 (H. 20.4 cm), which has survived damage by fire (fig. 4).[20] It is to be restored to a cauldron somewhat smaller than Olympia Br 4224.[21] The type seems to be motivated by the need to replicate in smaller scale the effect of the monumental cauldrons discussed above. The eyes, originally inlaid as in the other three specimens, have the same shape as NM 6635 and the wrinkled brow is here more plastically rendered. The head is lighter and sits on a muscular neck that is considerably narrower below the sack and wider closer to the attachment ring. The effect is one of propulsive energy: the animal is as tensed as it can be milliseconds before it springs forward with the momentum of a wild feline or a hitting snake.

The chronologically latest cauldron in the Acropolis series is the smallest in size in the surviving series (fig. 5). It is represented by a protome that would date to the decade 630–620 or slightly later (NM 6639). This is the smallest protome (H.

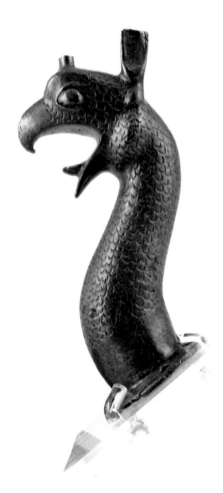

16 cm) and somewhat more subdued in effect than the cauldron specimens discussed above. It is the product of Gehrig's Samian "Hohe Stirn II" workshop, whose products are smaller in scale, less ambitious in effect than before, with cast oval-shaped eyes, thick eyelids, and rather clumsily punched, wide-arched scales.[22]

The four surviving human-headed bird attachments (sirens) represent three or four cauldrons. All of them have been dated to the first quarter of the seventh century. Scholars have recognized in them fine specimens of what they perceive as the lively Greek improvement of drab Near Eastern counterparts that are well represented at Olympia, Delphi, and Ptoion.[23] They could have belonged to siren-only cauldrons (i.e., without griffin protomes like those from Gordion and

Fig. 6. Bronze human-headed bird NM 6518; photograph by Hermann Wagner (D-DAI-ATH-NM 3350); © Hellenic Ministry of Culture and Sports, National Archaeological Museum/Archaeological Resources Fund.

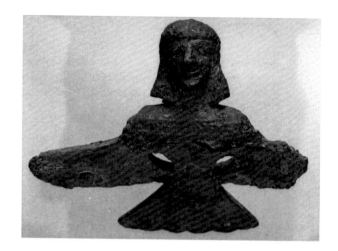

Fig. 7. Top: Bronze human-headed bird NM 6519; photograph by Hermann Wagner (D-DAI-ATH-NM 3119); © Hellenic Ministry of Culture and Sports, National Archaeological Museum/Archaeological Resources Fund. Bottom: Bronze human-headed bird NM 6517; photograph by Hermann Wagner (D-DAI-ATH-NM 3119); © Hellenic Ministry of Culture and Sports, National Archaeological Museum/Archaeological Resources Fund.

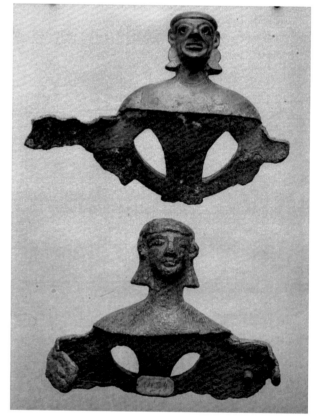

Delphi). It is less plausible that they were accompanied by griffin protomes on their parent cauldrons in the manner exemplified at Ptoion, Olympia, Praeneste, and Vetulonia. Be

that as it may, it is noteworthy that all four of them feature carefully rendered eyes. This is more emphatically evident in NM 6518 (fig. 6) and NM 6519 (fig. 7, top), both in a finer state of preservation than their peers, NM 6517, whose surface is weathered (fig. 7, bottom), and NM 6492, which is malformed by fire. NM 6518 has almond-shaped eyes with finely rendered eyelids. NM 6519 has no eyelids as the eye is plastically rendered and bulges out displaying disproportionately large holes for inset pupils in an unknown, now lost material. Today the impression exuded by these attachments is mask-like, an effect that would have been considerably more intense when they were still attached on their parent cauldrons with or without the company of griffin protomes. At this point, I will not venture into speculation as to whom or what they would have been seen to personify as I have addressed the matter elsewhere.[24]

The reasons I have insisted above on a detailed discussion of the remnants of orientalizing cauldrons on the Athenian Acropolis are multifold. First, I stress that however fragmentary these remnants are, they represent fabulous wealth deposited in the sanctuary during a period of political and social remission in Athens.[25] As Jeffrey Hurwit has convincingly shown, however, the Acropolis was not as poor in the seventh century as some scholars have suggested.[26] Intentional destructions and continuous construction in the sixth and fifth centuries have taken a severe toll on the original archaeological record, whose appreciation suffers from comparison with the Acropolis splendors of the sixth and fifth centuries. The presence of griffin cauldrons testifies to Athens's connectedness with Samos, perhaps as a result of an effort to keep up with developments at Olympia or Delphi, which imported cauldrons manufactured in Samian workshops. Second, Athens is exceptional in that we may consider these cauldrons and their effect or affect vis-à-vis pictorial or plastic representations in media that allow us to gauge local or regional responses to them.[27] These point to both restricted cognitive and physical accessibility to griffin cauldrons and to an altogether negative sentiment toward them. They also point away from the traditional understanding of orientalizing cauldrons as showy dedicatory objects (cf. with Sarcone's contribution in this volume). Instead they suggest that these objects were used as cultic equipment in performative contexts (e.g., processions like in the Berlin stand SM 31573. A41).[28] As I ar-

Fig. 8. Bronze griffin protome (by non-Samian workshop) NM 6636; © Hellenic Ministry of Culture and Sports, National Archaeological Museum/Archaeological Resources Fund.

gue in a recently published monograph on the Mediterranean life of griffin cauldrons, these cauldrons were not dedications by aristocratic individuals but equipment collected by sanctuary authorities to enhance the otherworldly ambiance of the Acropolis. We have to ask who was allowed to interact with the orientalizing cauldrons and in what circumstances. We also have to ask how these objects shaped the experience of sacred space on the Acropolis.

Synoptic Overview of Cauldrons from the Athenian Acropolis

If its provenience is indeed the Acropolis, the cauldron of the Oxford hammered griffin would be the earliest specimen deposited in the sanctuary of Athena, ca. 700–690 or shortly thereafter. In the first half of the seventh century three or four cauldrons were equipped with human-headed bird attachments. One impressive cauldron (NM 6634) belongs to the earliest surviving cauldron with hollow-cast protomes— it must have been an intriguingly innovative addition to the growing material wealth of the sanctuary (fig. 2). It would belong to the decade 680–670, and the same holds true for the cauldron of NM 6636 (fig. 8), a non-Samian product of

which only the head (H. 10 cm) survives. It was not until the middle of the century that a monumental cauldron (of protome NM 6635), a grandiose artifact in all respects, entered the Acropolis (fig. 3). I suggested above that its powerful impact is registered in the rendering of the gorgon's heads on the Eleusis amphora, a monument that speaks as much about the source of Polyphemus Painter's inspiration as it discloses a negative sentiment toward griffin cauldrons.

The second half of the century witnessed the addition of six more cauldrons (NM 6633 [fig. 4], NM 6637, NM 6638, NM 6640, NM 7016, NM 6639 [fig. 5]), all smaller than the monumental one but striving to reproduce the same effect in smaller scale. Of these, five were deposited in the decade 640–630 and only one (NM 6639) early in the last quarter of the seventh century. The protome NM 6641 was not attached to a cauldron but to a vessel of a different type.

This evidence has indicative value only. Even if the number of cauldrons brought to the Acropolis was twice or thrice as numerous as that of the existing corpus, it would still indicate that griffin cauldrons were sparse on the Acropolis at any given moment of the sanctuary's life in the seventh century. How were they set up or stored? How many of them were physically accessible and in what circumstances? And what did those who came into contact with them understand about their function, value, and significance? Answers to these questions can only be tentative.[29] It is worth stressing, however, that the deposition of cauldrons on the Acropolis was probably motivated by a need to attune the sanctuary's symbolic behavior, ritual or dedicatory, to that of the great sanctuaries of Delphi, Olympia, and Samos.

Notes

[1] Andreas Scholl has discussed these materials vis-à-vis the social life of the sanctuary and historical developments at Athens in a recent synthetic study; Scholl 2006, 101–5 (orientalizing cauldrons), catalog in 152–55, nos. 90–106. These bronzes were originally published in summary catalog-like form by de Ridder 1896.

[2] An eleventh protome (de Ridder 1896, 153, no. 440, NM 6641) belongs to a different type of artifact; it is not a cauldron attachment.

[3] De Ridder 1896, 287, no. 764; Athens NM 6519.

[4] Maxwell-Hyslop 1956, pl. 32, 1. Uncertain provenience (Jantzen 1955, 105, no. 1).

[5] Kavvadias 1888, 12 (in January 1888 the area between the east side of the Parthenon and the northeast corner of the Old Acropolis

Museum yielded an unspecified griffin protome in an almost empty layer of dirt sandwiched between a stratum of crumbled *poros* and the bedrock); 43–44 (unspecified griffin protome in the fill between the southeast corner of the Parthenon and the retaining wall along the south side of the Parthenon—a layer rich in black-figure and red-figure pottery buried after the Persian wars); 55 (two unspecified griffin protomes from a mixed layer east of the Old Acropolis Museum); 54 (in the area east of the Parthenon, west of the museum and close to the south Acropolis wall excavations retrieved the cast head of a composite griffin protome; Athens, NM 6635).

[6] Athens, NM 6641. It did not belong to a cauldron. It was retrieved in the area between the Parthenon and the Old Acropolis Museum, in a leveling layer full of sculptures fragmented during the Persian invasion. This layer was shaped after the construction of the Parthenon (Mylonas 1883, 48, no. 16, and 33–34 for description of layer).

[7] See Papalexandrou 2021, 148, on possible relics of griffin cauldrons treasured in the Parthenon.

[8] The provenience is based on a vague record in the Ashmolean's registration book of 1895: "purchased by the Keeper of the Museum from the Acropolis." I thank Helen Hovey, collections manager, Antiquities Department for providing this information (email to author, July 21, 2016).

[9] Gehrig 2004, 89–92.

[10] Papalexandrou 2005, 73; Touloupa 1972.

[11] Herrmann 1966, 11–17, pls. 1–2.

[12] For NM 6636, see de Ridder 1896, 147, no. 432; see also infra.

[13] See Gehrig 2004, 27–31; de Ridder 1896, 147, no. 431.

[14] Samos B 2088: Gehrig 2004, 189, cat. no. 19. Olympia Br. 2575: Herrmann 1979, 36, G 64.

[15] De Ridder 1896, 151, no. 437.

[16] Papalexandrou 2021, 177–85. Mylonas (1957, 88) has suggested that the gorgon's head on the Eleusis amphora were inspired by the griffin protomes of orientalizing cauldrons.

[17] An example is Gehrig 2004, 211, no. 88 (pl. 34, top).

[18] Papalexandrou 2021.

[19] On "Gruppe 6," see Gehrig 2004, 62–69. NM 6637 is published in de Ridder 1896, 149, no. 433. For NM 6638 and 6640, see de Ridder 1896, 153, nos. 438 and 149, no. 434 respectively.

[20] De Ridder 1896, 150, no. 435.

[21] NM 6640 was from a larger, originally very impressive, cauldron than NM 6633; NM 6637 and NM 6638 were smaller, lighter vessels.

[22] Gehrig 2004, 82–84s.

[23] Herrmann 1966.

[24] See Papalexandrou 2004/2005, for a discussion of the significance of human-headed birds on cauldrons at Delphi. This would provide a model for the type and range of ideas this new mode of

representation introduced to seventh-century Athens as well. On griffin cauldrons at Delphi, see Papalexandrou 2021, 74–83.

[25] Osborne 1989; Morris 1987; Camp 1979.

[26] Hurwit 1999, 94–98; see also the recent synthesis by Doronzio 2018, 27–54.

[27] Papalexandrou 2021, 173–85.

[28] On this stand females in procession hold griffin cauldrons above their heads; see Papalexandrou 2021, 175–77 (discussion), 176, fig. 5 (illustration).

[29] Papalexandrou 2021.

Works Cited

Camp, J. 1979. "A Drought in the Late Eighth Century BC." *Hesperia* 48:397–411.

Doronzio, A. 2018. *Athen im 7. Jahrhundert v. Chr. Räume und Funde der frühen Polis*. Berlin: Walter de Gruyter.

Gehrig, U. 2004. *Die Greifenprotomen aus dem Heraion von Samos*. Samos 9. Bonn: Dr. Rudolf Habelt.

Herrmann, H-V. 1966. *Die Kessel der orientalisierenden Zeit 1: Kesselattaschen und Reliefuntersätze*. OlForsch 6. Berlin: Walter de Gruyter.

———. 1979. *Die Kessel der orientalisierenden Zeit 2: Kesselprotomen und Stabdreifüsse*. OlForsch 11. Berlin: Walter de Gruyter.

Hurwit, J. M. 1999. *The Athenian Acropolis: History, Mythology, and Archaeology from the Neolithic to the Present*. Cambridge: Cambridge University Press.

Jantzen, U. 1955. *Griechische Greifenkessel*. Berlin: Verlag Gebr. Mann.

Kavvadias, P. 1888. "Ἀνασκαφαὶ ἐν τῇ Ἀκροπόλει." *ArchDelt* 1888:10–55.

Maxwell-Hyslop, K. R. 1956. "Urartian Bronzes in Etruscan Tombs." *Iraq* 18.2:150–67.

Morris, I. 1987. *Burial and Ancient Society: The Rise of the Greek City-State*. New Studies in Archaeology. Cambridge: Cambridge University Press.

Mylonas, G. 1957. Ὁ πρωτοαττικός ἀμφορεύς τῆς Ἐλευσίνος. Athens: Archaeological Society of Athens.

Mylonas, K. 1883. "Εὑρήματα τῆς ἐν τηι Ἀκροπόλει ἀνασκαφῆς," *ArchEph* 1883:33–48.

Osborne, R. 1989. "A Crisis in Archaeological History? The Seventh Century BC in Attica." *BSA* 84:297–322.

Papalexandrou, N. 2003/2004. "Keledones: Dangerous Performers in Early Delphic Lore and Ritual Structures." *Hephaistos* 21/22:145–68.

———. 2005. *The Visual Poetics of Power: Warriors, Youths, and Tripods in Early Greece*. Greek Studies. Lanham, MD: Lexington Books.

———. 2021. *Bronze Monsters and the Cultures of Wonder: Griffin Cauldrons in the Preclassical Mediterranean.* Austin: University of Texas Press.

de Ridder, A. 1896. *Catalogue de bronzes trouvés sur l'Acropole d'Athènes.* Paris: E. Thorin.

Scholl, A. 2006. "ΑΝΑΘΗΜΑΤΑ ΤѠΝ ΑΡΧΑΙѠΝ: Die Akropolisvotive aus dem 8. bis frühen 6. Jahrhundert v. Chr. und die Staatsverdung Athens." *JdI* 121:1–173.

Touloupa, E. 1972. "Bronzebleche von der Akropolis in Athen: Gehämmerte geometrische Dreifüsse." *AM* 87:57–76.

A Bronze Vessel inside the Parthenon's West-Side Entablature

Elena Karakitsou

Abstract

In March 2012, during restoration works on the southwest corner of the Parthenon an inscribed bronze phiale dating to the Archaic period came to light along with a part of a bone flute containing an internal bronze pipe. The phiale lay underneath an undisturbed earthen fill within a void behind the second west triglyph from the corner. Two more bronze phiale-shaped vessels had previously been discovered in the Parthenon. Judging from the red ochre they contained these were utilitarian vessels (paint pots) accidentally fallen into constructional gaps between architectural members. By contrast, the depositional circumstances of the new phiale indicate that it had been carefully placed right-side up at this precisely selected point. Traces of fire in the fill and on the flute fragment found inside the phiale point to a religious ritual, a libation performed at this spot during the temple's construction. The structural importance of the Parthenon's southwest corner and its orientation toward the sea (Poseidon's realm) as well as religious and ideological beliefs or artistically transmitted messages associated with this part of the temple may have contributed to the choice of location for this ritual offering of gratitude, performed to ensure the safe, successful completion of the building project.

An Extraordinary Find on the Southwestern Corner of the Parthenon's Entablature

ON MARCH 27, 2012, AN EXTRAORDINARY FIND WAS MADE during restoration works on the west side of the Parthenon— specifically, during the dismantling of the entablature at the temple's southwest corner (figs. 1 and 2).[1]

The removal of minor undisturbed fill and gravel (of about 3 cm) located in the architectural void (fig. 3) between the 14th triglyph, the backer-block of the 14th metope and close to the 18th block of the internal face of the frieze course (figs. 1 and 2) counting from the north at the southern section

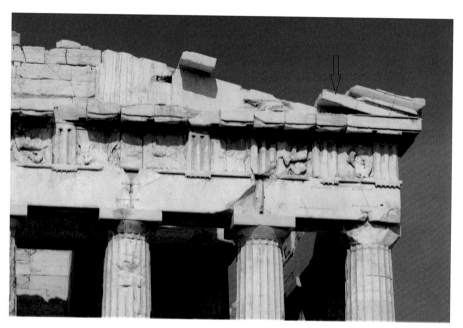

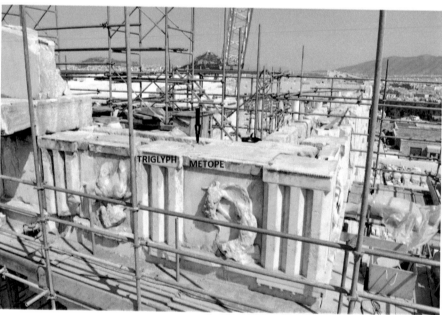

revealed a bronze phiale.[2] It contained part of an animal leg bone with a bronze laminated tube inside, possibly a flute or *aulos* (fig. 4), along with traces of fire on the surrounding soil (fig. 5).

This wide shallow bowl is a mesomphalic, engraved, decorated phiale (figs. 6–9). A band of cross-hatched decorations and a doubled crooked line commences at the rim, limited by two narrower bands shaped out of sidelong streaks. Both its interior and exterior surfaces are decorated using repoussage with a wreath of lanceolate leaves around the central omphalos, which is also surrounded by two rings. The rim has been reinforced through inward folds. Part of the rim's upper surface bears an engraved votive inscription that is illegible (fig. 7). It is an archaic votive inscription, probably dedicated to the goddess Athena. The last three letters of the dedicant's name can be read as [- - -]νις. Perhaps, the initial letters of the verb ἀνέθεκε(ν) or ἀνέθεσαν are also discernible.[3] This phiale belongs to the common popular type of Achaemenid toreutic, dated in the mid-sixth century, known as Lotosphiale, according to Heinz Luschey's categorization.[4] Phialae of various types were very popular in the Archaic and Classical periods as attested by finds in Greek sanctuaries (Perachora, Olympia, etc) as well as in burial ensembles.[5] The bronze Lotosphiale is a Greek product manufactured in workshops probably located in Corinth during the mid-sixth century B.C.E., later also in Athens.[6] Typological and stylistic elements cannot be easily attributed to specific workshops. The same style with few variations could be adopted in a number of areas. At the time this vessel is dated, from the mid-sixth century to the beginning of the fifth century, there were different production centers in Laconia, Corinth, and Athens, and craftsmen most likely traveled, practicing a homogenized style with few distinct differentiations.[7]

The discovery of 2012 represents the third time that a bronze phiale-like vessel has been discovered in the upper structure of the Parthenon. In particular, during restoration works on the temple's east side in May of 1990, a shallow phiale-like undecorated vessel made of bronze was found accidently fallen through the rabbets of the architraves; measuring 15 cm in diameter, it appeared to be bent and exhibited traces of red-earth paint (*miltos*) inside.[8] In 1994, during cleaning works east of the southern entablatures of the opisthonaos, an inscribed bronze goblet came to light inverted in the space above the capital of the southwestern doorpost.[9] It had a bright red interior coloring and was covered with a layer of fine-grained material from the on-site treatment of the marble members. The vessel would have initially been

Fig. 1 (opposite, top). Southwest corner of the Parthenon; photograph by S. Mavromatis; Hellenic Ministry of Culture and Sports/Hellenic Organization of Cultural Resources Development (H.O.C. R. E.D). Ephorate of the City of Athens, Acropolis Restoration Service.

Fig. 2 (opposite, bottom). Southwest corner of the Parthenon with arrow pointing to phiale's findspot; photograph by V. Manidaki; © Hellenic Ministry of Culture and Sports/ Ephorate of the City of Athens, Acropolis Restoration Service.

Fig. 3. The architectural void between the fourteenth triglyph and the eighteenth backer-block where the phiale was revealed; photograph by V. Manidaki; © Hellenic Ministry of Culture and Sports/ Ephorate of the City of Athens, Acropolis Restoration Service.

Fig. 4. The flute or aulos; photograph by V. Manidaki; © Hellenic Ministry of Culture and Sports/ Ephorate of the City of Athens, Acropolis Restoration Service. of Antiquities of Athens City).

perched on the upper surface of the southern frieze blocks for the placement of the architectural members of the entablature, where the red color was utilized for the checking of the flatness of block surfaces before the placement of the overlying stones. Due to a possible mistake by a mason, the vessel fell into a void, 2.05 m deep but it seems that it was impossible to recover it for further use.

In contrast to these two bowls, which were employed in the construction of the temple, as indicated by the existence of interior traces of coloring and their random positions of discovery, the newly discovered *phiale*, judging from its seem-

ingly deliberate location and position, appears to have been purposefully placed at the spot where it was found. The traces of fire in the surrounding soil and the bone flute found inside the vessel indicate that it had been used for one of the ancient world's most distinctive religious rituals, a libation (fig. 5).

Fig. 5. Traces of fire and marble shreds were in the soil around the phiale; photograph by V. Manidaki; © Hellenic Ministry of Culture and Sports/ Ephorate of the City of Athens, Acropolis Restoration Service.

Phiale and Libation

The phiale is quite a popular and extensively used shallow vertebral vessel, wherein the central cavity created externally by the umbo served as a fixing grip. We are aware of the manner it was meant to be used by means of iconographic depictions on Athenian vases.[10]

The religious act of libation is the effusion of liquid from an oinochoe to a phiale and from the phiale to the altar or directly to the soil.[11] The preparation before the arrival at the altar can be seen on the east frieze of the Parthenon. Sixteen (blocks 2, 3) and 11 women (blocks 7, 8, and 9) walk toward the central scene with ritual utensils indicating the performance of libations before and after the sacrifice. They hold phialae, oinochoae, and incense burners (fig. 10).[12]

The sacred performance of libations accompanied many moments in ancient Greek life, especially when someone wished to invoke the assistance or approval of the gods. Typi-

Elena Karakitsou

Fig. 6. Exterior of phiale after
its conservation; photograph
by T. Souvlakis; © Hel-
lenic Ministry of Culture and
Sports/Ephorate of the City
of Athens, Acropolis Restora-
tion Service..

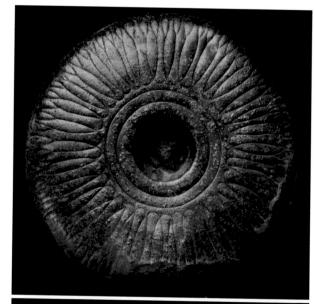

Fig. 7. Interior of phiale after
its conservation; photograph
by T. Souvlakis; © Hel-
lenic Ministry of Culture and
Sports/Ephorate of the City
of Athens, Acropolis Restora-
tion Service.

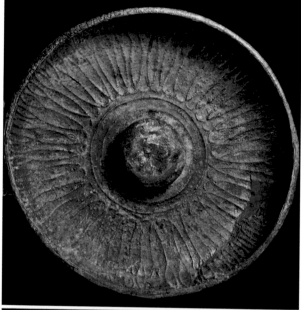

Fig. 8. Detail of exterior of
phiale after conservation;
photograph by T. Souvlakis;
© Hellenic Ministry of Culture
and Sports/Ephorate of the
City of Athens, Acropolis
Restoration Service.

124

21.3 - 22

0 1 2 3 4cm

L. Lambrinou 2019

cally, a priest uttered the votive appeal or expression of thanks while pouring the liquid offering, accompanied by a flute played by a *spondaulis*. The ritual of libation was a bloodless act, the purest form of offering. In contrast to animal sacrifices, the contents poured from the phiale were not later distributed to the believers. The main liquids used in libations were honey, water, oil, wine, and milk.[13] This ceremony was very important for worshipers, because in order for the plea to the gods to be done correctly, it had to be accompanied by a libation, as the relationship between people and gods is bridged through it.[14]

In libations depicted in vase paintings, the phiale is seen in the hands of both gods and mortals. Apollo, Artemis, Athena, Cybele, Zeus, Nike figures, and other deities are all shown performing libations from a phiale held in their right hand. Mortal worshipers commonly used phialae for libations at symposia, weddings, celebrations of victorious athletes, or at times of wartime departure.[15]

In addition, these vessels were instruments for the ritual sacrifices necessary at funerary banquets.[16] They could be given as prizes awarded to race winners and more rarely as

Fig. 9. Section and plan of the phiale; by L. Lambrinou; © Hellenic Ministry of Culture and Sports/ Ephorate of the City of Athens, Acropolis Restoration Service.

Fig. 10. Females holding ritual utensils in the eastern frieze of the Parthenon; photograph by S. Mavromatis; Acropolis Museum inv. 17945 © Hellenic Ministry of Culture and Sports/ Ephorate of the City of Athens, Acropolis Restoration Service.

wedding gifts. The presence of a large number of phialae in a woman's grave may indicate the priestly role of the deceased.[17]

The finding of this ceremonial phiale in a void within the entablature of the Parthenon is an extraordinary discovery, the uniqueness of which raises key interpretative questions. Tentative answers to these questions can only be guided by the examination of the archaeological evidence so far.

The main known use of the vessel in antiquity also suggests that the ceremony that took place centuries ago in the south-western part of the Parthenon was a libation performed as a thanksgiving offering to the deity. The libation was made at a significant moment in the temple's erection, when much of the building had been completed, but prior to the installation of its roof. It certainly had nothing to do with the building's inauguration ceremony, the *enkainia*, a ritual always held at the start of a building's construction that was seen as important for securing the divine favor necessary for continuing the construction work successfully.[18] Offerings were placed at the foundations of buildings, temples, walls, and even at the bases of statues to ensure through their votive dedication that a successful result would be ensured by godly intervention independent of human effort, knowledge, and will.[19] Thus the human will for action and creation ensured sanctification through faith, and in practice, through devotion. In the archaeological bibliography, the dedication of a bronze phiale

during the construction phase has been encountered at least once: at the Heroön of Opheltes at Nemea, where a vessel was deposited at each construction level.[20]

The oldest known foundation ceremony in Greece was found at a clay hut with eight anthropomorphic figurines of the Neolithic era, in a pit near the hearth and under the floor of a house in Platia Magoula Zarkou, Thessaly.[21] At least as early as the Mycenaean period, foundation ceremonies were held in Greece, but no ancient texts preserve any records of the ritual's details. Archaeological data lead to the conclusion that the practice varied. The votive declaration or prayer was accompanied by an animal sacrifice and the dedication of various objects: mainly vessels for drinking or pouring liquids, but also, occasionally, coins, figurines, and other valuable objects. At the start of a building's construction, the sacrificial animal, or parts of sacrificed animals, along with vessels, containers of olive oil, and other objects were laid in a shallow pit, in which a fire had been kindled, located among the foundations of the building and below its floor level. These erection ceremonies represented an appeal to the chthonic deities who dwelled in the earth and had the power to ward off evil.

The purification of a building's construction works was performed during the initial foundational ceremony. The selection of the spot where the offerings were to be placed was not dictated by any distinct set of rules or conditions, although erection ceremonies have been found at sites presenting special difficulties for construction, such as at Iria on Naxos and Treasury D in the sanctuary of Hera on Samos.[22] However, in the case discussed here concerning a ceremony held on top of the temple's entablature, and not down among its foundations, worshipers have sought to appeal instead to the divine, life-giving forces dwelling high up in the heavens.

The presence of the bronze phiale at this level in the structure, which had not yet been completed but had reached the height of the frieze, may point to the builders' desire to thank the goddess for her help in completing the temple up to that point, and to ask her for further aid in now successfully completing the project. Through the libation, the invocation, and the depositing of objects at this distinctive point in the structure, that is, the building's corner, the relationship between humans and gods acquired a formal dimension, a kind of collaboration. Athena became a partner and protector during the act of construction. The builders sought to strengthen the

127

temple's corner under the goddess's watchful eye, since solid and secure corners contributed to the structural strength and durability of the temple.

The phiale is a permanent gift to the deity or deities, a tangible proof of the city's relationship with them. It can be considered as a form of official expression of piety, fulfilling a request for protection, representing the whole city. Likewise, the sound of the flute, as a thanksgiving offering to the deity, leaves its traces in space and is a token of action. The act involves the ideal with the real and the human with the divine.

However, there are no similar *comparanda*, or none have survived, since very few buildings were preserved up to this height of construction. However, this does not prevent us from assuming that this particular ritual is unique and its interpretation may be dictated by the importance of the temple and the significance in the sculptural decoration found in the southwest corner. Then an attempt can be made to answer the following questions: Why was this particular vessel used? Why was this corner chosen? Who participated? When did it take place? The only question that can be answered with certainty is that the ceremony was a libation, and this is because it is dictated by the use of the specific vessel as mentioned above.

An older bronze vessel from the middle of the sixth century was used for the libation. Although the opportunity to utilize a silver or gold phiale, whose material would make it more brilliant and valuable—as can be seen from the votive catalogs of the sanctuary at *IG* I³, 292–362 (for the fifth century) and at *IG* II², 1370–492 (for the fourth)—is undeniable, the use of this bronze phiale could have been dictated by its sanctity as a vessel.[23] Metal votive offerings, such as phialae, belonged to the goddess's property and were reused in the rituals that took place during festivals.[24] These are sanctified objects that were considered divine property, associated with the goddess, and therefore charged with sacredness and divine energy. Therefore, the use of an older phiale contributes to the strengthening of the sanctity of the religious act since its antiquity contributes to its sacred character. Additionally, it could be hypothesized that the choice of this phiale was directed by its preservation during the Persian catastrophe; it might have been one of the few sacred objects that had survived and was available of reuse.

Reflections on the Find Spot of the Phiale vis-à-vis the Iconography of the Southwest Corner of the Parthenon

One also wonders why the Parthenon's southwest corner specifically was chosen for the libation.[25] An easy answer might be that its selection was random. What follows, however, is not a formal interpretation, but simple observations that may help explain the presence of the phiale at the spot where it was found. As no elements in the construction of the Parthenon were left to chance, the placement of the phiale at the southwest corner was intentional, too. In attempting to understand the libation that took place on the southwest corner of the Parthenon's entablature, it may be helpful to consider the iconographic messages embedded in the decorative sculpture on the temple's west and south sides, as well as the overall inspiration behind the Parthenon's sculptural program.

The temples and votives on the Acropolis were destroyed during the Persian invasion of Athens and remained in ruin for years as dictated by the oath of the Greeks in Plataea.[26] The Parthenon was erected on the very foundations of its unfinished predecessor and its building material was used for its construction.[27] The erection of the Parthenon could be considered as a monumental thanksgiving offering of the city to its patron goddess.[28] In this context, the symbolic connotations of its sculptural decoration are very important. The myths of famous mythological conflicts between men and centaurs, Athenians and Amazons, Greeks and Trojans, gods and giants, refer to the struggle of the Greeks against the Persians and allude to the Persian catastrophe; consequently, the struggle between good and evil, the "civilized" and the "barbarians" was prevalent on the Parthenon.[29]

To be sure, the large number of various hermeneutic approaches to date point to the difficulty of interpreting and analyzing the ideological role of the Parthenon as well as the echo of the meanings of its sculptural decoration. Nevertheless, I offer here some suggestions that may assist in interpreting the choice of placement. To begin with, it should be pointed out that the beginning of the procession ritual of the Ionic frieze is also in the southwest corner. The correspondence of the role of the Doric and the Ionic friezes in the transmission of messages is also obvious, since the metopes

express externally the same significance about the building as the frieze expresses internally.

The significance of Theseus as the mythical king of Athens, also founder of the Athenian democracy and reorganizer of the Panathenaea, is projected in the compositions of the Amazonomachy and centauromachy metopes as well as in the obvious messages of the thematic cycles of the metopes: Persian defeat and the contribution of Athenian struggle to the preservation of order. This is emphasized in the representations of the metopes, which symbolically perpetuate the victories of the Athenians against the Persians. Their victory was accompanied by a great loss, viewed as the price paid by the Athenian people for the restoration of justice and freedom.[30] The southwest corner presents a commentary on the special significance of the centauromachy, as it exhibits the punishment of barbarian hubris. Likewise, the Amazonomachy, would have been viewed as a mythical parallel to the battle of Marathon (fig. 2). It is important to note that the attribution of the victory of the Amazonomachy to Theseus, the son of Poseidon, would have strengthened the view that the naval alliance of the Delian League consolidated the Athenian economic and political power.

The contest between Athena and Poseidon depicted on the Parthenon's west pediment may have further transmitted the idea that Athens's divinely bestowed land and sea power were sanctioned from the summit of Olympus. This pedimental scene evoked Athena's triumph and blessing as well as Poseidon's wish to aid. The god of the sea is thus regarded not just as a competitor but as a protector of Athens's naval power and of its leading role in the Greeks' control of the Aegean. Here, we could look at another role of the sea god, who was worshiped as Hedraios, Asphaleios, Themeliouchos, and Teichopoios ("of establishment, of safety, of foundations, of wall-making"); he was considered responsible for the stability of the soil and the safety of buildings. These honorifics reflect the jurisdiction of the god in building, but also destroying edifices, as, among other things, he had control of all geological formations and earthquake phenomena. It is a fact that in various mythical descriptions, which are probably related to theogenic models, special emphasis is given to the relationship of Poseidon with the foundations of buildings, especially upon precarious soil.[31]

On either side of the pediment's central scene, figures of mythical Athenian heroes and kings observed the contest, within a space dominated by peripheral figures perhaps representing the waters of the Kephissos or Ilissos River and the Kallirhoe Spring, thereby alluding to the indigenous origins of the Athenians.[32] The aforementioned reflections may seem exaggerated and distant from the intentions of the original designers and viewers of the Parthenon. However, the southwest corner is the only corner of the temple that faces the sea, the source of Athenian authority (fig. 1). At the vicinity of that corner, the gods, the ancestors of the Athenians, and Theseus are all placed to remind viewers of the Athenians's autochthonous origin. They are all oriented toward the sea, the area where the city prevailed over the Persians and Athenian dominance emerged, also toward the west, where the sun sets yet the naval supremacy of Athens rises. "Away, where the sun [the king] sets" Aeschylus remarked in *The Persians* (230–232), was the answer of the chorus of the elders to the mother of Artaxerxes, Atossa, when asked where Athens is. This is the moment in Aeschylus's drama when the message of the destruction of the Persian fleet at Salamis reached the Persian court.

The Libation on the Parthenon's Southwest Corner in Space and Time

Another question of special interest is: Who attended the ceremony? As mentioned, the libation took place while construction of the entablature was in progress; the overlying stones of the horizontal cornices and the pediment sealed the phiale in the architectural void. There was limited space for the participants of the ceremony. Perhaps, prominent figures of the religious and political ranks of the city stood in the narrow space created in the work lofts of the masons. It is possible that the priestess of Athena Polias, a descendant of the Eteovoutades clan, was present as guardian of traditional cultic practices and as mediator between laypeople and the goddess.[33] Given that a flute was found next to the phiale, the *spondaulis* could have also been a participant. Could we hypothesize that other significant persons were also present? One thinks, for example, of Pericles, political instigator of the famous building program; could Pheidias have been present too, who according to Plutarch (*Per.* 13.6) was the "overseer" of all works? Worshipers probably stood below, west and

Fig. 11. Modern copy of phiale in place; photograph by V. Manidaki; Acropolis Museum inv. 17945; © Hellenic Ministry of Culture and Sports/Ephorate of the City of Athens, Acropolis Restoration Service.

southwest of the Parthenon. It would make sense if the libation ritual was an open public ceremony, albeit one not clearly visible to those standing on the ground below.

The date this religious act was performed is also hypothetical and may be approximately determined according to the chronology of the temple's construction work. The construction of the Parthenon began in 447; in 438 the temple was inaugurated during the Megala Panathenaea; in 432 its sculptural decorations were completed.[34] With the progress of the Parthenon's construction progress in mind, Manolis Korres has suggested that the libation of the entablature could not have been done after 442.[35] The Panathenaic feast of 442 could have offered a suitable ritual context for the libation. The traces of fire retrieved from the find (fig. 5) could have been transferred to the libation's spot from the ashes of Athena's altar just before the libation ceremony.[36] Similarly, once a year the diviners at Olympia transported ashes from the *prytaneion* and mixed them with water to cover the altar of Zeus, an act that served consecration and purification purposes.[37] However, there is no written evidence to confirm this suggestion. I included it here to provide a complete and sufficiently rounded interpretation of the find on the basis of archaeological, architectural, and religious data.

In conclusion, turning away from the symbolic semantics of the Parthenon's southwest corner, I would like to stress that the ceremony of the libation was a pious thanksgiving offering to the heavens; representing the entire city, the libation was a request for protection, a safety-procuring ritual aiming at godly consent to complete the project and to strengthen its foundation.

Upon the completion of the restoration in the southwest corner a copy of the bronze phiale, made of stainless steel, was placed in the same void as a tangible proof of the offering (fig. 11). The ancient offering represented the gratitude of the city in antiquity no less than its replica does now. It shall remain there for centuries, as a memorial in honor of the ancient religious practice and the grand goddess of the Acropolis.

Notes

[1] I thank Professor Vassilis Lambrinoudakis for his valuable feedback on my research; also my colleagues in the Technical and Documentation Office of the Parthenon with whom I shared my reflections. I also thank Nassos Papalexandrou and Amy Sowder Koch for encouraging me to present at the AIA Annual Meeting, Washington, DC (January 2020), and for their kind help.

[2] Acropolis Museum 19745, D. 21.3–22 cm, H. 4–4.6 cm. The backfilling started at a depth of -1.10 m from the upper surface of the internal face of the frieze course.; a *backer-block* refers to the block behind the triglyph.

[3] Meaning *dedicated, to dedicate*. I thank Aggelos Matthaiou and Elena Zavvou who kindly studied the inscription and noted that the following are expected to be inscribed on a votive phiale: (1) The name of the dedicant(s); (2) The verb ἀνέθεκε(ν) or ἀνέθεσαν; (3) The name of the deity (according to the dative), to whom the votive offering is dedicated; (4) The words: ἀπαρχέν (= χήν) -*apar-hen*, as the first fruits of the dedicant's earnings dedicated to goddess Athena- δεκάτεν (= την) -*dekaten*, an offering corresponding to one tenth of one's income (Makres and Scafuro 2019, 65); (5) Sometimes there are other words too, such as the profession of the dedicant, the type of votive offering or (often) the word ἱερόν, ἱερά, -*hieron, hiera*, meaning "sacred" to characterize it. Sometimes some of the above words are omitted (1–3). Sometimes the inscription is quite short, e.g., ἱερὸν Ἀθεναίας (meaning, *at the temple of Athena*). Attempts to read the inscription were made with the method of Reflection Transformation Imaging (RTI) and X-ray, which unfortunately did not yield more data.

[4] Luschey 1939, 121–24.

[5] Tarditi 2016, 201–2, 284 (nos. 7034, 7033); Raubitschek 1998, 21–23 (pl. 17); Waldstein 1905, 148s (pl. 53, 1–4, 6). The specific

phiale belongs to a popular type in the Archaic period, deriving from eastern models but with simplified lotus leaves (Tarditi 2016, 284). Most of the bronze finds of the Athenian Acropolis came from votives deriving from layers created during spatial reconfigurations after the Persian Wars. For more, see de Ridder 1896, 72–74: 7032, 7034 (nos. 219, 222); also see Tarditi 2016.

[6] Sideris 2008, 339–53 (fig. 2); Schütte-Maischatz 2011, 120–29; Tarditi 2016, 319. For a similar phiale, see NM 17122, from the ancient Agora.

[7] Tarditi 2016, 325–26.

[8] Unpublished.

[9] Koufopoulos 1994, 46 (fig. 8). Vlassopoulou (2017, 33–41) presents the inscription "Ναύαρχος ἀνέθεκεν Αθεναίαι" ("Admiral dedicating to Athena"), and dates to the early fifth century B.C.E.

[10] Proskynitopoulou 2009, 60. Indicatively I mention the red-figure *peliki* no. NM 16348, *CVA Athens* 2, III.ID.13, T. 20.4–8. *Stamnos: ARV* 2 1028/10, *CVA* 2, figs. 56–58. Red-figure amphora *ARV* 2 989, 24.

[11] Vrettos 1999, 646–48. On libation and its iconography see Gaifman 2018a.

[12] Jenkins 1994, 76–77, 81-82. Gaifman 2018a, 25 παρ.29 & 33. Gaifman 2018b.

[13] Gaifman 2018a, 14.

[14] Burket 1993, 164–68. Gaifman 2018a, 29.

[15] Gaifman 2018a, 13.

[16] Chrysostomou and Chrysostomou 2012, 373; Kottaridi 2012, 419; Stampolidis 2012, 174–175. Kavvadias 2009, 224.

[17] Ignatiadou 2012, 395–96. In Greece, the mesomphalic phiale is found mostly in sanctuaries, while in southern Italy and the Balkans it appears mostly in burial assemblages (Tarditi 2016, 283).

[18] Lambrinoudakis 2005.

[19] Lambrinoudakis 2005, 338.

[20] Hunt 2006, 81, 116.

[21] Toufeksis 1996, 161.

[22] Lambrinoudakis 2002, 1.

[23] The mesomphalic phiale was one of the most popular vessels among the offerings to the goddess (Harris 1995, 70–73).

[24] As the goddess's property, see Kalligas 1988, 95. For reuse, see Makres and Scafuro 2019, 63–64.

[25] During the restoration works of the Parthenon, all four corners of the temple were dismantled.

[26] Kousser 2009, 269; Korres and Bouras 1983, 133–34.

[27] Kousser 2009, 263.

[28] Delivorias 2004, 20, 171 n. 42.

[29] Kousser 2009, 277.

[30] Kousser 2009, 263.

[31] Kakridis 1986, 114, 120.

[32] See Delivorias (2004, 47) on the meanings emitted by the sculpted decoration of the Parthenon as a whole.

[33] Connelly 2009, 187; Burket 1993, 216; and Mantis 1990.

[34] Orlandos 1977, 93.

[35] Oral remark by Manolis Korres during the two-day conference "Special Issues of Research and Applications in the Acropolis Restoration Works in the Period 2010–2015," November 2016, when the phiale was first presented to a scholarly audience.

[36] Van Straten 1995, 167; Burket 1993, 145–47.

[37] Pausanias 5.13.10. Similarly, nowadays sanctification from the church is transferred to houses for the purposes of blessing; also, the Holy Light on Resurrection Saturday in the Orthodox traditions.

Works Cited

Burket, W. 1993. Αρχαία Ελληνική Θρησκεία: Αρχαϊκή και Κλασσική Εποχή, translated by N. Bizantakos and A. Afroditis. Athens: Καρδαμίτσα.

Chrysostomou, P., and A. Chrysostomou. 2012. "The Lady of Archontiko." In *"Princesses" of the Mediterranean in the Dawn of History*, edited by N. Stambolides and M. Giannopoulou, 366–87. Athens: Museum of Cycladic Art.

Connelly, J. B. 2009. "Στις Θεϊκές Υποθέσεις – Ο Μεγαλύτερος Ρόλος: Γυναίκες και Ιερατικά Αξιώματα στην Κλασική Αθήνα." In Γυναικών λατρείες: Τελετουργίες και καθημερινότητα στην κλασική Αθήνα, edited by N. Kaltsa and A. Shapiro, 186–93. Athens: Κοινωφελές Ίδρυμα Αλέξανδρος Σ. Ωνάσης.

Delivorias, A. 2004. Η Ζωφόρος του Παρθενώνα, το πρόβλημα, η πρόκληση, η ερμηνεία. Athens: Μουσείο Μπενάκη-Εκδόσεις Μέλισσα.

Gaifman, M. 2018a. *The Art of Libation in Classical Athens*. New Haven: Yale University Press.

———. 2018b. "The Greek Libation Bowl as Embodied Object." *The Embodied Object in Classical Art*, special issue of *Art History*, edited by M. Gaifman, V. Platt, and M. Squire, 444–65.

Harris, D. 1995. *The Treasures of the Parthenon and Erechtheion*. Oxford Monographs on Classical Archaeology. Oxford: Oxford University Press.

Hunt, G. 2006. "Foundation Rituals and The Culture of Building in Ancient Greece." Ph.D. diss., University of North Carolina, Chapel Hill.

Ignatiadou, D. 2012. "The Sindos Priestess." In *"Princesses" of the Mediterranean in the Dawn of History*, edited by N. Stambolides and M. Giannopoulou, 388–411. Athens: Museum of Cycladic Art.

Jenkins, I. 1994. *The Parthenon Frieze*. London: British Museum Press.

Kakridis, I. 1989. Ελληνική Μυθολογία: Οι θεοί. Athens: Εκδοτική Αθηνών.

Kalligas, P. 1988. "Από την Αθηναϊκή Ακρόπολη: Το Αθηναϊκό Εργαστήριο Μεταλλοτεχνίας." In Πρακτικά του XII Διεθνούς Συνεδρίου Κλασική Αρχαιολογίας 5 (Αθήνα, 4–10 Σεπτεμβρίου 1983), 2:92–97. 2 vols. Athens: Υπουργειο Πολιτισμου.

Kavvadias, G. 2009. "Ερυθρόμορφη πελίκη." In Γυναικών λατρείες: τελετουργίες και καθημερινότητα στην κλασική Αθήνα, edited by N. Kaltsa and A. Shapiro, 224. Athens: Κοινωφελές Ίδρυμα Αλέξανδρος Σ. Ωνάσης.

Korres, M., and C. Bouras. 1983. Μελέτη αποκαταστάσεως του Παρθενώνος, vol. 1. Athens: ΕΣΜΑ.

Kottaridi, A. 2012. "The Lady of Aigai – Tomb AZVII." In *"Princesses" of the Mediterranean in the Dawn of History*, edited by N. Stambolides and M. Giannopoulou, 70–81. Athens: Museum of Cycladic Art.

Koufopoulos, P. 1994. *Study for the Restoration of the Parthenon*. Vol. 3a: *Restoration Project of the Opisthodomos and the Ceiling of the West Colonnade Aisle*. Athens: ΕΣΜΑ.

Kousser, R. 2009. "Destruction and Memory on the Athenian Acropolis." *ArtB* 91.3:263–82.

Lambrinoudakis. V. 2002. "Rites de consécration des temples à Naxos." In *Rites et cultes dans le monde antique: Actes de la table ronde du LIMC à la Villa Kérylos à Beaulieu-sur-Mer les 8 & 9 juin 2001*, edited by P. Linant de Bellefonts, 1–19. Cahiers de la Villa Kérylos 12. Paris: Académie des Inscriptions et Belles-Lettres.

———. 2005. "Consecration, Foundation Rites," in *Thesaurus cultus et rituum antiquorum*, 3:337–46. Los Angeles: J. Paul Getty Museum.

Luschey, H. 1939. *Die Phiale*. Bleicherode am Harz: C. Nieft.

Makres, A., and A. Scafuro. 2019. "The Archaic Inscribed Bronzes on The Acropolis of Athens: Some Remarks." In *From Hippias to Kallias: Greek Art in Athens and beyond 527 to 449 BC*, edited by O. Palagia and E. P. Sioumpara, 62–77. Athens: Acropolis Museum Editions.

Mantis, A. 1990. Προβλήματα της εικονογραφίας των ιερειών και των ιερέων στην αρχαία Ελληνική τέχνη. Athens: Ταμείο Αρχαιολογικών Πόρων και Απαλλοτριώσεων.

Orlandos, A. 1977. Η αρχιτεκτονική του Παρθενώνος. Βιβλιοθήκη της εν Αθήναις Αρχαιολογικής Εταιρείας 86. Athens: Η εν Αθήναις Αρχαιολογική Εταιρεία.

Proskynitopoulou, R. 2009. "Φιαλόσχημο αγγείο." In Γυναικών λατρείες: Τελετουργίες και καθημερινότητα στην κλασική Αθήνα, edited by N. Kaltsa and A. Shapiro,

60–61. Athens: Κοινωφελές Ίδρυμα Αλέξανδρος Σ. Ωνάσης.

Raubitschek, I. 1998. *Isthmia, The Metal Objects (1952–1989).* Isthmia 7. Princeton: American School of Classical Studies at Athens.

de Ridder, A. 1896. *Catalogue des bronzes trouvés sur l' Acropole d' Athènes.* Paris: E. Thorin.

Schütte-Maischatz, A. 2011. *Die Phiale: Zur zeichenhaften Funktion eines Gefäßtyps.* Münster: Monsenstein & Vannerdat.

Sideris, A. 2006. "Achaemenid Toreutics in the Greek Periphery." In *Ancient Greece and Ancient Iran: Cross-Cultural Encounters; 1st International Conference (Athens, November 11–13, 2006),* edited by S. M. R. Darbandi and A. Zournatzi, 339–53. Athens: National Hellenic Research Foundation.

Stampolidis, N. 2012. "The 'Aristocrat-Priestesses' of Eleutherna." In *"Princesses" of the Mediterranean in the Dawn of History,* edited by N. Stampolides and M. Giannopoulou, 174–88. Athens: Museum of Cycladic Art.

Tarditi, C. 2016. *Bronze Vessels from the Acropolis. Style and Decoration in Athenian Production between the Sixth and Fifth Centuries BC.* Thiasos Monografie 7. Rome: Edizioni Quazar.

Toupfeksis, G. 1996. "Ομοιώματα σπιτιών." In Νεολιθικός Πολιτισμός στην Ελλάδα, edited by G. Papathanasopoulos, 161–62. Athens: Ίδρυμα Ν.Π. Γουλανδρή-Μουσείο Κυκλαδικής Τέχνης.

Van Straten, F. T. 1995. *Hiera Kala: Images of Animal Sacrifice in Archaic and Classical Greece.* Religions in the Graeco-Roman World 127. New York, Leiden: E. J. Brill.

Vlassopoulou, Ch. 2017. "Χάλκινη ενεπίγραφη κύλιξ από την Ακρόπολη." Γραμμάτειον 6:33–41.

Vrettos, L. 1999. Λεξικό τελετών εορτών και αγώνων των αρχαίων Ελλήνων. Athens: Konidare.

Waldstein, C. 1905. *The Argive Heraeum,* vol. 2. Boston: Houghton Mifflin.